1 *Frost clings to desert sand along the Kerman-Mahan road in southeastern Iran, glistening as the sun rises and melting in a few brief moments.*

2 *Wild grasses silhouetted against the setting sun at Mohenjo Daro, a major urban centre of the second millennium BC Harappan Culture, located along the Indus River of eastern Pakistan.*

3 *A solitary figure at prayer within the tiled chamber of the Mother of the Shah Madraseh, an early eighteenth-century theological college and one of the last important buildings erected in the Safavid capital of Isfahan, Iran.*

4 *An itinerant fish seller drenched in the golden light of dusk balances his wares as he walks along the beach at Ambalangoda in the far south of Sri Lanka.*

1

VISUAL
JOURNEYS

ROLOFF
BENY

Presented by

The

Roloff Beny

Foundation

NORTHWEST COMMUNITY
COLLEGE

WITH
157 PLATES
41 IN COLOUR

DOUGLAS
&
McINTYRE

VANCOUVER/
TORONTO

VISUAL JOURNEYS

ROLOFF BENY

PRESENTED BY
MITCHELL CRITES

PUBLISHER'S NOTE

ROLOFF BENY'S AUTOBIOGRAPHICAL WRITINGS
AS WELL AS THE REMINISCENCES OF HIS FRIENDS AND COLLEAGUES
ARE ALL SET IN INDENTED STYLE.

Endpapers: Byzantine peacock, Archaeological Museum, Istanbul

Text and photographs © 1994 Roloff Beny Collection, Accession
No. 1986–009, Documentary Art and Photography Division,
National Archives of Canada, 395 Wellington Street,
Ottawa, Ontario K1A ON3.

Douglas & McIntyre
1615 Venables Street
Vancouver, British Columbia V5L 2H1

Published simultaneously in Britain by Thames and Hudson,
30 Bloomsbury Street, London WC1B 3QP

Canadian Cataloguing in Publication Data

Beny, Roloff, 1924–1984.
 Visual journeys

Published in conjunction with an exhibition.
ISBN 1-55054-167-6

1. Beny, Roloff, 1924–1984—Exhibitions. 2. Photography,
Artistic. I. Crites, Mitchell. II. Title.
TR647.B46 1994 779.'092 C94-910298-9

Printed and bound in Singapore

CONTENTS

PREFACE

Roloff Beny and I travelled more than half a million miles together from India, Iran and Egypt to his native Canada. I suppose I have never spent more time with anyone than with Roloff.

We first met in the autumn of 1971 in New Delhi at the home of the Canadian High Commissioner and his wife, James and Carol George. I was working on my doctorate in medieval Indian history and Roloff had come to photograph the legendary state of Rajasthan, the main focus of my research. I remember he was charming, amusing and dressed in a flamboyant outfit of matching shades of fuchsia and purple. He asked me to join him and Carol George who was assisting on the book, and the three of us set off on a month-long tour of Rajasthan.

The artistic photographer and the itinerant academic got along well and later that year I joined Roloff at Tiber Terrace, his home and studio in Rome, and the base from which we would collaborate on two major books on Iran followed by projects on Egypt, Greece and the Mediterranean. We became close friends, and it was with considerable regret that I left Rome in the late seventies to work in London, where my wife, Nilou, and I would occasionally entertain Roloff on his visits to publishers and friends until his untimely death in 1984 at the age of sixty.

Two years ago I was startled by a phone call from Jack McClelland, an old friend of Roloff's who had published many of his books in Canada, asking if I would be interested in writing Roloff's biography. He explained that Roloff at the time of his death had been working on a book about his 'visual journeys' as an artist, photographer and creator of books and that he had left detailed instructions in his will about how this project should be completed. Roloff had played an important role in my life and after a moment's hesitation, I agreed.

The research was more difficult than I had ever imagined. The bulk of Roloff's early paintings and drawings, thousands of black and white photographs and colour transparencies, mock-ups of his sixteen published books, diaries, private and business correspondence were spread across Canada from The University of Lethbridge in his home province

of Alberta to the National Archives in Ottawa. Much of the material was still packed in the bright hand-made paper boxes that I had last seen in Rome now awaiting the patient revealing hand of the archivist.

I made several trips to Canada. It was slow going but eventually the core material began to emerge. The most astonishing discovery of all was a nearly complete autobiography which Roloff had written during the last four or five years of his life. It seemed unlikely there would be another opportunity for this personal and often eloquent document to be published, and I decided to make Roloff's unfinished autobiography the central thread of the book and to assume for myself the role of chronicler and commentator, weaving into the book excerpts from Roloff's diaries and letters as well as the interviews and reminiscences of colleagues, patrons and friends.

Back in London, the structure and visual content of the book began to evolve through an extraordinary and creative collaboration stretching over many months with Eva Neurath, co-founder of Thames and Hudson, who, along with her late husband, Walter, had commissioned Roloff's first photographic book, *The Thrones of Earth and Heaven*, in 1956. Eva had helped Roloff design *Thrones* and many of his later books. I had worked for years organizing the photographic archive in Rome. We now greeted the mountain of black and white prints and colour transparencies, all candidates for the book, as old friends. We rarely disagreed and, caught up in the process of creating a 'Beny book', often remembered Roloff. Many of his finest photographs from earlier books, long out-of-print, appear together with a number of unpublished images from the archive, including striking portraits of famous people, a radical departure from the timeless, romantic views of architecture, sculpture and nature which forged Roloff's international reputation as a photographer.

It's a book we feel Roloff would have liked.

MITCHELL SHELBY CRITES
Delhi, monsoon summer, 1993

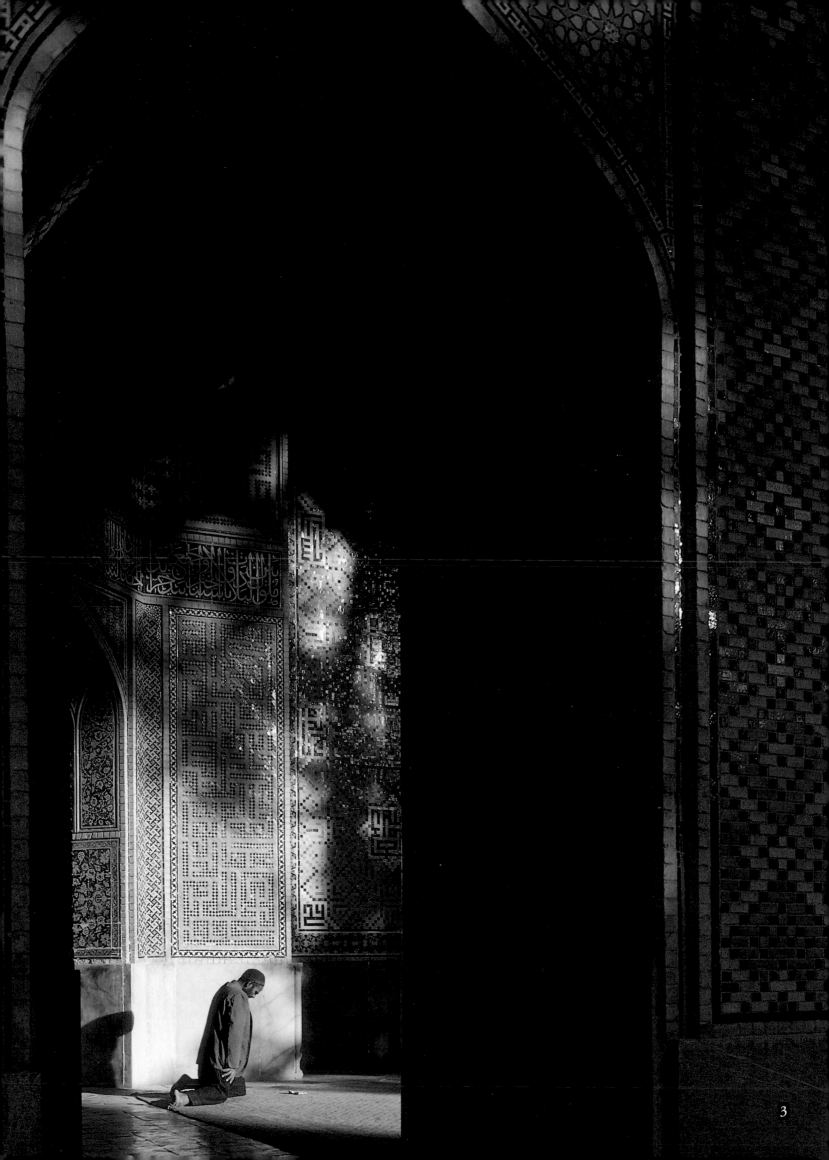

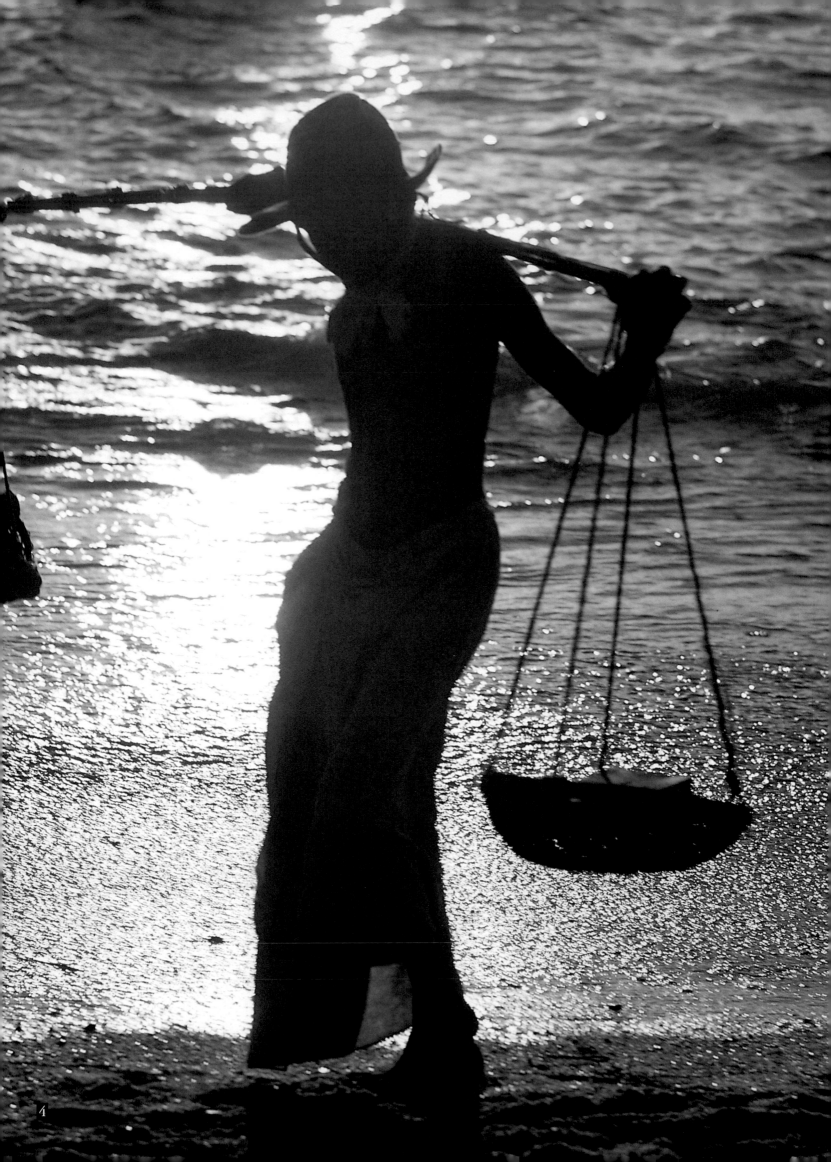

PART ONE

Marco Polo from Medicine Hat

THIS BOOK IS DEDICATED
TO CHARLES AND R▆▆ES BENY AND TO ALL OF R▆L▆FF
BENY'S FRIENDS AND PATRONS; PUBLISHERS, EDITORS
AND ART DIRECTORS; AUTHORS, SECRETARIES
AND RESEARCH ASSISTANTS; DRIVERS, GUIDES AND
GRACIOUS HOSTS FROM VILLAGE HUT TO ROYAL
PALACE WHO AFFORDED HIM THE
LUXURY OF UNFETTERED
SELF-EXPRESSION

PAINTER, PRINTMAKER
AND BON VIVANT
1924-1955

It must be known that from the creation of Adam to the present day, no man, whether pagan or Saracen or Christian . . . ever saw or inquired into so many and such great things as this Marco Polo. He wished in his private thoughts that the things he had seen and heard be made public for the benefit of those who could not see them with their own eyes.

The Travels of Marco Polo

Roloff Beny is best known today as a photographer and creator of beautiful large-format photographic books. What has been virtually forgotten is that by the time he had reached his mid-thirties he had achieved international recognition as a painter and printmaker. His paintings, drawings and lithographs were exhibited and collected by a number of major galleries, museums and private individuals in North America and Europe. A recent retrospective exhibition of his work as an artist and other researches are slowly revealing the complex thread of artistic influences and movements in Canada and abroad that moulded Roloff's work as an artist. I am deeply indebted to the scholarly analysis of Roloff's achievements as a painter and printmaker contributed by Jeffrey Spalding, artist, art historian and director of The University of Lethbridge Art Gallery, which concludes this book.

Roloff rarely mentioned his career as an artist, and it came as something of a surprise to discover diary notes and portions of his unfinished autobiography which explored in some detail his work as a painter and printmaker. It is my hope that by blending Roloff's own writings, reminiscences of friends and colleagues, together with Jeffrey Spalding's seminal research, a part of the excitement and complexity of that early period of his life may be evoked.

Wilfred Roy Beny was born on 7 January 1924 in Medicine Hat, Alberta, to Charles and Rosalie (Roses) Beny. Known as Wilfred to his

parents and Wilf or Woofie to his friends, he gradually adopted the name Roloff, taken from the maiden name of his mother, whose family had emigrated from Russia at the end of the nineteenth century. Roloff's paternal grandfather, Carl Beny, was born in Gau Heppenheim, in Germany, and, after a brief stay in Long Island, New York, hearing of the prospects in western Canada, moved his family to Alberta in 1904. He set up a small general store but soon began selling cars and before long opened Beny Motors Ltd, his own General Motors Agency in Medicine Hat.

Roloff's father, Charles Beny, joined his father in the family business which continued to prosper through the difficult Depression years. Described by many as a stern but loving man, Mr Beny was active in the local Anglican church, service clubs and civic activities. In 1921 he married Rosalie (Roses) Madeleine Roloff, a delicate and sensitive woman who loved fine clothes and art and through most of her adult life suffered from ill health. They had two sons spaced just a year apart. The eldest, Francis Charles, known as Chuck, took after his father, an all-round boy, who was good at sports and enjoyed tinkering with cars. Roloff inherited his mother's softer Slavic looks, dark brown hair and clear blue eyes, also her shifting moods and passion for beautiful things. He was a bright lively child, popular with other children, but from the beginning had a strong sense of his own nature and interests which he felt set him apart from others, a sense of aloneness that remained with him all his life.

We lived in a rather stark white clapboard house which to me then was as glamourous as an Ionic temple. The house was three stories high, had a clipped lawn in front with tall poplar trees and lilac hedges, and along the side, a delphinium and poppy border.

Within the 'townhouse', there were many marvels, not the least of all the cavernous basement and root cellar which contained a darkroom for developing my first film taken as a Boy Scout – a living theatre where I was in charge of the sets, lighting and costumes, and my brother's friends were the actors. It was a moviehouse with a silver screen on which I projected my own hand-painted films and strips of real movie clips I'd steal from ashcans behind the local cinema. Legendary ladies like Greta Garbo and Gloria Swanson were already in my archives before I knew or even photographed them.

When I was five years old, Mother took up a hobby painting luminous slogans on velvet pillows. One day she came home to find that her small son had borrowed her colours, and, after decorating his face and body, had started an enterprising experiment with abstract murals on the dining-room wall. Thus began, somewhat spectacularly, my career as an artist.

5 *Roloff as 'Little Lord Fauntleroy'.*

6 *Multiple images created as a Christmas card from Tiber Terrace in the late fifties.*

16

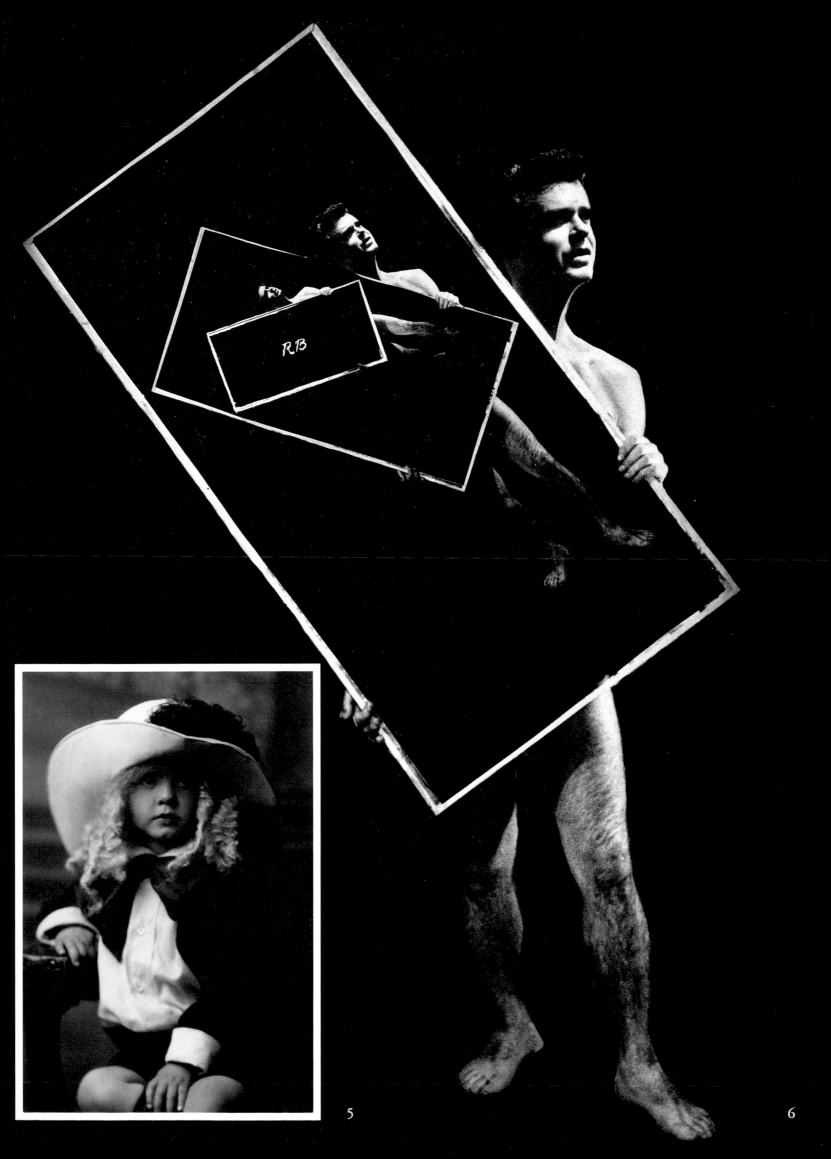

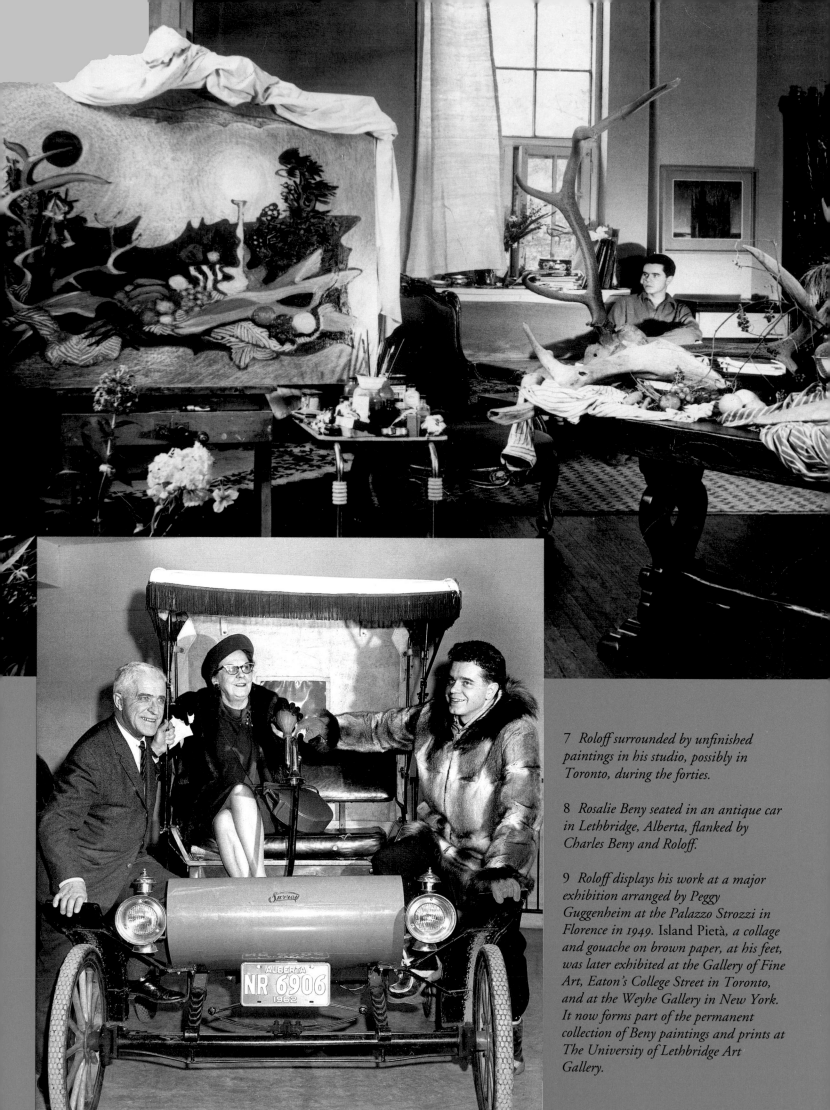

7 *Roloff surrounded by unfinished paintings in his studio, possibly in Toronto, during the forties.*

8 *Rosalie Beny seated in an antique car in Lethbridge, Alberta, flanked by Charles Beny and Roloff.*

9 *Roloff displays his work at a major exhibition arranged by Peggy Guggenheim at the Palazzo Strozzi in Florence in 1949. Island Pietà, a collage and gouache on brown paper, at his feet, was later exhibited at the Gallery of Fine Art, Eaton's College Street in Toronto, and at the Weyhe Gallery in New York. It now forms part of the permanent collection of Beny paintings and prints at The University of Lethbridge Art Gallery.*

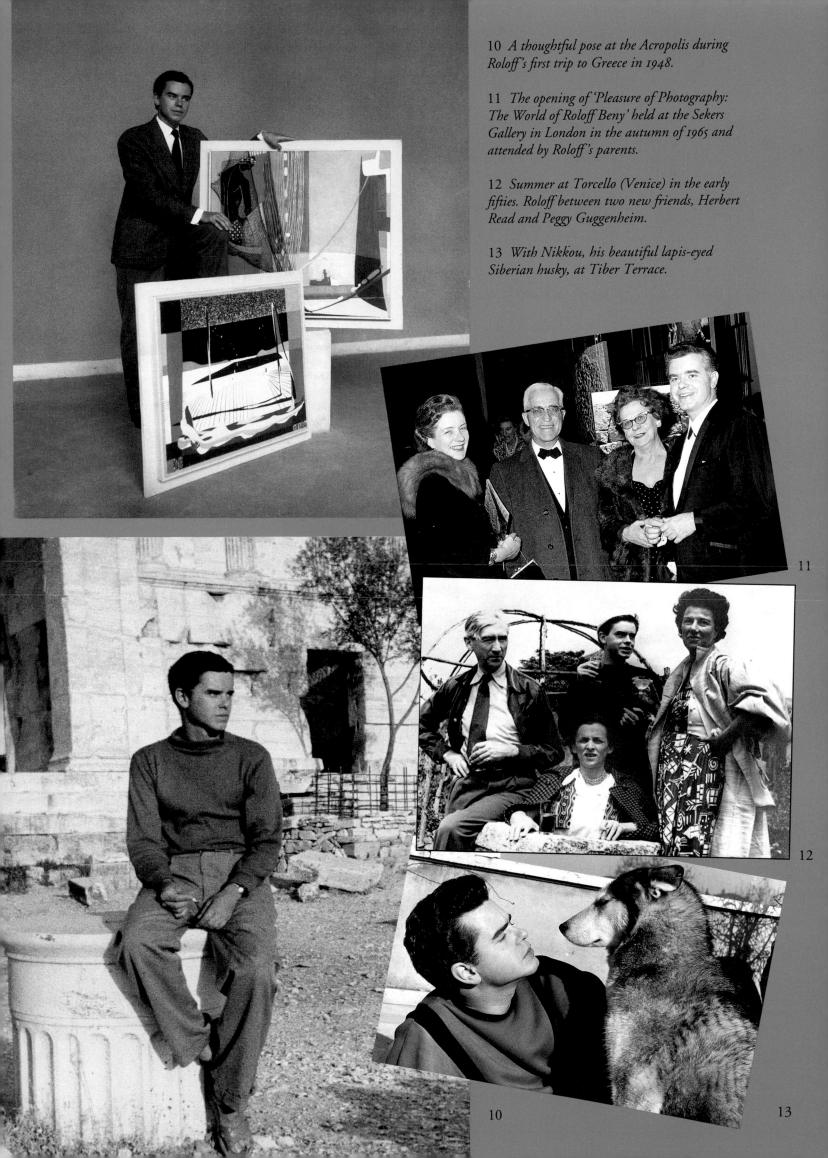

10 *A thoughtful pose at the Acropolis during Roloff's first trip to Greece in 1948.*

11 *The opening of 'Pleasure of Photography: The World of Roloff Beny' held at the Sekers Gallery in London in the autumn of 1965 and attended by Roloff's parents.*

12 *Summer at Torcello (Venice) in the early fifties. Roloff between two new friends, Herbert Read and Peggy Guggenheim.*

13 *With Nikkou, his beautiful lapis-eyed Siberian husky, at Tiber Terrace.*

11

12

10

13

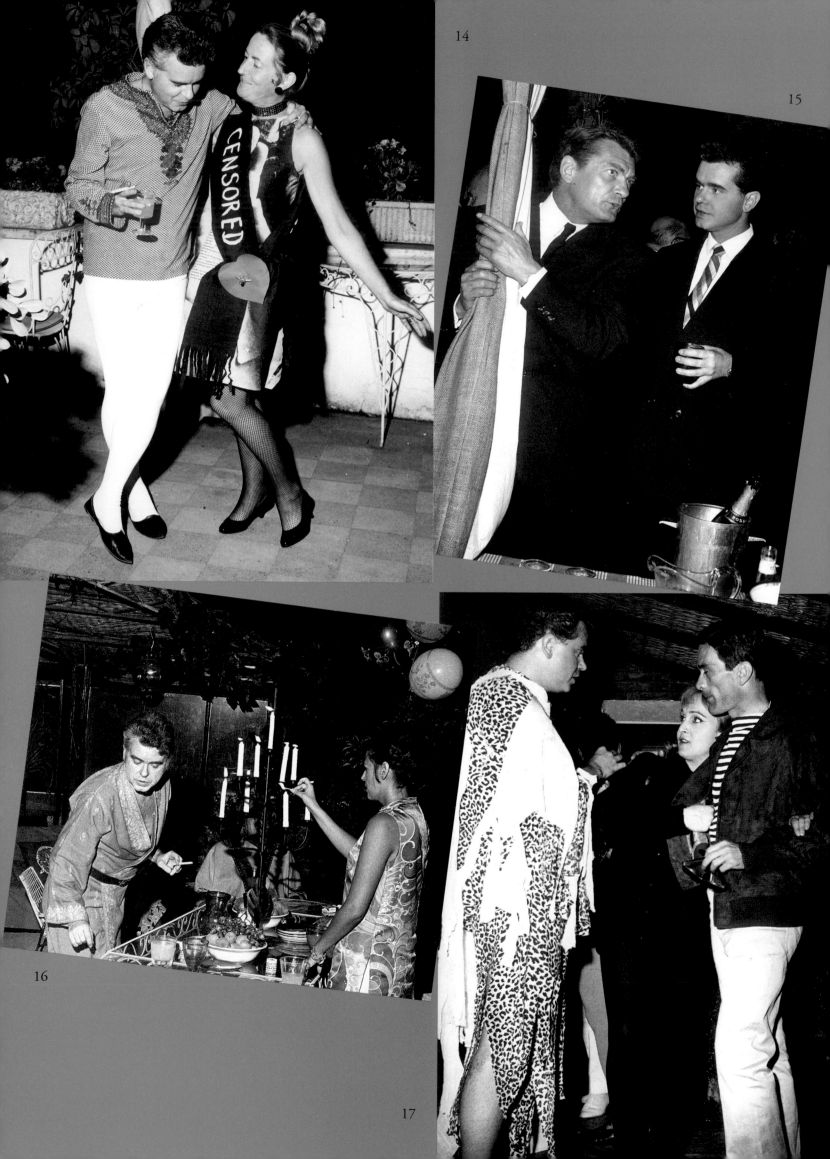

14

15

16

17

Two years later I set up a studio in our attic – my first private atelier. There I escaped every day after school. When not painting indoors, I wandered over the fields sketching grain elevators or the eroded coulees of the Badlands, resting place of dinosaurs.

When I was seven, Mother gave me an edition of the *Book of Knowledge*. One volume always seemed to fall open at 'Classical Greece', with images of Greek sculpture and architecture. Suddenly I discovered a world where the beauty of forms, of temples, had a human measure, sensual and tactile, rather than abstract and elusive like the prairies where I lived and felt so disembodied. I had been taught that women are 'beautiful' and men are 'handsome', and I'd learned that boys are not supposed to like flowers . . . the usual, almost unspoken laws of small-town propriety. The only sculpture I'd ever seen was a snow man . . . I decided to give up piano and become an archaeologist, architect, even a photographer – or was I to be a Michelangelo from Medicine Hat? I had to take hold of beauty, possess it, recreate it. It was as if I had discovered inside myself something that I had always wanted, longed for and sought without knowing exactly what it was. I solemnly dedicated myself to my own nature.

The landscape of my childhood had great impact on my work; the environment in which I grew up is linked to my later books on Classical and Asian cultures. I loved the magic names of nearby towns – Purple Springs, Milk River, Moosejaw and, most improbable of all, Medicine Hat, which, according to a rather dubious legend, was named for an Indian medicine man who drowned in the river and left only his head-gear floating on the surface. I loved, too, the silence of the prairies, the swaying of the fields of grain, the profile of the hills, the cold and intense Northern Lights and the sparkle of the stars that seemed to be very near. When I reached Greece and Asia I felt a sort of 'shock of recognition': the sky and air of Greece have the same rarefied and crystalline quality I knew in Alberta, the stars are just as close, the forms of the hills and mountains just as steep and austere; the luminosity I observed as a child I found again in the highlands of India, and the cold winters of the Persian desert are like Canadian winters. In all places I felt at home . . .

Father was tall, handsome and military in bearing. His entire personality was locked into business, into making his mark with General Motors – which he did superbly. He always corrected my grammar, and he could spell better and dress more impeccably than anyone else I'd ever seen. He was frightening, in a cold sort of way.

Mother was my ally. She was wise, gentle, and from earliest childhood I was aware of her as a grand hostess. I remember her

Four gala parties hosted by Roloff at Tiber Terrace during the sixties:

14 *Roloff chats with the author and socialite, Felicity Mason, at his 'Black and White' party.*

15 *With the actor, Jean Marais, in a more formal mood.*

16 *Preparing for the 'Maharaja and Maharani' dinner party to celebrate the launching of* India *in 1969.*

17 *Draped in leopard skin for his 'Mermen and Mermaids' theme party, Roloff greets the Italian film director, Pier Paolo Pasolini.*

wearing a pale-blue lamé open-back dress with a train, carrying a long cigarette holder and sipping sherry – rather daring for the thirties in Medicine Hat. She was trendy before the term was invented. Later I designed clothes for her.

My parents were constantly apologizing about me to friends, relatives and employees. Chuck was already following in the family footsteps, first laid down by our grandfather who had prospered and started a family of respectable and respected citizens. And now, cropping up from nowhere, a shy, skinny child who painted pictures and set his own strange fashions in dress. A painter, more than half a century ago in western Canada, was a creature unheard of. I grew up against a background of loneliness, feeling myself an oddity and an outcast.

I couldn't stop painting. At last my parents succumbed and allowed me to take watercolour lessons from an English spinster named Miss Terry, who lived with a cat and a goldfish in an ivy-covered cottage. When a minor English watercolourist gave a talk at the local town hall, I sat in the front row, and as soon as the talk was over I rushed up on stage and showed several of my paintings to the astonished speaker. Next day the *Medicine Hat News* reported that the painter, a Mr Leighton, had declared, 'This nine-year-old boy shows great promise as a serious painter!'

At the age of thirteen I sold my first painting, for fifteen dollars. For two weeks I paid a daily visit to the bar of the Assinaboine Hotel to gaze at my *Portrait of a Cowboy* elegantly framed and hanging over the shelves of liquor bottles. But in the third week the hotel burned to the ground, portrait and all.

At the same time I plunged into photography, inspired by my Scout Master, Colonel Bruce Buchanan, who years later refreshed my memory of those first 'snaps' in a letter: 'You saw things that other kids missed . . . the pattern of a spiderweb, the way a bird nest was secured to the bush, the small prairie crocus and bean flowers, the shapes of clouds, the construction of a beaver dam. The very first photographs you made were of a big Dill Pickle fern while you were lying on your stomach with the lens about 24" from the frosted stems and looking almost square into the sun. I have never failed to note in your photography that you actually "play" the sunlight to etch your subject with shadow lines, and rarely do you use straight backlighting. You were so keen on the hobby that your mother gave me 37 dollars to buy a camera she could give you for Xmas.'

Colonel Buchanan also mailed me negatives of photographs I'd taken of King George VI and Queen Elizabeth during their first state visit to western Canada in 1939. Years later, when I was photographing the Queen Mother Elizabeth at Clarence House in

London, I was able to amuse her by telling her she had been my first inspiration as a photographer, and that I had snapped her in Medicine Hat with a Box Brownie; 'and a very good camera, too!' she remarked.

Mother had the habit of clipping every mention of me from the press, which now reminds me that when I was fifteen one of my watercolours, exhibited at the Manitoba Society of Artists, won me a scholarship to study art 'for four weeks in the heart of the Rockies', at the Banff Summer School of Fine Arts under H.G. Glyde, an inspiring teacher and fine painter who first taught me the techniques of watercolour, a deeper appreciation of art, the majesty of nature and the role of the artist in contemporary society. For the first time at Banff, I met other art students, and discovered that I was not necessarily a sideshow oddity for wanting to devote my life to painting.

At Banff, Roloff cemented the first of a number of friendships he would make during his lifetime with strong, cultured and influential women. Margaret Hess, usually known as Marmie, was from Calgary, the only daughter of a prominent businessman. She was later to pursue a distinguished career as art historian and civic leader in western Canada. When I interviewed Dr Hess in Calgary, with a delightful side trip to Banff, she spoke affectionately about her lifelong friendship with Roloff.

Roloff was remarkably intelligent, charming and good looking. He had decided from his early teens to dedicate his life to art. Roloff's summers at Banff School of Fine Arts were very important in expanding his horizons. Here he met students from all over the world and studied with a number of outstanding teachers.

Roloff's mother encouraged his artistic nature. Charles Beny always had a sense of wonder and pride in his son's achievements. He hoped that both boys would join him in the family business and he bought a second General Motors dealership so that Chuck in Medicine Hat and Roloff in Lethbridge could each have an agency. He didn't understand much about art; after all, paintings came in different colours, didn't they, a bit like cars. He made it clear that if that was what Roloff wanted, he could have it, provided he prove himself both academically and through his art. This meant good grades and recognition of his work as an artist, a form of 'Prairie Puritan Ethic'. Roloff understood the rules and worked hard all his life. His father was always there to give him support when he needed it as long as he remained successful in his own right.

He enjoyed art, theatre, fine food and elegant clothes. Success came abundantly due to hard work and incessant travel.

Throughout his life he had to be a loner, constantly marching to his own drum as he went along through his achievements.

Roloff graduated from high school in 1941 with an excellent academic record and growing recognition of his skill as an artist. His father agreed that he could attend Trinity College, University of Toronto, one of the few schools in Canada to offer a degree in fine arts, with a strong department of Classical Studies as well. Roloff would often visit but never again live for any length of time in Alberta. Shortly before heading east to begin his studies and restless with anticipation, he addressed the local Kiwanis club on the subject of art:

When asked to speak, I found myself more than ever chafing against the provincial dullness that surrounded me. 'The gulf between artists and the community has not been bridged . . . In Canada some of our leaders still think of art in terms of a pretty sunset in a golden frame, and of artists as psychological specimens unfit for anything else but the pursuit of this harmless pastime . . .' But I was optimistic; I saw 'a new society, which is even now emerging, in which the artist will be shoulder to shoulder with his fellow men', and appropriately enough I ended with an appeal to William Morris, exemplar of the egalitarian aesthete. Heaven knows what the Kiwanians made of it. I couldn't wait to escape . . .

In September 1941, after three days and nights on the train, I found myself three thousand miles away, at Trinity College of the University of Toronto. I was seventeen and leaving behind the impoverished western prairies of the Depression years. Trinity was an elite, eastern high-Anglican college with an Anglophile, Oxbridge flavour, most of its students from the big cities of the East, particularly Toronto. There I was plunged into a new cosmopolitan setting. I was shy and vulnerable, but intoxicated at being on my own at last, away from the world of my childhood.

In those days Trinity was both grand and strict – high teas on Sunday, academic gowns in the chapel, and compulsory running before breakfast. Coming from a provincial high school, it was something of an honour to be admitted to those hallowed halls. Enduring the academic discipline, and the initiation rites, left an indelible stain on my soul; it was only later, when I came to understand the advantage of a Classical education, and the symbolism of the rituals, that I was able to appreciate my experiences there.

After much plotting, I found a perfect retreat: the neo-gothic belfry of the college's central tower. The Provost's wife had used it for storage and offered it to me as a painting studio, where, to the

music of Sibelius and the regular carillon of bells, I turned out large oils of western skies and grain elevators, charcoal portraits of my colleagues and a series of graphic nudes. This was my indulgence – but it led to my first real exhibition, a one-man show in Hart House, the University of Toronto's athletic and cultural centre.

I told a reporter at the opening that my short time at the Banff School was my only formal training; that I had no desire to spoil my originality by submitting to any organized schooling, and I vowed never to become a commercial artist or a commissioned portrait painter. Bold words – but why shouldn't I have believed in myself when the *Toronto Evening Telegram* praised my 'great talent' and rejoiced in the 'rare experience' of finding a young artist's first show so interesting and full of promise, but continued by warning that things might come too easily for me, and that 'the iron of discipline is surely good for the soul'.

By the end of my four years at Trinity I had even been elected 'The Father of the Spiskopon', the college secret society, and was editor of the *Review*. My paintings had been exhibited in Winnipeg and Saskatoon, and, without wanting to blow my own horn, I'll add that I graduated with top honours, and a medal to prove it.

Stewart McKeown, Roloff's roommate for three years at Trinity College, who was to become a brilliant criminal lawyer in Toronto, recalled how quickly he had adapted to life in the big city:

Roloff was ambitious right from the start, had an engaging 'prairie' freshness about him and was very popular. He could enter a room and knew instinctually the right people to meet. He was drawn to power, wealth and beauty.

Dorothy Cameron Bloore, another close friend and fellow student at Trinity, remembered Roloff's beautiful eyes, his adorable feline manners and his incredible commitment to work and art. Although she felt he never became a major artist, she remarked on his exceptional eye for proportion, distance and objects in space.

After his graduation from Trinity, Roloff's parents still expected him to return to Alberta and enter the family business, but their expectations were foiled by his winning a scholarship to study art at the State University of Iowa, followed by a second fellowship to continue his graduate work in New York and, at last, Greece.

Corn-fed Iowa isn't that different from Alberta, but at least I was among artists and able to devote myself to my work. Perhaps to symbolize this, both to myself and to others, about this time I began

changing my name. 'Wilfred Roy Beny', I felt, wouldn't do for a serious artist. Wilfred was wrong, Wilf too casual, and I never liked Roy. So I decided to become Roloff, using my mother's maiden name. It was a gradual process: 'W. Roloff' first appeared in 1947, in Iowa, but it wasn't until 1950 that I became just Roloff.

I studied under the noted Argentinian printmaker, Mauricio Lasansky, with whom I worked in new variations of traditional techniques, combinations of etching, engraving and colour lithography. He had an immense influence on me. It was my first encounter with a professional artist of international fame, and, although he could be tough as well as gentle, he was a great teacher. Philosophically, I was leaving regionalism behind, cutting myself off from what I felt was the rustic nationalism of Canadian artists, their cultural adolescence, their preoccupation with trees and mountains, their summer-vacation art. I also heard lectures by Robert Penn Warren on comparative literature, but it was his Sunday evenings at home that gave the rare chance to explore our private worlds in civilized company.

For my Master of Fine Arts I worked on a series of prints based on passages from *Ecclesiastes*: 'A time to be born, and a time to die, a time to kill, and a time to heal, a time to break down, and a time to build up . . .' The summer after I left Iowa I made one of my first sales, an oil called *Conception of the Cathedral*, inspired by the Medicine Hat Catholic Church with the Northern Lights in the background. It now hangs in the Trinity College Common Room.

In the winter of 1947–48 I moved to New York where I rented rooms in a physician's house on the East River. I had won fellowships to study art history at Columbia University under Meyer Schapiro and to pursue a doctorate in art history at the Institute of Fine Arts of New York University, then housed in the gilt and green velvet of the opulent old Warburg mansion on East 81st Street.

In New York everything was in movement, not only the bustle of the great city, but even more the excitement, intellectual, artistic and scientific, of the postwar boom – Space-Time physics, as well as the latest movements in art. I wanted to be an artist of the time, one in touch with and reflecting the tensions of the age, not fleeing from contemporary life but facing it. I saw art as the opposite of an escape, and I was looking for that art which would be the 'tortured mentor of our generation'.

I was feverishly active. At the Weyhe Gallery in New York I participated in a group show, and I was exalted when the *New York Times*, *Art News*, the old *New York Herald Tribune* and other papers all reviewed the show favourably, singling me out for special praise. The Library of Congress, Yale University, the Fogg Art Museum at

Harvard and other institutions were showing and acquired some of my *Ecclesiastes* prints. The Brooklyn Museum bought a complete set of my lithographs for their annual print show, where they won first prize. Knoedler's also bought a set, beginning my long relationship with that famous gallery.

Printmaking appealed to me then because I felt that it was sufficiently 'democratic' to meet the spirit of the times; but I was beginning to be even more interested in book design, both for philosophic as well as purely formal reasons. My first commission in this field was a novel, *The Village of Souls*, by the Canadian Philip Child. The subject was seventeenth-century Canadian history, and I did a series of original illustrations for it, but I wasn't completely satisfied. I dreamed of a book all my own, over which I could exercise total artistic control: a dream, which more than any other, has shaped my entire life as an artist, and bridged the transition from painting to photography.

After a year in New York I was about to realize one of my earliest dreams – to go to Europe, to Greece, the Greece I had discovered in my old *Book of Knowledge* in the attic in Medicine Hat.

So soon after the War it was impossible to call oneself simply a tourist: there weren't any, only travellers. I had several good excuses for going to Greece. I told a newspaper reporter I'd been commissioned to design and illustrate a book for a poet in Athens, but I now have no idea whether this was merely a fantasy, or a real commission that somehow failed to come off. However, the American School of Classical Studies in Athens, an academic group of scholars and scientists headed by my old college mentor in Toronto, Dr Homer Thompson, decided that their facilities should be extended to the artist who would most benefit from contact with the Classical world, and I filled the bill. They gave me a study in a Turkish-style house on the slopes of Lycabetus. From one huge window I could see the Parthenon gleaming white in the sun; from the other stretched the endlessly blue Aegean and the silhouettes of the blessed isles.

The impact of Greece was to change the course of my life, physically and spiritually – my wildest anticipation of life seemed drab by comparison with the reality of this new-found land, my spiritual home. In my diary I copied the lines of Rainer Maria Rilke:

Love consists in this,
That two solitudes protect and touch,
And greet each other.

I doubt if I could recapture the flavour of the unashamed and deep collision between myself and Greece now, so many years later,

from the fragments and scraps of diaries and notebooks that remain. I am still living in first impressions, and this ordering of papers and sketches – fragments of my sojourn in the Aegean – these I offer now, before they become lost to me or distorted by time . . .

Far into each night Athens would still be caught in the hot embrace of day, and it was not until dawn when winds swept in from the Aegean that one was released for a few hours of sleep.

Monday evenings were for music. In the remains of the Odeon, built under the Roman emperor Hadrian, guest conductors from Europe directed the Athens Symphony in such delights as Gluck's *Orpheus* and *Alceste*. Cloudless summer nights guaranteed that only stars would light this open theatre, carved from a natural stone basin at the foot of the Acropolis. The night of the full moon was always an event. The gates to the Propylaea, the triumphant portal of the Acropolis, were opened and I would climb the coral slopes to be immersed in timelessness.

The first autumn rains came after three months of clear summer skies. I was interpreting in watercolour the spatial eccentricities of the Erechtheum and the Parthenon when clouds enfolded the Acropolis. I was left alone to dwell on these remnants of perfect form. Each trip to this fortress was a fresh discovery of empathy awakened by the Greek principle of construction. Here, I thought, were aesthetic dynamics for the twentieth century already perfected in the fifth century BC. Though convinced that man's art forms will change and must change with the advance of attitude and technique, I believe that the Classical aesthetic, one alive to man's needs and dimensions, will continue to be a stimulus to the moulding of space by the architect and the artist . . .

In my memory, many of my voyages in the Aegean are as magical as the dream-world of the child's crystal globe, but none is so much the fusion of the real and the illusory as that first trip to Santorini . . .

Arriving at Piraeus in the early evening, I had time for an ouzo and a double Turkish coffee in a little café by the port. The venerable harbour can capture the imagination at any time, and at twilight it was easy to shed one's identity and board a ship, one of a fabled fleet directing its gilded bows into the Aegean.

Early afternoon brought us in sight of the broken volcanic cone that thrusts bizarrely from the turquoise sea and is called Santorini. The approach to this island is Dantesque. Once ashore, an hour of lamenting donkeys up a tortuous staircase brought us to the white-washed streets of this perilous city. In the absence of electricity, moonlight made of these streets an abstraction, a phosphorescent web suspended between night and the indigo sea thousands of feet below. The island's two hotels were still closed for repairs.

ROLOFF THE ARTIST

18 Tamar, *oil on canvas, painted in 1946, (detail).*

18

19

20

19 Island Pietà, *collage and
gouache on brown paper sheet,
November 1948.*

20 Mutilation in the Museum –
Agora Excavations, Athens, *one of
twenty lithographs from* an Aegean
note-book, *created by Roloff in his
Lethbridge studio during his recovery
from rheumatic fever in 1950.*

21

22 A Time to Build, *one of six intaglio over relief prints, created for the* Ecclesiastes *series, conceived in 1947, while Roloff was at the State University of Iowa.*

23 A Time to Mourn, *intaglio over relief print, a strong figural image, also from the* Ecclesiastes *series, 1947.*

24 A Time of Peace, *oil on canvas, 1953, inspired by the original* Ecclesiastes *prints.*

22

23

21 Mourning Interior, *oil and crayon on canvas, 1947.*

24

25

26

Near collapse, I escaped from the whiteness of the street to take a Turkish coffee and assemble my few Greek words to inquire about accommodation. In the taverna three young Frenchmen had a similar problem, without the benefit of a word of Greek. However, the very presence of friendly strangers brought an influx of villagers, and we were soon guided to the Mother Superior of a crumbling French convent, where we were given the choicest dormitory.

Each morning we set out to explore some remote corner of Santorini. From the crest of this treeless island we would watch the moon cool the sea on one side and the sun heat the horizon on the other. In the next ten days we hiked twenty miles to the remains of the Classical city, Mesavouno. We discovered a vast Byzantine cathedral lying in strange splendour by a deserted beach, swam naked three times a day, filled out sketchbooks with impressions, invented new ways to cook octopus, and were content just picking grapes by the roadside as we wandered together . . .

While in Greece, I was befriended by Lady Norton, the wife of the British Ambassador. Together we cruised in the ambassadorial yacht, and she invited me to a reception at the Royal Palace, where I caught my first glimpse of the Greek Royal Family I was later to know so well. Before I left Greece, Lady Norton sent a letter to my parents asking that they be more understanding at this critical point in my life; and a letter of introduction to Peggy Guggenheim.

Roloff flew from Athens to Rome at the end of October 1948 and, after spending two weeks travelling in Italy, arrived in Venice in search of Peggy Guggenheim, the famed American collector of contemporary art who was to become a lifelong friend and guide in the world of art and photography. The winter was spent in Florence, where he settled into an elegant apartment in Palazzo Amerighi, studied Renaissance art, sketched, painted and came to terms with himself:

On 16 November I arrived in Venice, entering the lagoon city amid fog and rain. The next day I explored the churches and set out to find Peggy Guggenheim, armed with the letter from Lady Norton. I went from bar to bar, from trattoria to trattoria, searching for some trace of her address. Finally I was told she was living in Palazzo Barbero on the Grand Canal. That night I climbed the steep stairs to the top floor where she had her apartment. An ancient maid in starched white apron and gold teeth announced me: an unknown artist, dripping wet on the doorstep. Peggy Guggenheim agreed to have dinner with me, and we walked out in the winter rain.

A few nights later we met again. After many grappas, I found myself throwing violets from her penthouse balcony into the Grand

25 In the Beginning, *charcoal on card sheet, 1958, first exhibited at the Here & Now Gallery, Toronto.*

26 Arctic Vertical, *one of the last works created by Roloff in the sixties before turning almost entirely to his photographic books. Charcoal and gouache on card sheet, 1964. Exhibited at the Canadian Group of Painters, Art Gallery of Hamilton, Ontario, 1966, and at 'Odyssey: A Journey of Discovery Through Modern Art: Roloff Beny 1924–1984', Lethbridge, 1989.*

Canal, and weeping . . . from happiness, I suppose, and delightfully drunk. To my everlasting joy, I had discovered my 'soul sister'. That night I slept in her penthouse, along with her five dogs. For Peggy I represented her third child, 'Minxie' as she affectionately called me, between her son Sinbad and her daughter Pegeen.

Some weeks later I left for Florence and on Sunday 5 December I had a crisis. It was sexual. My Greek summer had dazzled me, and the fall in Italy had been liberating, but they had wrought my sensibility to a very high pitch. I sent a marriage proposal to C as a kind of SOS, hoping she'd throw me a life-preserver and keep me from drowning in a way of life, a way of love that seemed to me then a kind of dangerous psychic underworld. In that moment I think I came closest to interior disintegration: even the world outside the self, chaotic and confused as it is, seemed remarkably orderly compared with the disorder within.

The telegram in reply came six days later: 'Desperately sorry – impossible – letter following all love . . .' and I knew that this was a milestone – and perhaps a gravestone!

These last cryptic and apocalyptic passages need some explanation. C was a most rare Canadian girl I'd left behind in Toronto, with a sort of informal understanding that upon my return we were to marry. Like me she was a lover of elegance; unlike me she had been raised amid exquisite wealth. I'd spent many hours with her drinking exotic wines from 'slender Venetian glasses'. She was one of a close-knit circle of friends from my Trinity days; one of the links in this tiny chain was a beautiful and brilliant young man named P (these initials sound unpleasantly coy, but some of the surviving cast of characters might be hurt by too much accuracy).

P fell in love with me, and I with him, but – strange as it might sound to a college student of today – this love was never consummated, aside from a few embraces. It was literally platonic – except that prudishness contributed more to our 'purity' than any philosophical considerations, however much we might have disguised this to ourselves at the time.

Immediately after college, when I went off to Iowa, P joined the air force, and after that our affair became largely epistolary; he wrote the most moving love letters in a fine Italic hand, literate and witty. I was in such awe of this erudite lovemaking that I sometimes worked on several rough drafts of my own letters before I dared answer him. But the chastity was causing us, by now, more pain than joy. P married one of the girls of our college crowd who gave him one child and – I hope – some happiness. I began to think I should put as many borders between us as possible, either geographical or mental. One way of escaping the problem would be

to go to Greece, and another – or so I thought – would be to marry C. To be sure, it would be a marriage of minds, perhaps more a partnership in the arts than a traditional family unit. I allowed the idea to be born, and to float freely about. Nothing very definite, however, was allowed to spoil the hothouse ambience of love's cross-currents.

In New York I had been picked up several times by pleasant cultivated gentlemen who turned out to want to take me to bed, and each time I'd fled in panic. At last, however, came one who was simply too pleasant, too good looking, too cultivated, etc., and I decided, what the hell, let's see what it's all about. He announced his intention of locking me up for ten days in his (splendid and spacious) apartment, and making love to me non-stop. 'Before we begin, is there anything you want to make you perfectly happy with the situation?' he asked. I was so nervous all I could think of was corn-on-the-cob. 'Corn-on-the-cob,' I blurted out. 'What?! Not money, not art, not tickets to the opera, not . . .' 'No, just corn-on-the-cob, plenty of it. A ten-day supply.'

This and several other similarly pleasant interludes, however, did nothing to change the psychodynamics of my Canadian triangle (or quadrangle, including P's wife); I was still in love with him, determined to find 'normalcy' with C, and still planning to run away from all of it.

In Greece I discovered that one does not go to Greece to run away from 'it'. I was still too much of a prairie-bred Protestant to admit it even to my diary, but those kind soldiers in the trench had a lot more to offer than retsina, ouzo and olives. And later I enjoyed the astonishing experience of being taken home by a Greek sailor to his remote and tiny village, where I was treated like visiting royalty, and where his own mother smilingly made up the best bed for us. Pure paganism! Little by little the shackles of ice began to break and melt, as they have for so many other frustrated Anglo-Saxon romantics before me, in the warm sun of Hellas.

Life had made up my mind for me, and I ceased struggling. I found that what I really loved was not limited by gender, but rather defined by beauty; and gradually I grew able to love, simply love. A tiny room furnished only with a carpet, in a mudbrick village of the desert outside Shiraz; in the old Edo quarters of Tokyo; in Venetian palaces . . . wherever and whomever the goddess sent me.

Not that I ever became a total libertine. I remember once when Peggy and her current lover and I found ourselves on the road, desperate for a hotel, and forced to share a single bed with a big feather-comforter. Peggy suggested a *ménage à trois*, but I protested: 'I simply wasn't brought up that way!' So we bundled instead . . .

PORTRAITS

27 *Henry Moore, the British artist and sculptor and a friend of Roloff's, photographed behind a miniature model at his home and studio 'Hoglands', Much Hadham, Hertfordshire, in 1956.*

From Roloff Beny's Diary:

Coco Chanel was a timeless, witty and arrogant Frenchwoman who never stopped talking. When I objected to jewels on tweed, she replied, 'This is real elegance'. She lay down in front of her fireplace, slit open her skirt and said, 'Voilà!'

28 *Coco Chanel, the celebrated couturier, photographed by Roloff at home in Paris in the early fifties.*

In the early 1950s I had the luck to be placed next to Jean Cocteau at a luncheon at 'Junky' Fleischman's on Avenue Foch. We struck up a conversation and Cocteau helped arrange a show for me at the Palais Royal, just under Colette's apartments. Through him I met a galaxy of Parisians, all going off like a string of fireworks. For me, Cocteau symbolized everything an artist should be – he was backstage and in front of the footlights; he was a virtuoso, a poet, a playwright, a director, turning everything he touched into magic. His virtuosity was part of his charm, and seemed like a form of irresponsibility . . . He once told me the burning of the library at Alexandria had been a blessing; otherwise, we would have all been crushed by the learning of Antiquity.

29 *Jean Cocteau, seminal French artist and writer, befriended Roloff in Paris and contributed a text on Egypt for his first photographic book,* The Thrones of Earth and Heaven.

30 *Ezra Pound, the poet, photographed in Venice in 1968.*

31 *Bernard Berenson, one of the greatest art historians of the twentieth century, photographed at his villa 'I Tatti' outside Florence in the late fifties or early sixties.*

32 *Federico Fellini, the Italian film director, poses in his Rome studio beside a poster proclaiming in German his classic film* La Dolce Vita *(1960).*

33 *Pier Paolo Pasolini, another famous Italian film director, relaxes on a bridge near Roloff's home in Rome (1960s).*

Perhaps Dali would really like time to stop. In any case, he is always tinkering with Freud, and with the innards of his own psyche, where, they say, experience is timeless anyway.

34 *Salvador Dali, the surrealist artist, photographed on stage at the Fenice Theatre by Roloff, while he was on one of his visits to his old friend Peggy Guggenheim in Venice during the 1960s.*

35 *His Holiness Archbishop Makarios in the garden of his residence in Cyprus (1960s).*

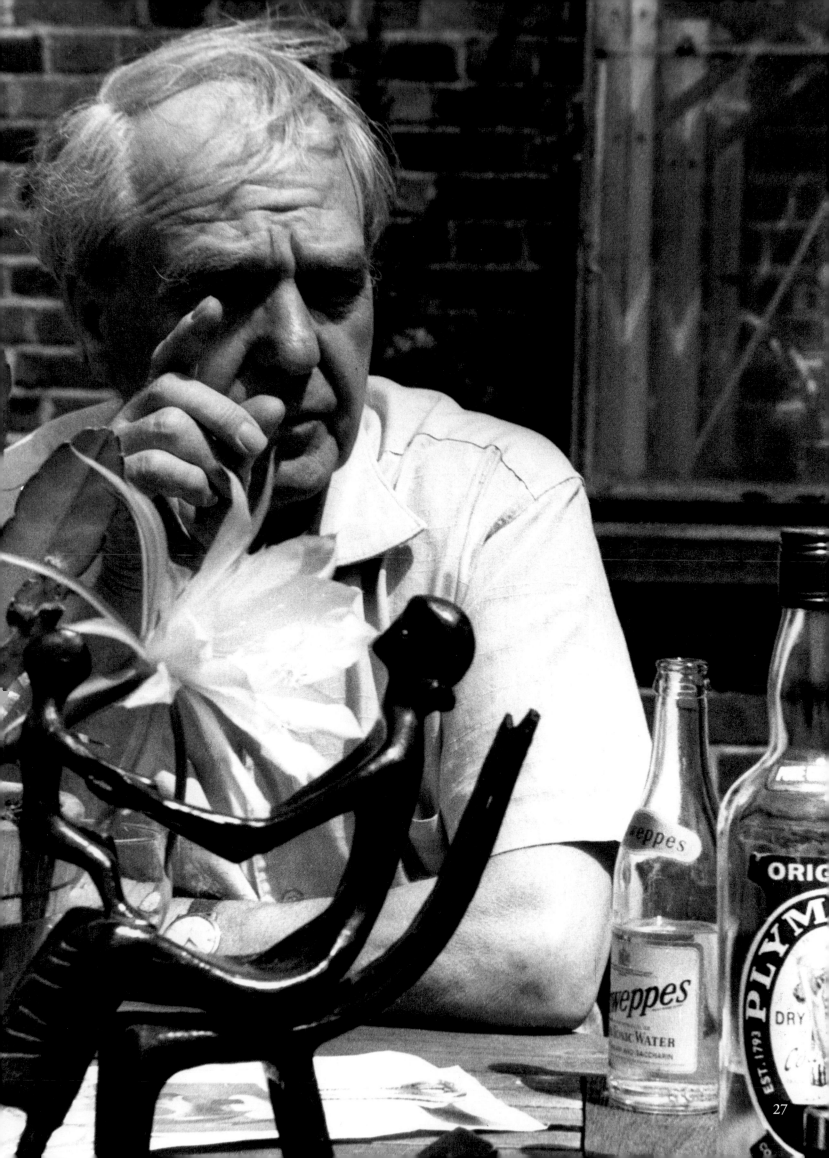

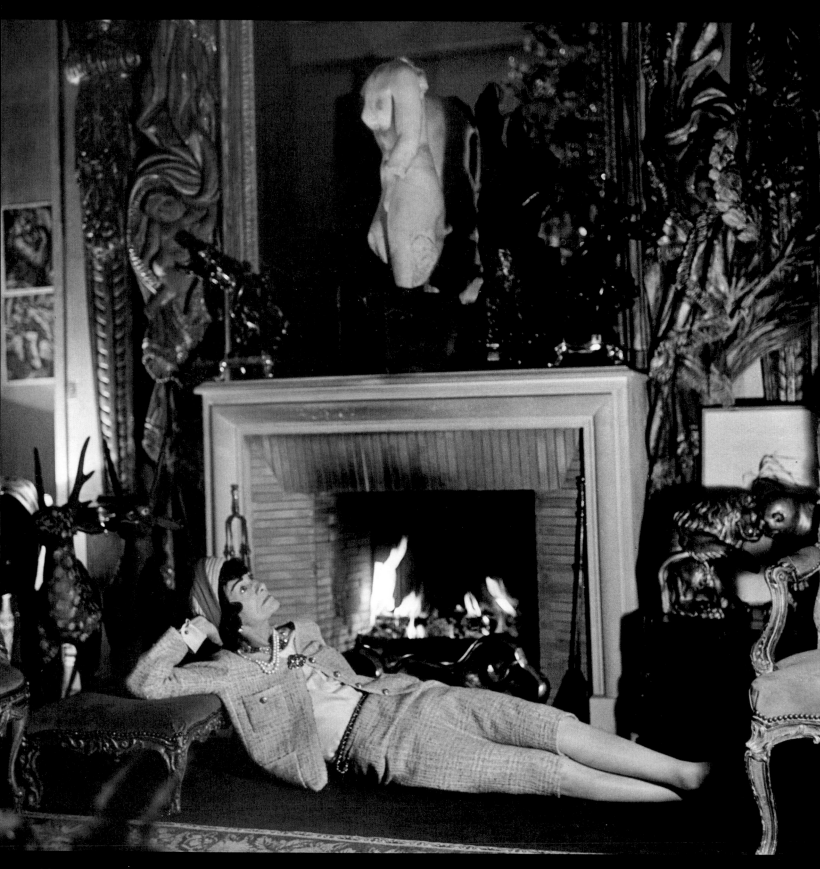

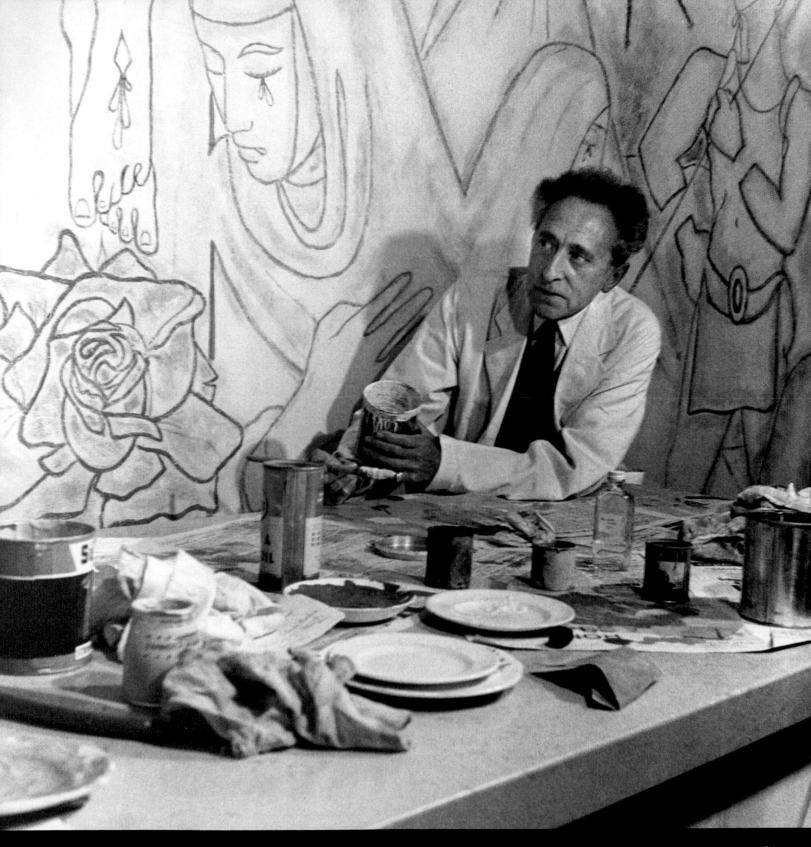

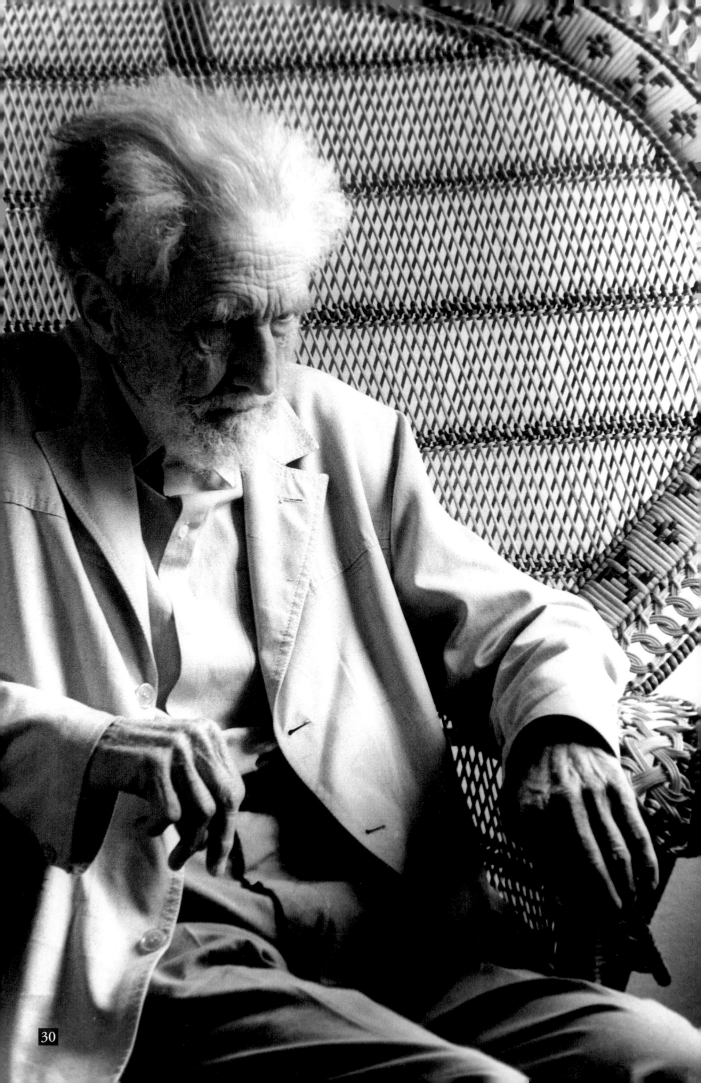

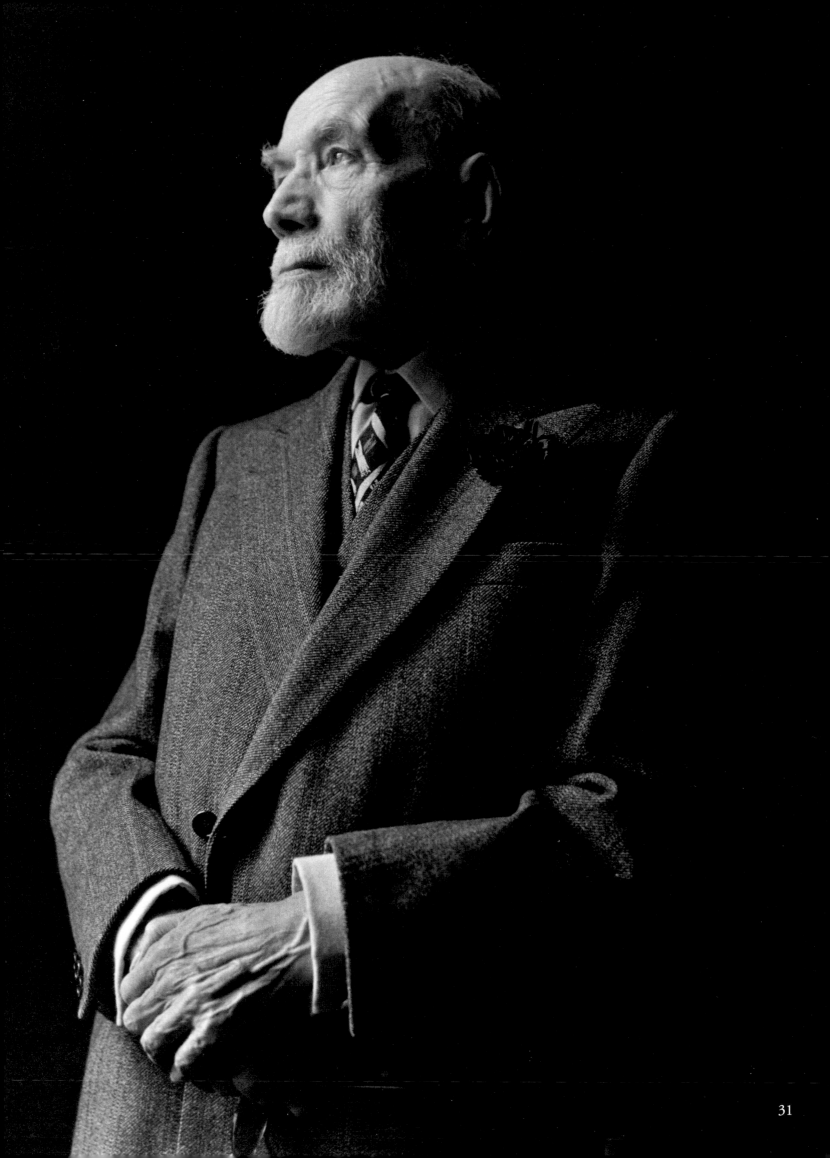

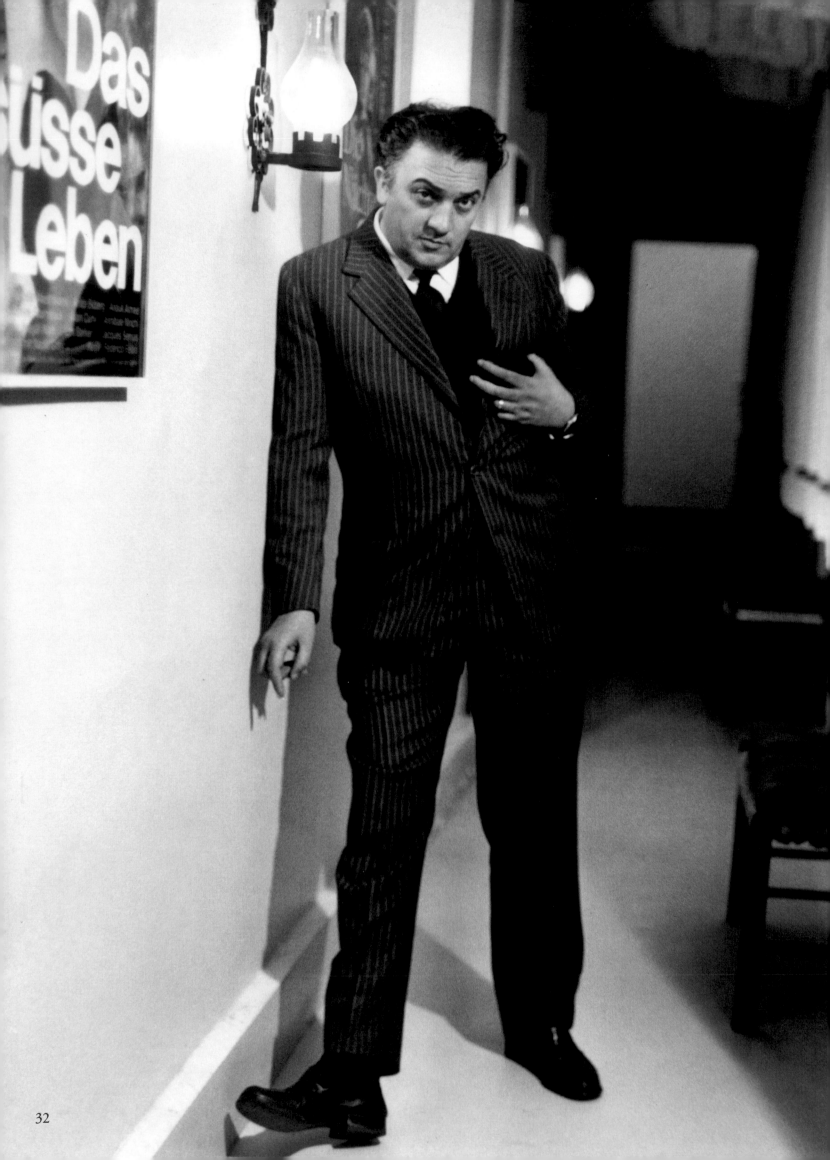

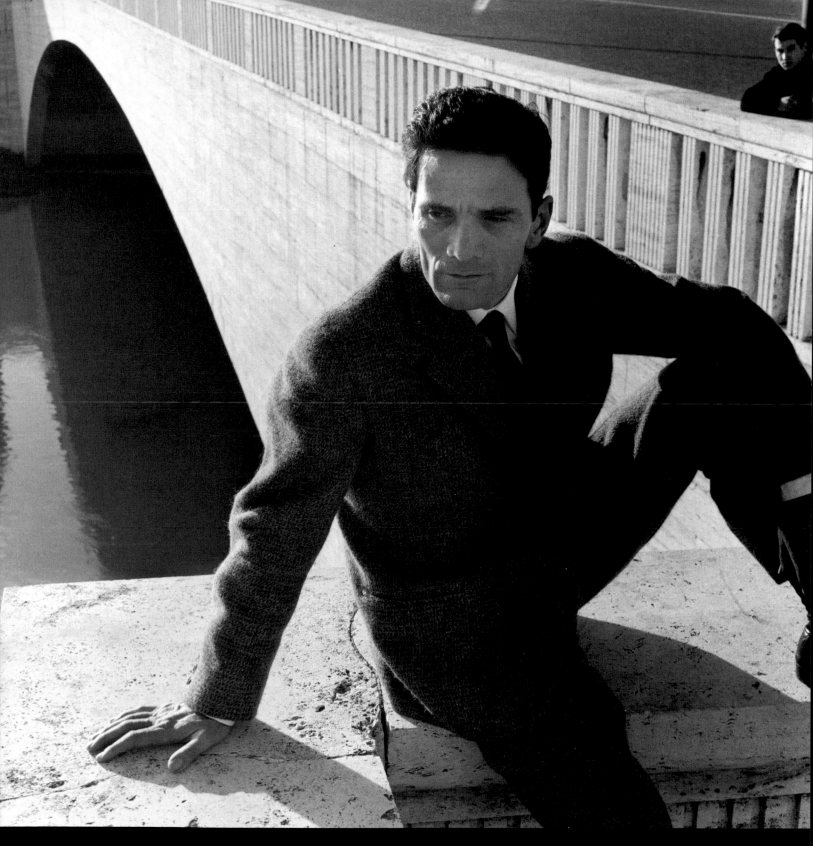

33

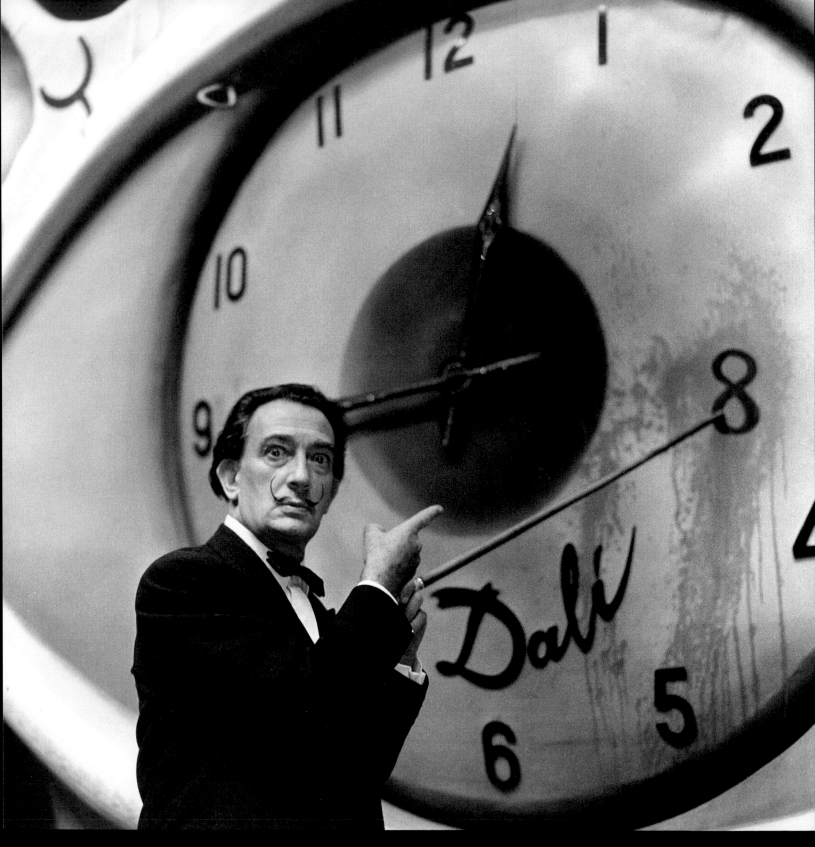

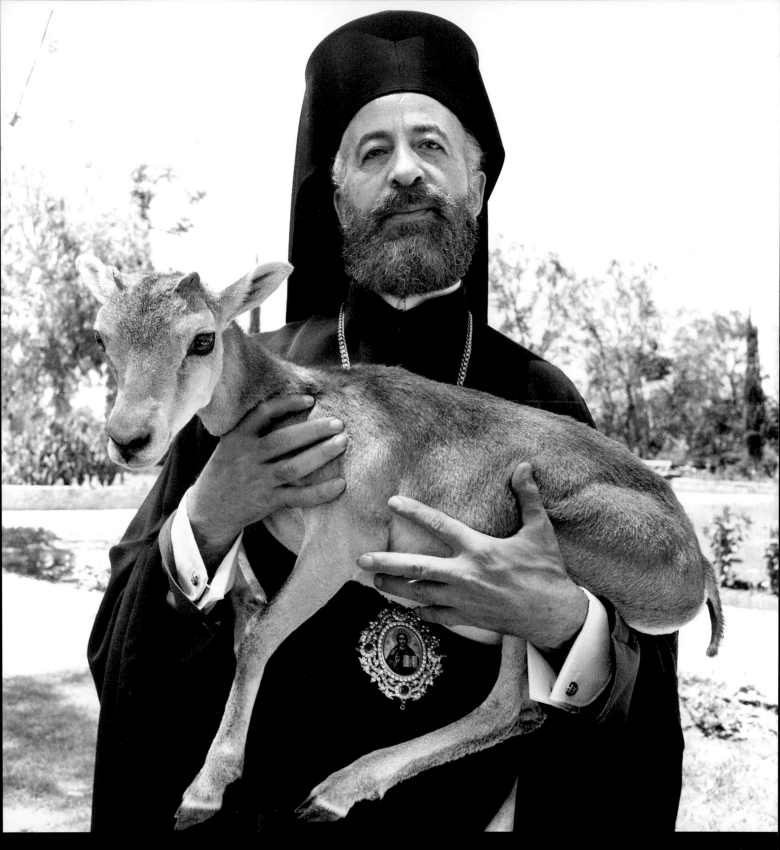

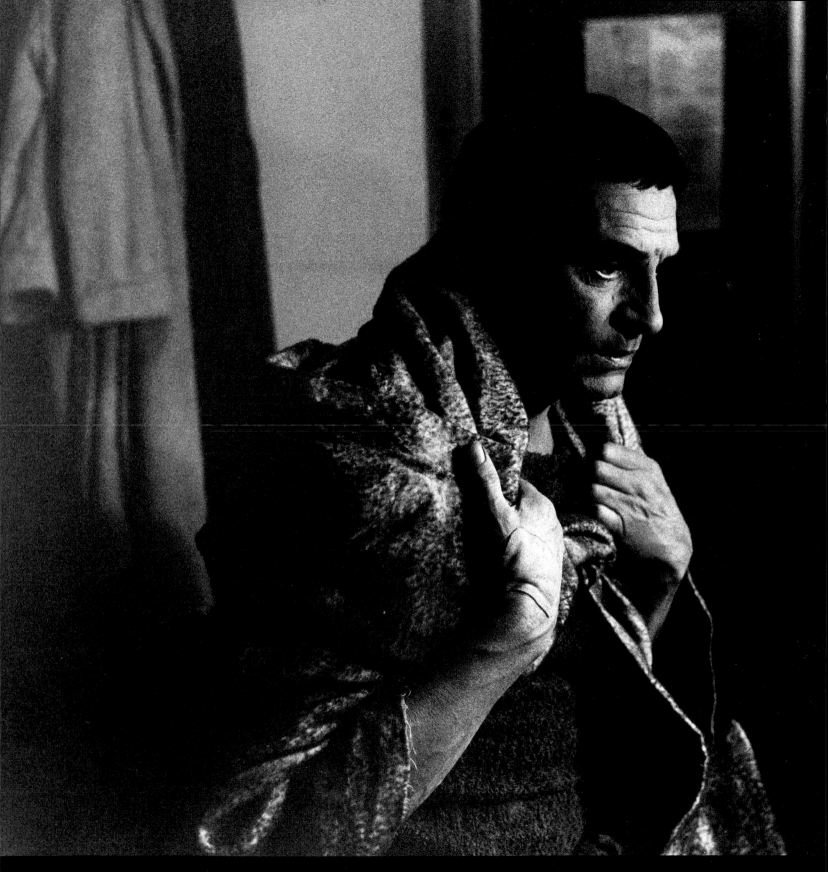

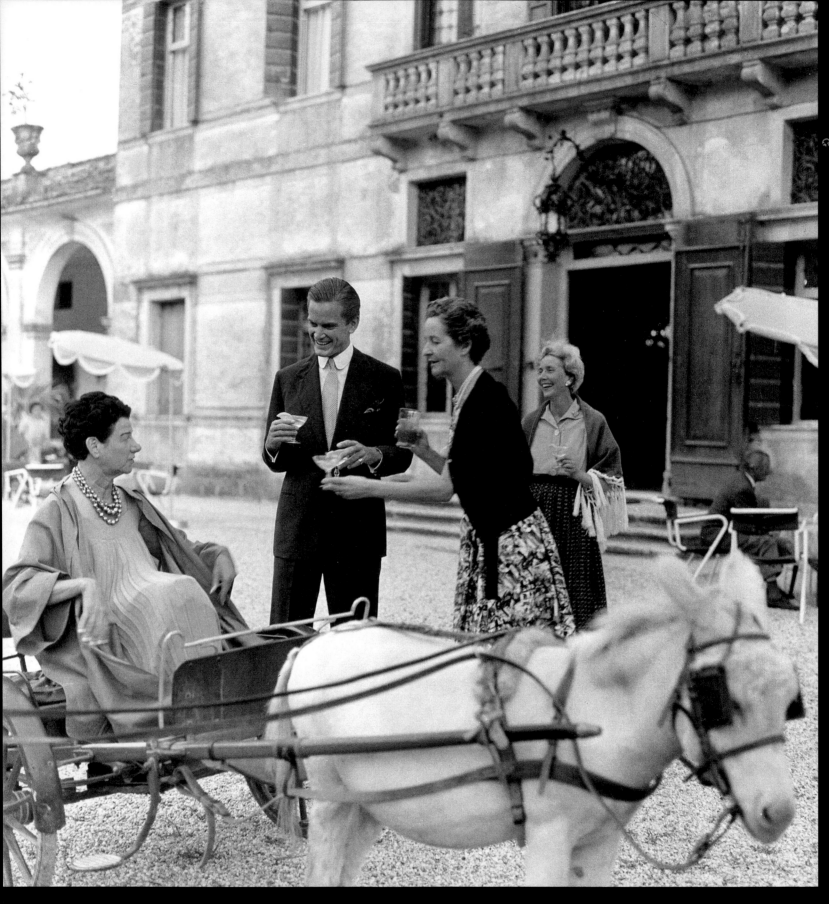

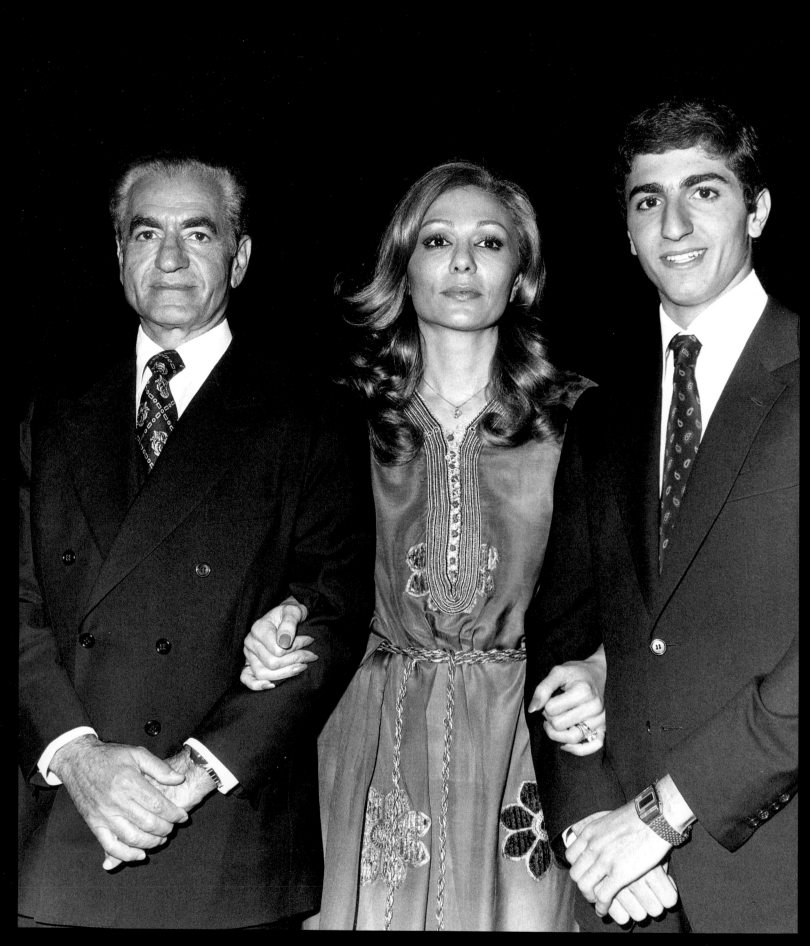

40

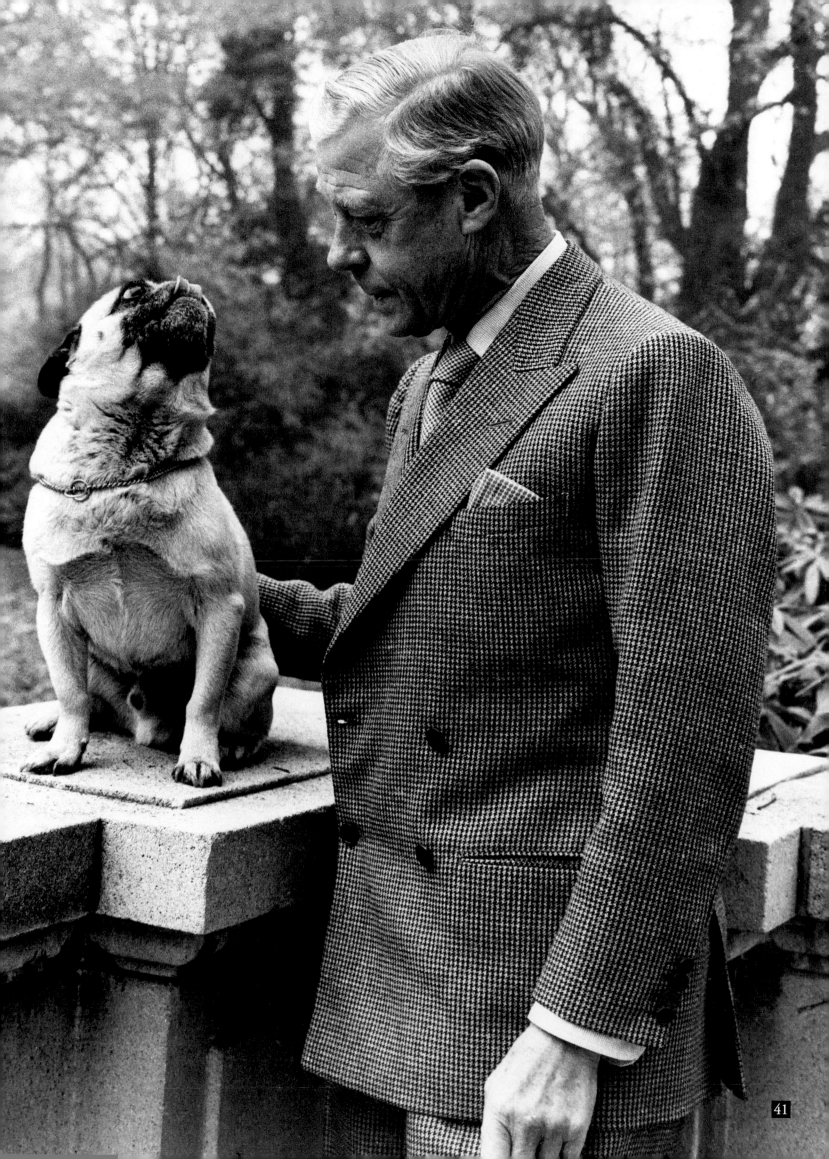

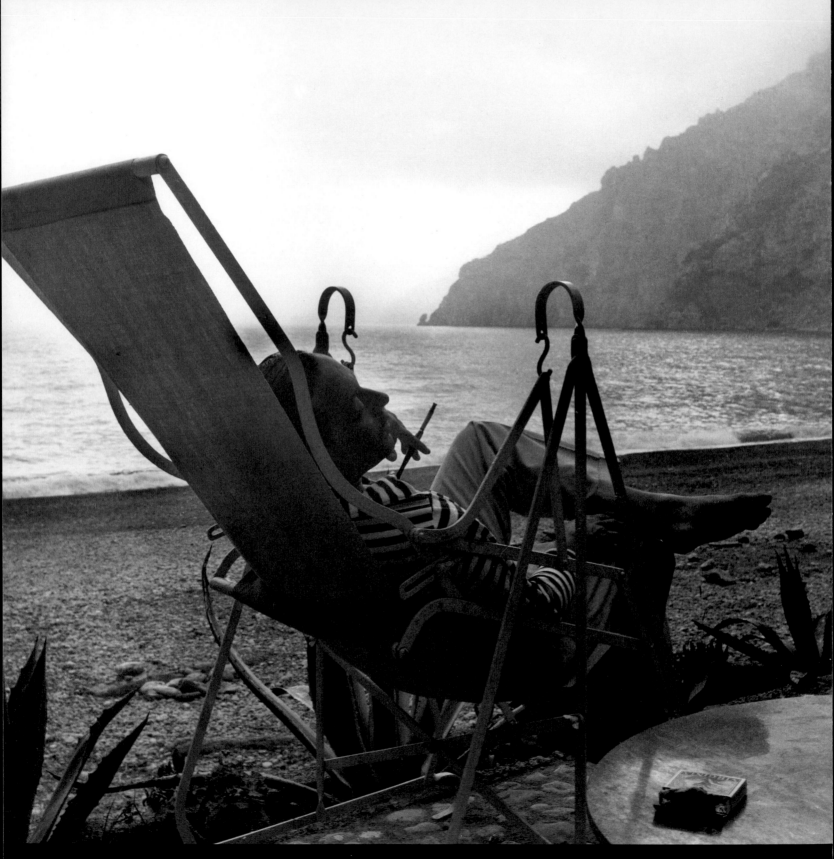

36 *Margaret Rutherford in her dressing room at the Garrick Theatre, London (1960s).*

I found Margaret Rutherford in her dressing room at the Garrick Theatre, London, after her performance in 'Farewell, Farewell, Eugene'. A bundle of chiffon, languidly removing mascara with a rabbit's foot, she said: 'I think if we're going to do a "serious" photograph, we'd better have a drop of Dubonnet . . . and just a drop of gin as well'. Several hours later, I remembered what I'd come for and managed to focus my camera. 'What can I give you, young man?' she wondered. 'Oh, here, take the rabbit's foot for good luck.' The porters swept me out into the night and I floated off on the London fog.

37 *Laurence Olivier photographed during rehearsals for a production of* Coriolanus *at Stratford (1960s).*

I photographed Laurence Olivier at Stratford during his rehearsals in the title role of Shakespeare's *Coriolanus*. A few nights later, having seen the play again, I was waiting for him backstage, overcome with emotion at the brilliance of his performance. When he received me in his dressing room he was just fresh out of the shower. I rushed forward to kiss him on both cheeks and, to my chagrin, stepped squarely on his bare toes. He gave a yowl of pain, then exclaimed, 'For heaven's sake, Wilfie, try to control your emotions and your clumsy feet and relax until I've gathered myself together. Have a Scotch, old boy.'

38, 39 *Peggy Guggenheim was one of the first friends Roloff made in Europe. She is seen in a miniature horse-drawn carriage, being welcomed by Nancy Mitford (centre) and friend in Venice, early summer 1957, and masked and seated on her carved marble throne at her Venetian palazzo in the early seventies.*

As an artist, I was always creating fantasies, always getting carried away, and Peggy Guggenheim brought me back to earth. 'Why? Where? When? How? What?' she would ask. 'Why did you bother with that person?' She taught herself the history of art by reading Bernard Berenson. She was in awe of his erudition and his disdain for modern art. 'If you come to see me in Venice,' she told him, 'I'll cover the objectionable paintings with sheets.'

40 *The Shah, Shahbanou and Crown Prince of Iran in a rare photograph, taken in Morocco during the spring of 1979 while they were in exile.*

41 *The Duke of Windsor at his home in Paris in the Bois de Boulogne, 1959.*

The Duke popped in, preceded by mysterious snorts and clicks – his four pug dogs, inseparable companions, close at his heels, their nails rattling smartly on the parquet. 'Oh, hullo, Mr Beny, ' he said, seemingly unembarrassed by the chewed-up old slipper he held in one hand. 'I hope you find my suit appropriate for a photograph.'

Rather an understatement for the man who invented the Windsor Knot and the concept of matching tie and kerchief! In fact, no photograph I'd ever seen had prepared me for his fresh colouring and radiant vitality, nor for his easy and relaxed Grand Manner. He knew exactly how to behave before the camera and received my compliments with, 'Well, after all, I've had some practice!'

42 *Tennessee Williams relaxes on holiday in Italy.*

I met Tennessee in Spoleto at the Festival of The Two Worlds in the summer of 1959, and often saw him thereafter. Here he is slouched in a languid twilight mood on the beach at Positano. In spite of his themes of cannibalism, rape and eternal frustration, Tennessee is a gentle and most obliging man.

Roloff had come to terms with his own nature but throughout his life remained unable to commit himself deeply to anyone. Totally obsessed by his own work, fleeting impersonal relationships became the pattern. It was a deliberate choice which he appeared never to regret – sustained perhaps by a rich and diverse circle of close friends who tolerated and understood his consuming passion for art, photography, travelling and the creation of books.

Roloff resumed his painting and began thinking about staying permanently in Europe until an unexpected illness changed everything:

Peggy had taken me under her wing as her protégé, and had arranged a one-man show for me at the Palazzo Strozzi in Florence, where the critic Carlo Ragghianti had just opened a modern art gallery. Most of my best American work was displayed, along with all the major pieces I had done in Greece and Florence. The May Florentine Festival was on, the Sadlers Wells Ballet was in town, and my opening was crowded with slender dancers, including Margot Fonteyn.

Peggy was not the only guest who purchased something. I donated a painting to the fund to restore the famous bridge of Santa Trinità, destroyed by the Germans during the War; I presume it paid for at least a few bricks. On the whole it was a resounding success, and I planned to follow it up with shows in Venice, Rome and Paris.

Around this time I gave my first real party, a costume ball. I dressed as a Greek fisherman. Peggy came as a Spanish dancer. Among the colourful guests were a classical Chinese philosopher, a flapper from the twenties and Billy Rose, who arrived in his Rolls Royce with a garbage pail of ice wrapped in silver foil, a perfect theatrical gesture. I've always been attracted to stars, on the principle that one plays one's best game with players more skilful than oneself. People of power, position and accomplishment intrigue me because I admire them and because they inspire me to do better.

In June the season came to an end for me. After an afternoon fishing in the Arno with Margot, I succumbed to rheumatic fever. The Mother Superior at the Convent Hospital of the Blue Nuns in Florence advised me to convalesce in Merano, a cloistered world high up in the Dolomites. But the fever lingered on, and at last it was decided that I should be flown home to Lethbridge, where my parents had moved a few years earlier, a city I hardly knew.

It was winter when I arrived, poor in purse and much poorer in health. My parents were shocked at the sight of this structure of skin and bones, and hoped that my narrow escape from death would sober me into settling down to a more practical life in Canada. But

my passion for Greece had in no way diminished. I would return there via a book I would write, illustrate and design.

I rented an office with a large pseudo-Romanesque window overlooking the park in Lethbridge. Here I began work on *an Aegean note-book*. I had the idea of using different kinds of paper – building paper and tarpaper for the covers, and imported Fabriano rag paper with deckle edges for the prints, pure black on a sensual dimpled beige.

The local printer I selected for the job was baffled. However, by standing over him for a month, I finally saw the book come off press. It was one of the happiest times of my life. There it was, my *Aegean note-book*, handmade, boxed and signed, fifty copies of the special edition to be sold at $100 each, with the others at $50 and $25. The Knoedler Gallery in New York sold every one of them, including a copy to the Museum of Modern Art.

The book was hailed as a breakthrough. *Mayfair* magazine ran a feature on it. The *Toronto News* hailed it as: 'one of the best printing jobs ever done in this century'. Knoedler's presentation of the book centred around its lithographs and was enthusiastically received by the New York critics.

It had been a feverish winter. I had painted Greek subjects on jumbo canvases, made collages, prints and lithographs. But my most significant creation had been *an Aegean note-book*.

If you could still find a copy you might wonder about the dedication 'For Angelo'. I might have written 'In memoriam Angelo, 1949–1949'. He was conceived and born under my bed at Peggy Guggenheim's palazzo. A Lhasa terrier, Peggy had given him to me as a companion during my convalescence from rheumatic fever and to accompany me on my Atlantic crossing. In Toronto he was apprehended, poor illegal immigrant, and clapped into quarantine. He only survived a month of his three-month sentence. The loss so depressed me that my father was in despair. One day he asked me to come into the living room and meet a Royal Canadian Mountie. There, next to the scarlet and blue of the man's uniform, sat a silver-white regal shape, a Siberian Husky with Nefertiti turquoise eyes, a gift to me from the RCMP. I named her Nikkou and had a turquoise collar made to match her eyes.

Two things restored me to health in 1950 – the *Aegean note-book* and Nikkou. I moved to Toronto with her and rented a large wooden house, advertised myself as a teacher and acquired a dozen students – the 'twelve disciples'.

That spring, Eaton's Fine Art Gallery arranged a one-man retrospective of my work. By this time, I had met John David and Signy Eaton, who bought some of my paintings and remained close

friends and patrons throughout my life. The idea of a retrospective for a western neophyte was greeted with hoots of derision. The same exhibition appeared at the Knoedler Gallery, where the New York critics were more enthusiastic. The paintings sold, and I set myself up in a glamourous New York apartment behind the Plaza Hotel. It was like an expensive brothel, with a mirrored bedroom, pink satin wainscotting, and a fold-out kitchen bar in pink.

The most memorable events of that short New York stay were two parties. *Vogue* editor Leo Lerman, noted for his wine-and-cheese get-togethers for the Bohemian and avant-garde world of the city, gave a party for me. There I met Truman Capote and Andy Warhol.

Truman invited me to another gathering at the home of Gloria Vanderbilt. Unnerved by all the famous faces, I got drunk and crashed into a cabinet of Dresden figurines.

In May 1951 Roloff decided to return to Europe crossing the Atlantic with Stewart McKeown, his Trinity College roommate, and touring France, Spain and Italy. Peggy Guggenheim was their hostess again in Venice and she arranged two exhibitions of his paintings, one in Vicenza and the other in Merano:

I was seen as an artist; and art, in Italy, has always been an honourable profession. I received dinner invitations to villas and palazzos where few foreigners had ever set foot. I discovered a small forgotten world, living on the memories of past centuries and vanished glory.

Autumn in Venice with Peggy Guggenheim was becoming a tradition which was to last for thirty years. This time I found her in her new home, Palazzo Venier dei Leoni, perching low on the Grand Canal. She was just moving in, and we slept in cots with only the open fireplace and the dogs to keep us warm. In the wake of the annual autumn flood, the city was bitterly cold. When I suggested there might be a rug to protect my feet from the glacial marble floor, Peggy snapped, 'Where do you think you are, the Ritz?' I held my peace. I've always been willing to suffer for elegance.

During the winter of 1951–52 I realized my dream of living in Paris. My stay there was a constant struggle between my desire to savour the glamour and heady perfume of postwar Paris and my budget. I was new to the scene, but my talent was vouched for by Jean Cocteau, whom I met at a party and who had undertaken to arrange a show for me at the Palais Royal.

The Café Flore was the intellectual-artistic magnet of the era, the place to be seen; there I experimented with *fine à l'eau* (but really preferred Pernod, which, of course, reminded me of Greek ouzo)

and learned the custom of figuring the bill by the number of little glass saucers which would pile up in a drunken tower through the course of the protracted afternoons.

All Paris seemed to breathe art. Once I was delivering a new and over-sized painting to 'Junky' Fleischman, the King of American Gin and Yeast, and my latest client. The framed canvas was strapped to the luggage rack on the roof of the car, and as I was hurtling through the Bois de Boulogne I heard a woman screaming. I screeched to a halt, and the lady ran over to me. 'What could be worse,' she exclaimed on the verge of tears, 'than the death of a painting!' I looked back. My latest work had flown from the rack and now lay under a truck. Fortunately, only the frame had been crushed. The painting was saved, and the Frenchwoman with the artistic soul went happily on her way.

Cocteau was the key to everything for me in Paris. He was the soul of generosity, wit and mad elegance. He had introduced me to Paul Morihien who presented my *peintures récentes* – mostly landscapes inspired by Spain and Italy – at his gallery in the Palais Royal in April 1952. Almost all the paintings were sold.

I was 'riding the crest of a wave of popularity unusual in contemporary art', as Reuters put it. 'He has a one-man show running here, another set for the Il Milione Gallery in Milan in May, and a third scheduled for London in the fall. The Alberta boy is a minor rage in European art circles . . .'

Jean Cocteau also brought me luck. On the morning of the *vernissage*, I received an impressive-looking envelope stamped in gold letters, 'John Simon Guggenheim Memorial Foundation'.

'Dear Mr Beny,' the letter read, 'I have the pleasure to inform you that the Foundation has awarded you the Fellowship you requested . . .' It was not Peggy who had worked this magic for me. When I had asked her for a recommendation, she had warned, 'Don't even admit you know me. My name is the kiss of death around there.'

Back in New York, I decided to set up house in Manhattan for Nikkou and me. I found a 'Charles Addams' Park Avenue penthouse and settled in with my canvases and neo-Palladian decor.

I prepared for the annual print show of the Brooklyn Museum and won a contest sponsored by Hallmark Cards. The most important challenge, however, came from Knoedler's. Basil Petrov encouraged me to prepare for another one-man show, and I began a monumental series of oils, once again on the theme of *Ecclesiastes*.

To bolster my income, I experimented with fashion photography. Basil's wife, Bette, was editor of the chic *Park East* magazine, and she bought as much as I could produce. My exclusive

model was Sonya Hurst, a striking British beauty. I can't say I'm proud of this work, most of which has vanished as completely as the fashions it glorified, but as an apprenticeship for later and more serious endeavours, it proved invaluable.

By January 1954 I was ready to hang my one-man show at Knoedler's. Sonya was to be my date for the opening. Despite her striking appearance, she was by nature conservative. When she showed up at my penthouse, her costume struck me as being rather dowdy. I stripped a gold lamé spread from my bed, and we spent a feverish half hour draping and pinning, leaving large and strategic areas uncovered. Then we set off for the gallery on 57th Street.

Sonya's daring gold-swathed entrance on my arm, holding Nikkou on a matching leash, was snapped by someone, and the photo appeared in *Time* magazine, along with a titillating account of the Bohemian demimonde of the wicked city. This publicity coup assured the success of the show at Knoedler's. *Art News* noted that 'Beny's is a theatrical talent, and it might well be that the space, scale (and budget) of the stage would suit his tastes.' The combination of critical praise and nationwide publicity brought in prices from $1000 to $3000 per painting.

I decided to invest half my profits in the works of other artists. Peggy advised me to buy only from the solid and reputable, so I went to Kurt Valentine, Picasso's first New York dealer, and to Pierre Matisse, the artist's nephew. I bought for my own pleasure, and I suppose in minor imitation of Peggy, but it turned out to be the best investment I ever made.

Guided in the early stages by Peggy Guggenheim and Herbert Read and later by following his own informed and highly developed instincts, Roloff created during his lifetime an impressive art collection which focused primarily on the work of twentieth-century painters and sculptors. While the bulk of the collection was kept in Alberta, where it was looked after by his parents, a number of major pieces – including a Henry Moore tapestry, drawings by Cocteau and Matisse, a gouache by Graham Sutherland, lithographs by Picasso, Léger and Magritte and an Arp bronze – were displayed at 'Tiber Terrace', a beautiful penthouse apartment in historic Rome, which became Roloff's home in 1957.

At the age of thirty, Roloff had established himself as one of Canada's best-known modern artists, and his exhibitions had generated considerable attention in American and European art circles as well. He was, however, shortly to embark on a new visual journey into the world of photography and book design which would gradually overshadow his painting and printmaking and become the primary creative focus for the remaining years of his life.

PART TWO

Photographer and Creator of Books

THE THRONES
OF EARTH AND HEAVEN
TO ICELAND
1956-1985

Roloff Beny's international reputation rests firmly on his work as the photographer and creator of sixteen imaginative and beautiful books beginning with *The Thrones of Earth and Heaven*, commissioned in 1956, and ending with *Iceland*, which appeared in 1985, a year after his death. The transition from art to photography, once referred to by Roloff as a 'reluctant seduction', began as early as the spring of 1951 when Roloff and Stewart McKeown, then on their European tour, reached Spain, where Roloff was working on a second book of sketches and paintings as a sequel to *an Aegean note-book*.

In May Stewart and I sailed for England. I'd just gotten an international licence and learned to drive on the left, and bought a little Vauxhall in Liverpool which was to take us some 6,000 miles, through England, Holland, Belgium, France and the whole of Spain. With my Mediterranean prejudice, it was really Spain that drew me, and we rushed even through Paris.

In Greece I had learned to carry a camera to capture the architecture and nature I could not always stay to sketch and also to avoid the insistent curiosity of street children. By this time I had graduated to a Rolleiflex, and the photographs began to look like something more than mere snapshots for future reference. I still saw them as an adjunct to my painting, but began to be aware of light as opposed to paint and to compose my photographs as I did my drawings.

Light in fact was beginning to become a major obsession. In Spain I first invented my custom of looking at five or six rooms of each hotel I slept in, searching for the one with the best light and view. I found much to love and much to return to in Spain, but at the same time I considered the trip a major disaster. A month's worth of sketches were stolen! All I had to show for the whole

voyage, I mourned, were a few rolls of exposed film. Because only these photographic images remained, I laboured over them in the darkroom to urge them to project graphically more than the mere place and object; this is when, I believe, the idea of 'going further with the camera' became a latent passion. Could the theft have been some sort of omen?

McKeown certainly viewed the theft as a 'catalyzing event', recalling that during the remainder of the trip, Roloff concentrated almost entirely on photography which excited him greatly. The camera seemed as natural to him as his paints and pencils, and there appeared to be no deep regret at the loss of the sketchbooks.

Shortly after his Spanish trip, Peggy Guggenheim, both friend and guide in the world of art, began to nudge Roloff gently in the direction of photography. In the early seventies, during one of Peggy's frequent visits to Tiber Terrace, I remember asking her what Roloff was like during his early years as an artist. She candidly replied that he had considerable talent and great sensitivity but that from the first moment she saw his photographs, she knew that was his destiny. 'Roloff had enjoyed a limited success through his paintings and prints but fashions were changing and along with many of his friends I was concerned that he would be unable to adapt and develop his art. Photography was the answer.' Her first move was to introduce Roloff to Herbert Read, a leading critic and art historian, at an exhibition of Roloff's paintings at the Galleria Il Milione that she had helped organize in 1952.

Milan considers itself the art capital of Italy, and the Milione is Milan's establishment gallery, so the show was a breakthrough for me. Ironically, however, it was here that a seed was planted that was to change my life and turn me from a painter into a photographer. The seed was my meeting with Herbert Read, a close friend of Peggy's. Sir Herbert was to become a real mentor – I almost wrote 'guru', for there was something quasi-mystical about Peggy's and my admiration for him, and even at this first meeting I felt awed by his seemingly flawless taste and compendious knowledge of art.

I showed him my prints, drawings and paintings; then, almost diffidently, the photographs from Spain that had survived the theft. To my surprise, he liked them very much – almost, it seemed, more than the paintings and prints. Peggy joined her praise to his. They plotted together and began to encourage me to pay more attention to photography. Perhaps I seemed a bit doubtful, after all, I had looked on the camera till then as merely an *aide-mémoire* to my serious work, but in any case, Sir Herbert ended by promising me an exhibition of photographs at the Institute of Contemporary Art

in London, if and when I felt ready. I continued to pursue my career as an artist and four years were to pass before I could accept this offer during which time I was to undergo the slow metamorphosis that Peggy and Sir Herbert had foreseen.

It was 1955, on my annual September pilgrimage to Peggy Guggenheim in Venice, that several threads of my destiny ultimately came together and led to my first show as a photographer.

When I arrived at Palazzo Venier dei Leoni, I saw a woman I had first encountered seven years earlier in an espresso bar on the Lungarno in Florence. I had been riveted by the figure wearing a huge silver Calder brooch, almost an entire sculpture. She turned out to be Nellie van Doesburg, widow of the famous Theo, one of the founders of *De Stijl* and a prominent Dutch painter.

It seemed that Nellie was a close friend of Peggy's, and I was delighted when she suggested we travel together in Mexico. I agreed, stipulating only that we spend most of our time in Yucatán searching out Mayan ruins. I looked on the trip as an opportunity to follow Sir Herbert's directions – 'Follow photography!' – and this was to be the first trip I made where my cameras vied with my paints. Nellie turned out to be a perfect fellow-traveller, tireless and convivial. Very convivial. In fact, when it came to amorous adventures in the jungle, she beat me hands down!

On his return from Mexico, Roloff took stock of his career as an artist. His paintings were selling, but perhaps Peggy and Sir Herbert were right; the time had come to embark on a new 'visual journey'.

He studied the bold black-and-white photographs of Mayan temples and sculpture entwined by the jungle and decided that together with his earlier work on the cathedrals and palaces of Spain it would indeed be possible to create something striking and uniquely his own. Roloff's first photographic exhibition opened at the Institute of Contemporary Art in London on 30 January 1956.

I felt I was ready to be launched as a photographer and, to my relief, Sir Herbert agreed. I deeply regret that none of my diaries or notebooks from these years have survived, and I am a bit hazy about the public reaction to my first photographic exposure. I do recall that, apart from most of my English friends, Henry Moore was also there; Peggy and Sir Herbert, of course, and two new acquaintances, Walter and Eva Neurath, founders and owners of Thames and Hudson Ltd, publishers of some of the finest art books in Europe. Some time during the course of the evening, an idea was born: I was to do another book. This time, a book of photographs, and the Neuraths would publish it.

Walter liked the photographs. But it was my proposal for the text to accompany the pictures that really sold him. The idea was to produce a book on the art and architecture of the Mediterranean world, with essays by famous authors on their favourite parts of that world. I'm sure I name-dropped quite shamelessly, mentioning Cocteau, Sir Herbert, Bernard Berenson . . . After all, I had no reputation as a photographer, and if the book was to sell, I needed those names, because my ambitions for the book were enormous, megalomaniac and sumptuous. It had to be the book of my dreams, a hundred times more beautiful than my *Aegean note-book*. At the end of my stay in London, the Neuraths were almost convinced. 'Deliver the authors,' Walter told me, 'and we'll do it.'

Thus began my long, stormy and loving relationship with Thames and Hudson. Walter was a big man, both commanding and demanding, and over the next two years he must often have regretted his promise. When I suggested that the book should have five different colours of paper, one for each author, he replied that no such thing had ever been done. By the time that session was over, he was flinging books and paperweights around his office, but he never went back on his word. I did not fail him, and I got the five colours.

The Neuraths had taken a big gamble on Roloff. It was his first photographic exhibition, but the powerful and abstract images of Spain and Yucatán with their haunting timeless quality so reminiscent of his earlier paintings and drawings had convinced them that he could create something extraordinary. Eva Neurath vividly remembered her first encounter:

Herbert Read was one of Roloff's greatest champions. He insisted we attend the opening of the exhibition. We were very impressed, and although Roloff had little experience in photography, much less a major book, we commissioned him to go ahead. How did he do it? He certainly had a magic touch and limitless charm when he needed it, always managing to meet the right people at the right time, and the photographs were brilliant.

Christened by Roloff as a 'divine and tempestuous union', Thames and Hudson and their young Canadian protégé were to produce over the next twenty-five years some of the most beautiful photographic books in the world, and he was to become one of their most important authors.

THE THRONES OF EARTH AND HEAVEN

By the end of February 1956 Roloff had thrashed out his contract with Thames and Hudson, received an advance for travel and film and embarked on a five-month tour of the Mediterranean to photograph his first book, *The Thrones of Earth and Heaven*. The title, which was taken from Shelley's *Prometheus Unbound*, was thought too poetic and obscure by the publishers, but Roloff won them over. His first stop was Turkey.

I crossed the Bosphorus into Istanbul under a gloomy February rain, with my faithful Rolleiflex, a tripod and several cartons of tropical-packed film. In late winter, Istanbul has a sallow ugliness. The Golden Horn only reflected mosque silhouettes at dawn or dusk, forcing me to rely once more on my brushes rather than my camera. With the enthusiasm of a neophyte, I trekked about the city, being refused permission to photograph by surly Turkish bureaucrats, getting myself covered with such mud and *merde* as only a Turkish bath could remove. This was my introduction to the oriental art of bathing and the male-dominated world of Islam. Gradually, in spite of the inclement weather, I was falling under the subtle spell of Byzantium.

By March I was in Lebanon. With the help of Professor Serig, director of the French Institute for the Lebanon, I found an ancient black Buick and a rotund beetle-shiny driver named Ali to transport me towards the Euphrates. Hundreds of miles east, in the desert at Palmyra, the weather was splendidly varied – desert sun breaking through leaden tents of cloud, and a cold orange sun setting on ochre tufa ruins. The Syrian desert is cold in March; and in that primitive but distinguished outpost, the Queen Zenobia Hotel, where I was the only guest, I was glad even of the soggy weight of the goat-smelling blankets the management provided.

Before leaving I was asked to sign the guestbook, a crumbling holy of holies in real parchment which the staff seemed to revere even more than the Koran. Indeed, it dated back to the age of the legendary travellers.

We left the desert and climbed back into Lebanon towards the ruins of Baalbek, a vision of majestic porphyry, columns and temples miraculously set in a remote mountain pass. The sky opened blue, making the pecan blossoms even pinker, the porphyry columns even redder. Cherry and apricot blossoms, calla lilies and violets graced the hotel garden – and for the first time in three weeks I had a real bath.

From Beirut a primitive plane took me south to Jerusalem. I wandered in the old city and realized I was lost. An Armenian

archdeacon in robes and diamonds rescued me from the filth and smells, far worse than anything I'd experienced in Mexico.

But Egypt, ah . . . Egypt was different. Pharaonic splendour on the one hand and on the other, an amorousness worthy of the *Perfumed Garden*.

There was Sherif . . . '17 March, St Patrick's Day: Sherif came to visit at 5.30 – what a shy and nice boy – his sister – wife of the Egyptian ambassador to Moscow. He is pure-white Arabian with aquiline nose, sparkling eyes slightly oblique, wide smile, moustache but very neat, perfect teeth and rather short chin – tall, lean and very strong – at twenty-four has still not been allowed to travel even as far as Rome – not because of money but because of family sentimentality.' The first time I visited the Pyramids I recorded no impressions in my diary. When I went a second time with Sherif, I was able to write of 'uncanny feelings beside these five-thousand-year-old monuments – feelings belonging to the very rhythm of man's relationship to nature which has been the avowed subject matter of my painting – love by a moon-filled sun-ship . . .'

I had been anxiously expecting Nellie van Doesburg to join me somewhere en route; now finally she appeared in Cairo. Nellie's outlook and background were in perfect rapport with the tangible geometry and Brancusian simplicity of Egyptian art, and she exercised strict aesthetic control over me.

Together we made our ascent of the Nile into temperatures that nearly melted my film, and Nellie's nights were again, as they had been in Yucatán, busier than mine . . .

In late spring, two months after beginning my tour of the eastern Mediterranean, I realized that my visa was about to expire. Nellie left for Paris and I flew west, where I found myself standing alone on the desert tarmac near Benghazi in the middle of a sandstorm. After a night as the only guest at the Cyrene Hotel, I worked my way back along the Libyan coast to the ruins of Cyrene themselves – that rich embroidery of stratified Greco-Roman skeletons half buried in the pine-tufted red sand overlooking the Mediterranean.

I then flew from Benghazi to Tripoli, where I was the guest of Contessa Anna Maria Cicogna. She was the daughter of the last Italian governor of Libya, and under old King Idris she'd been allowed to stay on in Villa Volpi, where she entertained everyone from international bankers to Bernard Berenson.

The Thrones of Earth and Heaven, which would be dedicated to Anna Maria, finally came together at Villa Volpi in its oasis of palms where I was granted the most precious gift of all – rest and freedom. Time to dream and sort out my memories and images of the dead cities lying like a necklace about the shoulders of the Mediterranean.

Roloff's next objective was to secure the authors he had promised Walter Neurath. *Thrones* was loosely divided by geography and history into five regions, and the task of the authors, inspired by Roloff's photographs, was to narrate their personal reminiscences and experiences of the Mediterranean world. Roloff decided to write his own introduction – a tradition he was to follow in many of his later books – and also to research and compose the art historical notes to the photographs. Herbert Read agreed to contribute the foreword and Roloff tracked the others down one by one, beginning with Jean Cocteau at his villa at Cap St Jean Ferrat.

In the South of France I continued to add photographs to the stock from which *Thrones* would be created, seeking out the haunts of the great painters, Aix-en-Provence, Moissac, Albi; but it was now that I really began the formidable task of seducing five great writers with the black-and-white images I'd gathered around the shores of the Mediterranean. At least, I felt sure, I could depend on Cocteau.

'Could you do the essay on Egypt?' I asked, spreading the photographs of my Nile adventure before him on the floor. 'But Roloff . . . I have never been to Egypt!' Before I could give way to despair, he smiled and said, 'but now I shall go there – through your pictures'.

All day he studied them, rhapsodizing on each of them with electrifying spontaneity; it was indeed as if his imagination had transported him there. 'Now,' he said at last, 'what would you like me to write?' 'Exactly what you have just said to me in these last few magic hours,' I answered, and he did.

Anna Maria Cicogna, who was well acquainted with Bernard Berenson, helped me unlock this door. Trembling, I unveiled my photographs before his piercing eyes. Grasping the glossy enlargements, he shook the most offensive ones in my face. 'You have cut off the legs of my favourite Aphrodite! This temple didn't look like that in my day!' What right have you young people to interpret the past, distort the monuments of Egypt . . .'

Anna Maria discreetly removed those images which annoyed him, and Berenson ended the tea hour with the pronouncement, 'You are undoubtedly a brilliant photographer, but a very perverse young man . . . Go ahead, but choose the least distorted images for my section.'

Next I approached Freya Stark, one of the great travel writers of all time, who had long been an idol of mine. Now I was ready to show her my visual odyssey through a world she knew better than anyone else. I found her at 'Villa Freya' in Asolo exercising astride an enormous model globe of the world, the centrepiece of her study

with the famous revolving round desk. She applied herself to the task with so much enthusiasm and precision that when recently a reprint of *Thrones* was being contemplated and I asked her if she would like to make any changes in her original essay, she replied, 'Not a word, not a comma nor a dot!'

The English poet Stephen Spender was my next target. We had also first met at Peggy's palazzo. Visiting him in his London office at *Encounter* magazine, armed with my Italian photographs, I persuaded him to compose a handful of poems for the book.

Then there was Rose Macaulay. When Dame Rose held my photograph of San Pere de Roda in her long unadorned writer's hands, and shuddered with annoyance that she hadn't climbed those thousand feet to the abandoned monastery crumbling upon the thorny heights of the Costa Brava, I knew that I had succeeded.

In November 1956, photographs all taken and authors hard at work, Roloff returned to Rome, where he settled into his first Roman studio, a converted, all-white, marble meat shop in the heart of the city.

The first step was to prepare the final black-and-white prints for *Thrones*. Roloff never liked working in the darkroom. He had the technical knowledge but lacked the time and patience to do his own developing and printing and preferred to collaborate directly with a photographic laboratory. He did, however, know exactly what he wanted from his negatives and how far they could be pushed. Working every day with the printers at the Vittorio Mazzo Studio in Rome, he rejected print after print, but eventually the subtle tonalities and atmospheric light so typical of his early photography began to emerge.

The final prints and all the texts were ready by the end of May. Roloff tenderly packed them into brightly coloured handmade paper boxes and set off for London to lay out his first book.

Authors and photographers generally turn their work over to the editorial and art departments of a publishing house, where everything is done for them. Roloff wanted to be involved in every aspect of putting a book together which Thames and Hudson encouraged from the start.

In the basement of their new Bloomsbury headquarters, Eva Neurath worked closely with Roloff, whose chief experience in creating a book had been *an Aegean note-book* eight years earlier. He was fortunate not only to have Thames and Hudson as his mother publisher, pioneers in the early fifties of large-format art books whose popularity stemmed in part from the hunger for culture and beauty in a Europe devastated by war, but also to have Eva as a teacher. Experienced in graphic design and gifted with a superb eye and attention to detail, she patiently guided him through the technicalities of layout, binding, gravure printing and typography. Slowly the book began to take shape.

CLASSICAL ARCHITECTURE

43 *A study in light, shadow and form at the three great third millennium* BC *pyramids of Khufu (Cheops), Khafre (Chephren) and Menkaure (Mycerinus) at Giza, Egypt.*

44 *Nature and Classical architecture captured at the magnificent Temple of Concord, one of the best preserved of all Greek temples, built in the middle of the fifth century* BC *at Agrigento, ancient Akragas, on the island of Sicily, and described by Pindar as the 'most beautiful city of mortals'.*

45 *A striking view of the Classical theatre at Palmyra, Syria, the fabled Roman caravan city that sprang from the desert, situated on the ancient trade route connecting Persia, China, India, Egypt and Arabia with the West.*

45

Roloff, who felt every photograph he took was a 'masterpiece', somehow managed the final agonizing selection of the images that would 'make' the book. The essays, as he had dreamed months before at the ICA exhibition, were to be printed on thick textured paper tinted to evoke desert sand and stone, a decorative device already used in many of Thames and Hudson's art books, although five colours was something of an innovation and an added expense. Monotype Poliphilus and Blado, a strong classical typeface favoured by Thames and Hudson, introduced the book and chapter titles, while regional maps printed in ochre, white and khaki guided the reader through a maze of ancient and Classical ruins. The book's dramatic red cloth binding was blocked in gold with the shattered head of Medusa from the Imperial Forum at Leptis Magna, an effective contrast to the starkness of the matt black endpapers, a design motif Roloff had lifted from traditional editions of the Bible.

Walter Neurath insisted on having Thames and Hudson's art books printed by photogravure, a complicated and expensive engraving process rarely used by English publishers, which gave rich velvety black tones to the image. Braun of Mulhouse, one of the finest printers in Europe, guided by the interpretations Roloff had prepared in Rome and working directly from the negatives, produced the lustrous final prints which gave his early books a luxurious and dramatic look and considerably enhanced his reputation from the outset as a serious new photographer.

Large-format art and photographic books have always been expensive to produce and depend heavily on foreign co-editions to succeed. Thames and Hudson, a leader in international publishing, prepared an elaborate dummy of *The Thrones of Earth and Heaven* and took it to the Frankfurt Book Fair, where American, German and French editions were secured. At last, *Thrones* was ready to go to press.

Roloff liked to compare the process of creating a book to that of giving birth, and after two years of preparation, the first of his sixteen children, *The Thrones of Earth and Heaven*, was born in the spring of 1958. Roloff received star billing with credits as photographer, designer and author of the impressionistic yet scholarly notes to the plates.

Reviewers and critics would often observe the intellectual and artistic unity that nourished Roloff but none more eloquently than Sir Herbert Read, in his Foreword to *The Thrones of Earth and Heaven*:

A Photographer usually holds his camera against his eye; sometimes against his heart. Roloff Beny's camera is annealed to his imagination. It has become an internal organ, a jewel in the brain, and functions as an integral part of his poetic mind . . .
These are poetic images, seen by a poet, but felt plastically. That is to say that they are a painter's images, and though they owe their precision to the prodigious skill of the photographer, it is the

46 *Hadrian's Temple, dedicated to the Roman emperor who ruled in the early second century* AD, *stands on one of the main avenues of Ephesus in southern Turkey.*

47 *The superb Roman amphitheatre at Arles, now considerably restored, is thought to date from the reign of Hadrian. Once capable of containing 26,000 spectators, converted into a fortified enclave in the Middle Ages, it is now primarily a tourist attraction and venue for bull-fights.*

48 *Detail from the carved stone staircase of the Apadana Palace at Persepolis, the ceremonial capital of the Achaemenian Empire, in south central Iran, until its defeat by Alexander the Great in 330* BC.

painter that sees and the poet that relates. In short, this is not an art that we can categorize; it is simply the creation of an artist. Each print is a palimpsest, an evocation in its velvet depth of the mystery and terror of the past, of the light and beauty of the present.

An official and lavish launch for *Thrones*, instantly seized on by Roloff as a 'tradition' for all future books, was held at Zwemmer's, one of the oldest art book shops in London, on 5 June. Two other celebrations for *Thrones* followed later the same year in Rome and New York, creating additional publicity for the book. As usual, Roloff took charge of all the arrangements for the first London launch:

> I planned every detail. To reflect the colour scheme of the book jacket – black, white and red – I requested that everyone wear matching dress. The refreshments too were colour-coordinated. The one drink allowed was Black Velvet – a mix of champagne and stout – to match my velvet suit. The only food was red 'near caviar', as one journalist cattily called it, served in white eggshells, and strawberries dipped in chocolate.
>
> The arrogance of these orders drew the crowd. To begin with, there were the authors, already a constellation of stars; or, as the *London Evening News* called them, 'resounding intellectual topliners'. Among the distinguished guests was John Gielgud, who intended to recite a poem for the occasion but was reduced to shyness by the presence of Laurence Olivier, who had just been knighted. Vivien Leigh, now Lady Olivier, admitted that she'd accepted the invitation for the opportunity to appear in scarlet silk from head to toe.
>
> But my happiness was overshadowed by a telephone call from Rome. Nikkou, my beloved turquoise-eyed husky, unable to accompany me to the launching due to quarantine laws, had suffered a heart attack – or had it been a broken heart? Her ashes were scattered in the cemetery under the shadow of the pyramid of Cestius between Keats and Shelley.

The Thrones of Earth and Heaven was awarded the International Prize for Design at the Leipzig Book Fair, the first of many honours Roloff's books were to receive, and critics on both sides of the Atlantic generally praised the book.

After the publication of *Thrones*, Roloff gradually stopped painting and concentrated his energies entirely on photography and book design. There appeared to be no regrets. Roloff rarely spoke of his career as an artist, but when he did, he would stress the continuity between his art and photography:

I realized that I was what I call a 'visual doer' – that is, I encompass whatever comes visually and try to express it either through camera or by paint brush.

Thrilled with the success of *Thrones*, Roloff decided to settle permanently in Europe and in the summer of 1957 found a stunning penthouse apartment in the heart of historic Rome. The flamboyant decor of 'Tiber Terrace', Roloff's new home, often described by visiting journalists as 'magnificent' or 'opulent', in reality had an engaging tacky splendour about it – superb pieces from his contemporary art collection jammed next to fake Etruscan bronzes, tigerskin rugs and glittering velvet cushions – but the views were wonderful.

With a bit of scrimping and improvising, borrowing on future royalties and most important of all, help from my father, I acquired the top three floors of a 'palazzo' on the Lungotevere Ripa (Along the River) overlooking the Tiber Island and the outlet of the ancient Cloaca Maxima – or 'Great Sewer' of the Roman Forum – my private waterfall and a constant battle of seagulls from Ostia. Like the ancient Celtic bards, I believe one must be near running water for inspiration.

The panorama from the terraces may be the most all-inclusive in Rome, a city of views *par excellence*. Visible are five of the Seven Hills, a dozen churches, an Imperial Circus, a forum, orange groves and pines, the forbiddingly beautiful hilltop citadel of the Knights of Malta and Michelangelo's Capitoline. To the west, the setting sun profiles the Vatican City, crowned by the great dome of St Peter's.

The War had impoverished Rome, so that life was inexpensive and the Romans were eager to sell whatever they could. I began to patch together an interior – mostly illusion created by mirrors and columns from Porta Portese, the local flea market, which offered a veritable paradise of bargains, enabling me to fill Tiber Terrace with the elegant throwaways of the nobility.

While the world suffered from the Cold War, Rome focused on minor starlets bathing in public fountains under the flashbulb illumination of street photographers. Fellini's revolutionary film, *La Dolce Vita*, was in full swing and captured the mood of the time.

Many people discovered there was no need to work. The Eternal City, after all, represented the antithesis of the Protestant ethic. The rule became: repent in the morning, provided one is not too hung over, in which case one can repent during siesta, between lunch and cocktails.

A curious innocence hovered over the 'sweet life'. Late nights, abundant wine, dressing with flair . . . One had to be naughty and

abandoned, but above all charming, or one would not be invited to join the revelry. The theatrical and hedonistic way of Roman life and the almost mythical beauty of the city had determined my choice.

Tiber Terrace was both theatre and workshop, and it became an attraction for the illustrious. Earl Blackwell of the *Celebrity Register* in New York sometimes showed up for my theme parties, and described one such event for *Town and Country*:
'Roloff Beny . . . has a lovely penthouse overlooking the Tiber and the palaces of the Twelve Caesars. This summer he is planning a gala supper party following Aida . . . Everything will be in black and white. He's expecting Giorgio and Lauredana Pavoni, Alberto Moravia, Consuela and Rudi Crespi, Leontyne Price, Rex and Rachel Harrison and Prince and Princess Paolo Borghese . . .'

At one dinner party, I counted among those present two princes, two princesses, three counts, three contessas, one marchese and one marchesa. Out of twenty-three guests. Was all this real? Did it happen? My diary says yes.

In those days Rome was known as 'Hollywood-on-the-Tiber'. Mussolini's giant studio at Cinecittà created hundreds of films every year. This drew stars from all over the world. The epochs were marked off by which colossal movie was in the works. Thus, we had the age of *Quo Vadis* or *Ben Hur*, *Barrabas*, *Cleopatra*, *The Bible* . . . Often I'd visit the sets to photograph the stars and extras, and these visits led to many acquaintances and some friendships.

Late one night I returned home to find Vivien Leigh in my bathtub. Her mother, Gertrude Hartley, was lying in my bed, consuming a large peanut-butter sandwich. Inside the 'Elephant Ballroom', decorated in the colours of an elephant's ear, my friend John Lindsay Opie was walking up and down, wringing his hands. He had been left holding the fort and was gallantly trying to keep my guests entertained. The visit was cut short by a summons from London for Vivien to return to her role in *Duel of Angels*.

A few weeks later Sir Laurence phoned to thank me on behalf of the family for sorting out what he called a sticky moment. He was in Rome to discuss a film project, and he invited John Opie and me to dinner.

Somehow he had found out that my given name was Wilfred, and he asked me why I had abandoned such a solid Anglo-Saxon name for Roloff. I explained that as a child I had considered Wilfred a name more suited to a rabbit than an artist, but he insisted on calling me Wilfie. He became a treasured friend. He never wasted time playing the 'great actor' and he disliked loud parties. One autumn when we were both in New York, I told him I'd like

to give a party to show him off to my friends. I asked if I could say it was in his honour. 'You can say that if you like, Wilfie, but there's a good chance I won't appear.' I went ahead and planned the evening. He came half an hour early and left a short while after the party began, before the arrival of Isak Dinesen, Hermione Gingold, Peggy Guggenheim, Zachary Scott and Ruth Ford. He saved my reputation, but managed to maintain his independence.

Roloff's wardrobe, always on the eccentric side, became even more Bohemian after Tiber Terrace. He loved dressing up. I remember bringing him bolts of brightly coloured 'Delhi velvet' from India which he adored and instantly had stitched into flowing kaftans or exotic dinner jackets. A little make-up, a tint to the hair and he was ready. Once, in Tehran, painstakingly groomed and about to depart for a party at the palace given by the Empress in his honour, he noticed my look and with that wonderful capacity to poke fun at himself, retorted, 'I know. I look like an old tart but I don't care!'

Roloff spent the winter of 1959 in Hollywood with the actress Hermione Baddeley and Lady Joan Duff Assheton-Smith photographing a number of stars including Rex Harrison, Agnes Moorehead, Bob Hope and Liberace. Lady Joan, a wonderfully eccentric English aristocrat, became one of Roloff's closest and most loyal friends. She was a frequent guest at Tiber Terrace, and Roloff often stayed with her when he visited London. They also made many trips together to America and Canada, and she became part of the family, sharing Roloff's tantrums, triumphs and despairs.

During the late fifties and early sixties, Roloff also wrote and photographed for a number of international newspapers and journals. He regularly contributed to English *Vogue, Queen, Harper's Bazaar* and *The Sunday Times* and to *Chatelaine* and *Maclean's* in Canada. The articles were vintage Roloff: 'The World's Most Fascinating Women', 'Rome: City of Illusion', 'Pets By Their People', 'Millionaires I have Known' and a special photographic feature on the Duke and Duchess of Windsor.

He also found time to create 'Metaphysical Monuments', an early equivalent of a Surreal 'happening', held at the Galleria Appunto in Rome in February 1960, where he exhibited giant photographic collages of Vivien Leigh, Jean Cocteau and other famous friends wandering through romantic palaces and crumbling ruins. The twenty-four-hour event featured creative dance, poetry and music and was orchestrated and written by Eugene Walter, a gifted American expatriate author, translator and occasional actor who also lived in Rome and would soon collaborate with Roloff on his next book with unfortunate results.

A TIME OF GODS:
A PHOTOGRAPHER IN THE WAKE OF ODYSSEUS

Roloff, restless and bored from his magazine work, approached Thames and Hudson with two very different ideas for a second book: *Ladies and Gentlemen*, a portrait album of the wealthy, beautiful and famous people he had photographed, or, returning to his beloved Aegean, a book retracing the footsteps of the legendary hero Odysseus on his epic travels through Greece and the eastern Mediterranean. Thames and Hudson preferred the Classical theme, and Eugene Walter, who had collaborated with Roloff on 'Metaphysical Monuments' as well as a number of magazine articles, was chosen to write the text. Peggy Guggenheim accompanied Roloff and Eugene in the spring of 1960 on the first of four journeys they would make through mainland Greece and the islands.

In my search of Ulysses, I travelled in a sturdy Opel station wagon, my ship on wheels. And like the sailors of Ulysses, some of my crew members were lured by the Sirens and stricken by mysterious diseases.

I never intended a strict obedience to archaeology or geography, nor did I aspire to produce an illustrated guide or textbook, but rather a sequence of images made more plausible in their ordering by being based on the events of the *Odyssey* and the adventures of its hero. I assumed that few of my potential readers would have reread the poem since their school days. I wanted my own contribution to act as an incentive to relive the tale as a contemporary voyage through Homer's world, and to find that the gods are still there. I was after an elusive spirit, and I was prepared to be as vague as Homer and as tricky as Odysseus to capture it.

The bronze Athena which I eventually chose for the jacket of the book, and used throughout the text wherever the goddess is evoked, had just been brought to light. Dr Papadimitriou, who had uncovered her under a railway track in the port of Piraeus, generously allowed me *carte blanche*. I was able to interview her as often as I liked, lying flat on her sandbags with a cloak of gunnysacking, seeming to breathe and speak. She is as moving a human-heroic document as was ever bequeathed to us by a sculptor. For me, her aesthetic appeal was as intense as that of the bronze charioteer from Delphi, who had haunted me from earlier schoolbook reproductions, which concluded the book. I was the first to photograph her. When my camera broke the silence of the centuries with its mechanical 'click', I fantasized that she had returned to earth to grace my book.

In spring '61, near the end of my journeys, I succumbed to an acute case of hepatitis on one of the remote islands. Eugene managed to hire a Greek driver. Writhing in pain, I was shipped back home on a mattress in the back of the station wagon, and a year of convalescence followed.

That was the last I ever saw of Eugene. The adventure had been too traumatic for him. No text ever materialized. I heard he'd vowed not to speak to me for at least three years, and was trying to form a cabal of my enemies called the 'Bye-Bye Beny Club'! At last recovered, lovingly I edited the text (selections from Chapman's translation of the Homeric epic), and my friend John Lindsay Opie saved the book by doing the superb plate notes.

Of course, Eugene had his own tale to tell: 'Roloff was an hysterical egomaniac. Gifted he was, but impossible to work with. He was lucky I got him back to Rome, end of story.' Rome was not big enough for two talented, charming and exasperating expatriates. They never spoke again.

This would not be the last time Roloff fell out with friends, authors or colleagues. He could be capricious, was totally self-obsessed and used and manipulated people shamelessly. The ones who could or had to put up with it stayed around him while others gradually drifted away. But there was also a warm, more vulnerable side, and a devastating charm revealed at moments when pretence, fatigue and tension would melt away. On form, he could entertain and delight like no one I have ever met. Many of the people I interviewed began the same way: 'Do you know what he did and what he got me to do for him!' But within minutes, they would be smiling, amused by the recollection of one delightfully outrageous Roloff story after another. All things considered, he was worth the effort.

When his photographs were ready, Roloff returned to London to lay out *A Time of Gods*. Although he was gradually becoming more confident about book design, he still relied heavily on the Thames and Hudson art and editorial staff. The newly discovered statue of Athena adorned the jacket, which was conceived in tones of black and silver. Reviving an earlier tradition in English publishing that had gone out of fashion, the cloth binding was printed with mirror images of pebble mosaic floors, which were also echoed in the endpapers. Each chapter opened and closed with textured black paper and sixteen hand-tipped gravure plates added extra cost but a crafted elegance to the book.

In the absence of an original text, Roloff's edited quotations from the classic Chapman translation of the *Odyssey* seemed a little forced and barely managed to hold the images together. The plates notes, however, written by John Lindsay Opie, an American professor of art history based in Italy, were eloquent, carefully researched and added academic

weight to the book. The final result was a magnificent volume, beautifully photographed, designed, printed and bound.

Published by Thames and Hudson in 1962, *A Time of Gods* went into nine foreign editions, including German, Dutch, French, Spanish, Swedish, Finnish and Italian – the broadest international exposure of any of Roloff's books. Following in the footsteps of *Thrones*, it received the Silver Medal at the Leipzig Book Fair, and the French edition, entitled *Terre Des Dieux*, was selected as one of the fifty great books of 1965 by the Comité des Arts Graphiques Français.

In 1962 *A Time of Gods* was also voted the best book of the year by the American Society of Magazine Photographers, and their reviewer Andreas Feininger once more acknowledged the continuity between Roloff's art and photography:

> Once in a great while a new picture book is brought out that stands like a giant above the mass of other books of photographers . . . Beny is a professional painter whose canvases hang in museums in the United States, Canada and Europe. I do not know his paintings but his painter's eye and training are evident to me in every one of his photographs. His sense of composition and design is free from sterile photographic 'rules' and preconceptions; it is strong, sure, graphic, and always directly to the point . . . His close-ups are masterpieces of bold and direct statement in which essentials are pared to the bone; and he has an uncanny way of suggesting the whole in the description of a part . . . But perhaps the most impressive aspect of *A Time of Gods* is its impact as a unit, an integrated work of art. Beny made the layout, and his layout is one of the best I have seen.

A Time of Gods was christened in London and Toronto, but the most star-packed celebration took place in New York:

> Zachary Scott and his wife Ruth Ford gathered a galaxy of friends at their apartment in the legendary Dakota on Central Park West. The surprise guest was Greta Garbo. In a black velvet trouser suit, she ignored the other guests and leafed through the book. At last she spoke: 'Ach! I vish I could be your brother and follow you in your travels. I vould even carry your camera bags. I neffer can go anywhere. I haff hardly been any place at all.'
> 'But I've been dreaming of photographing you for years!' I answered. 'If you came with me, I'd spend all my time snapping you, and forget the monuments.'
> 'Only iff you giff me the film to develop myself – und probably *destroy* it!' But her eyes were twinkling.

SCULPTURE

49 *Roloff researched and wrote the photographic notes which accompanied this powerful image from his first book,* The Thrones of Earth and Heaven: *'Brancusian simplicity of volume and incision gives the granite Horus at Edfu the look of contemporary sculpture . . . The Ptolemaic temple at Edfu . . . was dedicated to Hathor of Dendera and to her husband Horus, the falcon-headed Sun-god, whose polished granite representation here guards the great entrance pylon, as does the silent dragoman.'*

50 *A small bronze statue of Eros stands above the Gulf of Naples with the island of Capri and Punto Campanella in the distance.*

51 *A marble emperor watches over the ruins of Italica, near Seville, reputedly the birthplace of three emperors – Trajan, Hadrian and Theodosius.*

52 Dawn, *part of Michelangelo's tomb for Lorenzo II, Duke of Urbino, in the Medici Chapel in Florence, built by Michelangelo between 1520 and 1533.*

53 *Detail from a Roman statue of the Greek goddess, Aphrodite.*

54 *Bronze statue of Athena, dating from the mid-fourth century* BC, *which graced the cover of Roloff's second book,* A Time of Gods.

55 *The face of Bartolomeo Colleoni, one of the leading mercenary generals, or* condottieri, *who conducted war on behalf of the Italian states during the fourteenth and fifteenth centuries. The magnificent equestrian monument in bronze was designed by Verrocchio in 1481.*

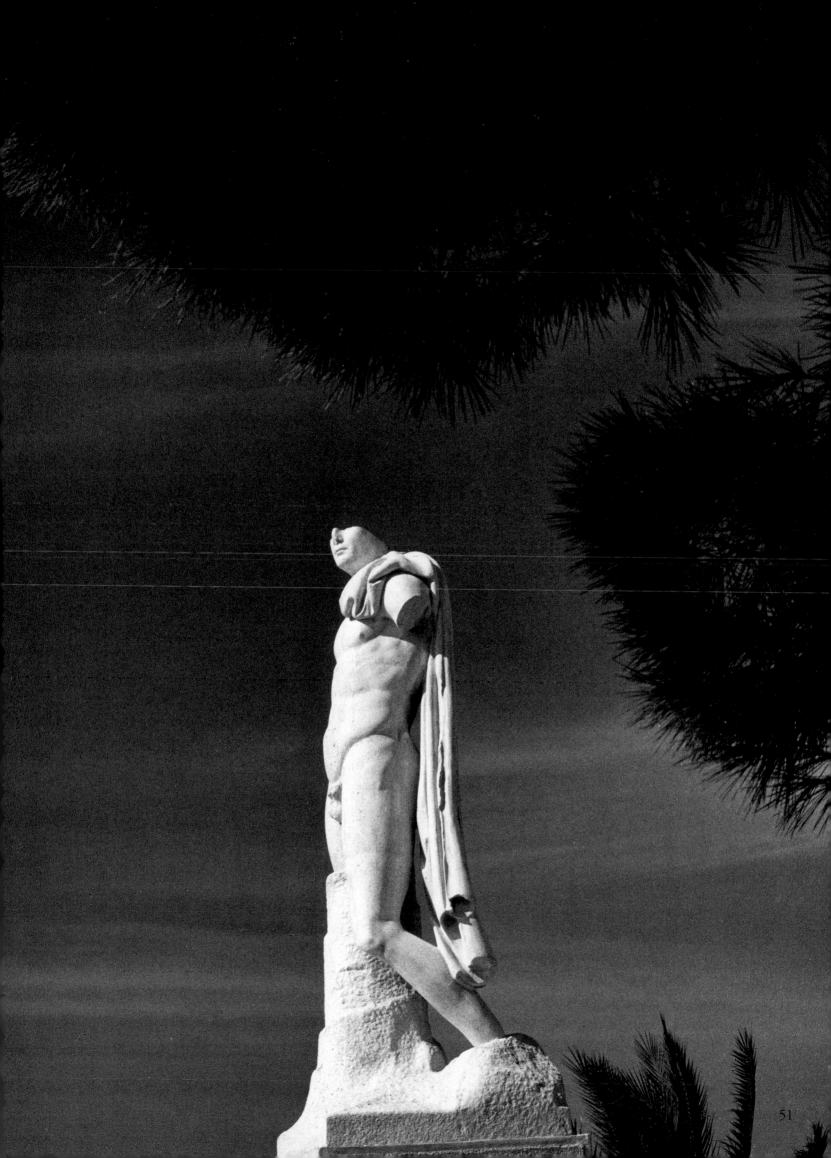

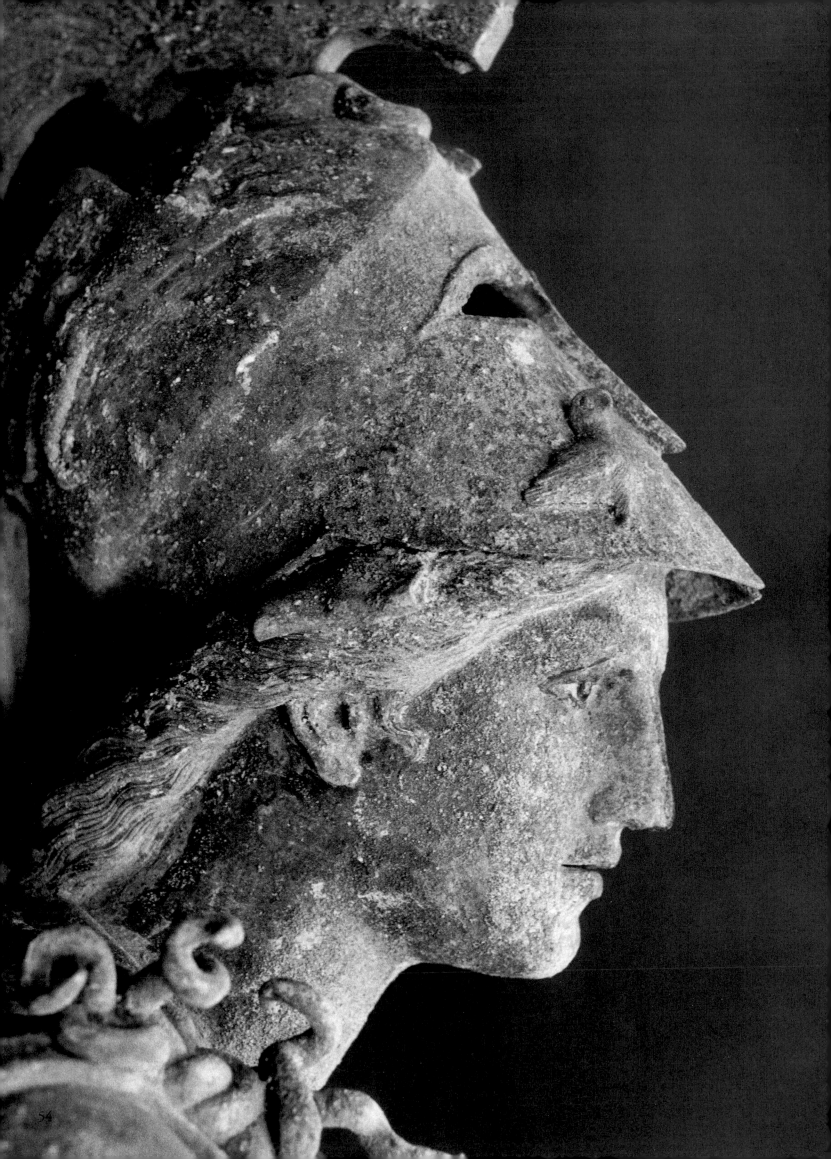

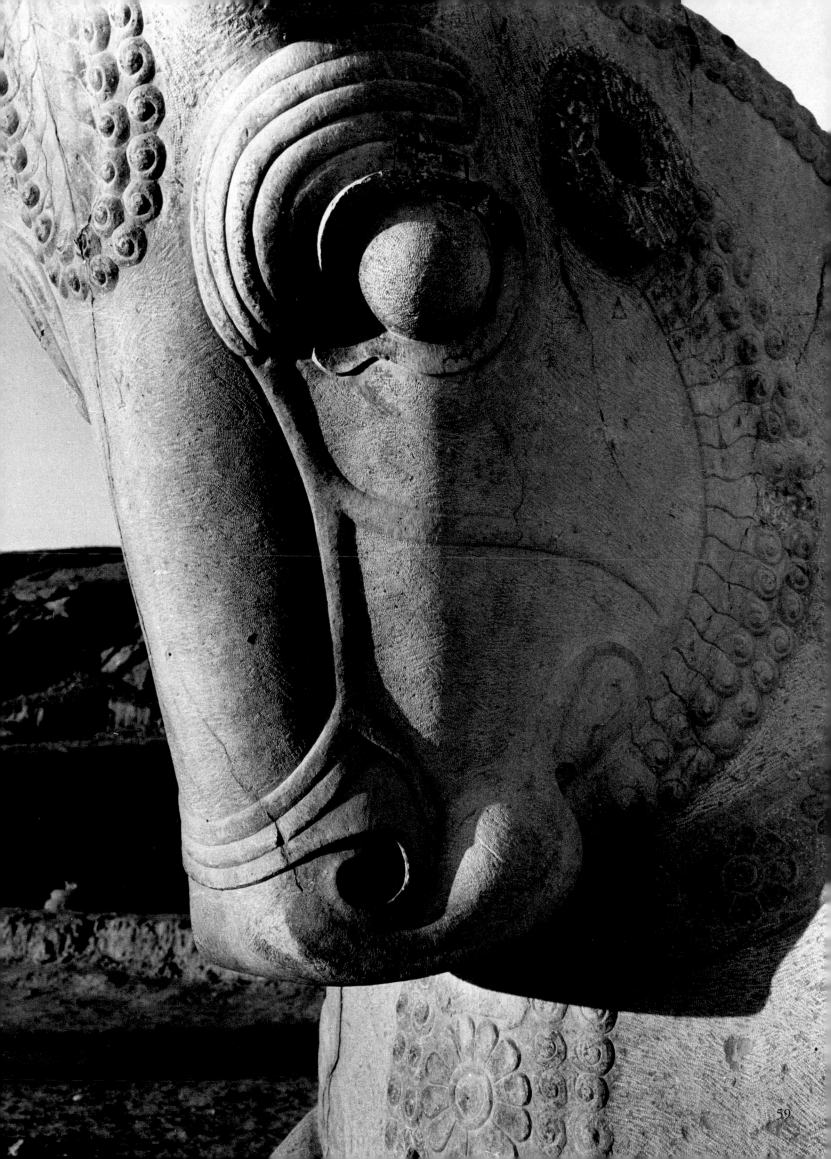

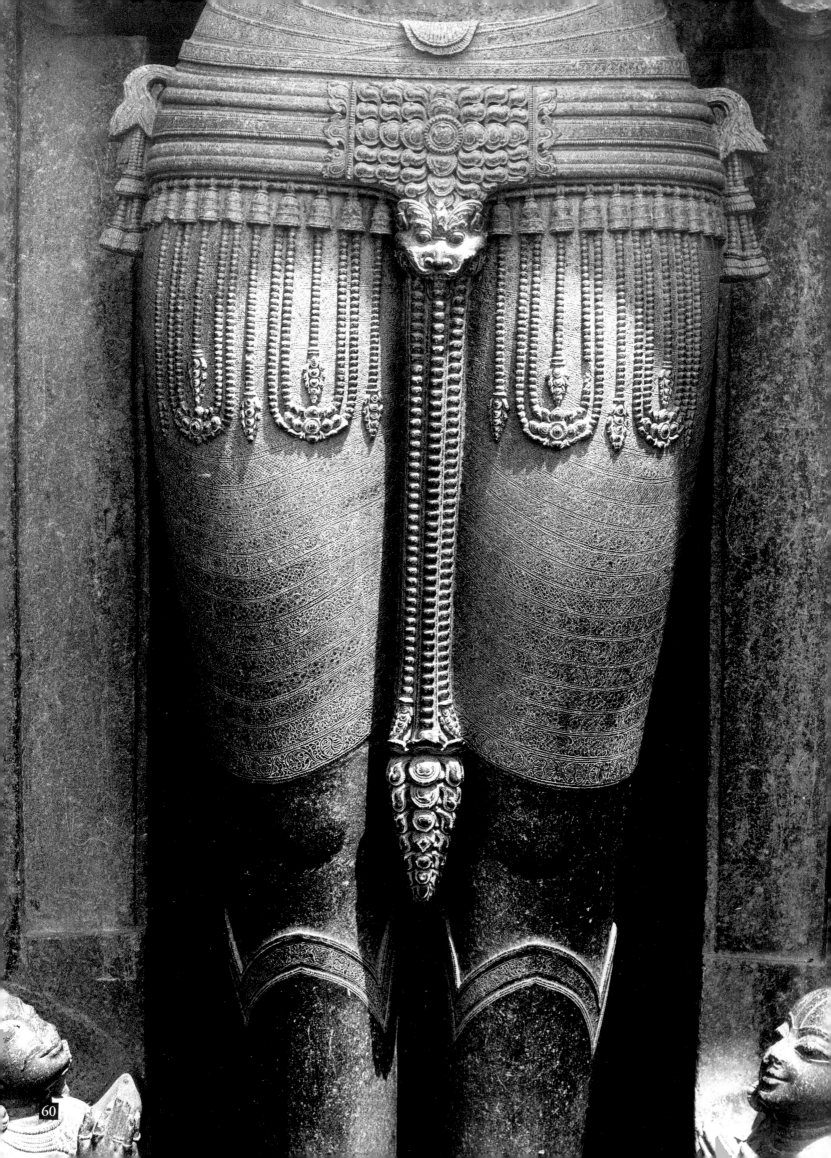

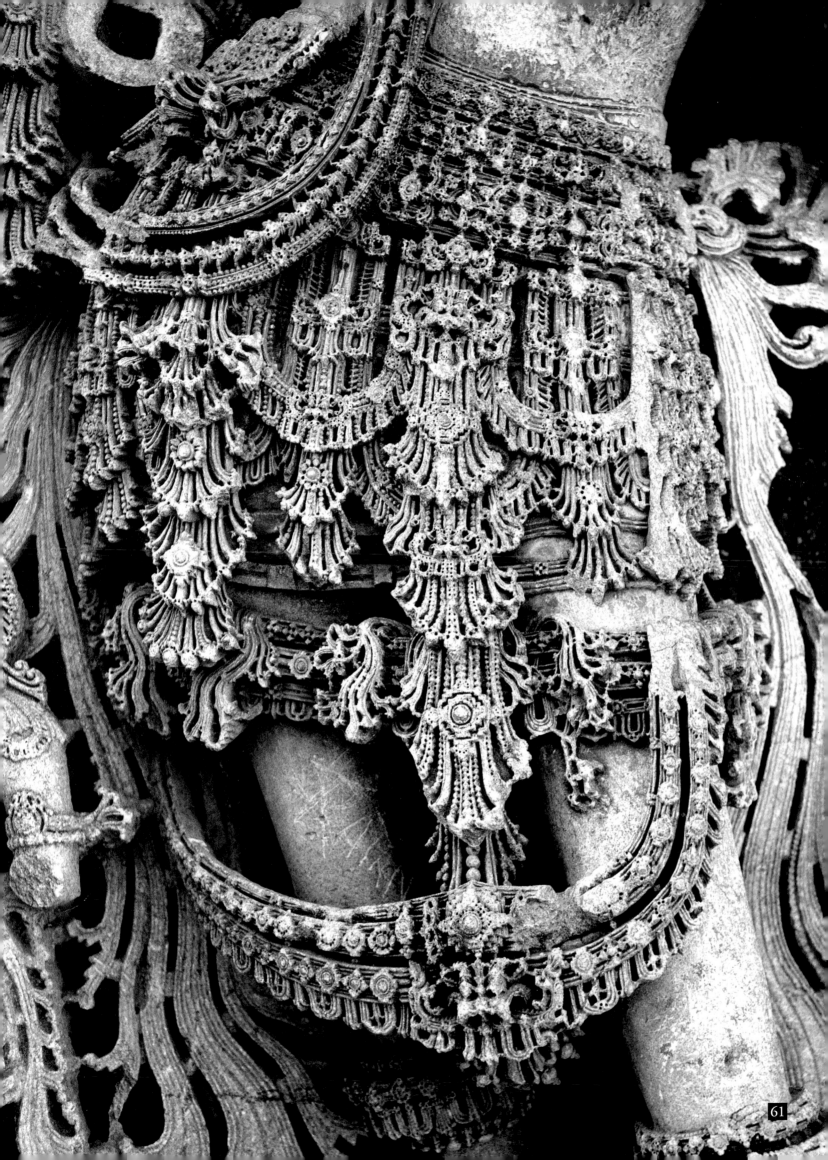

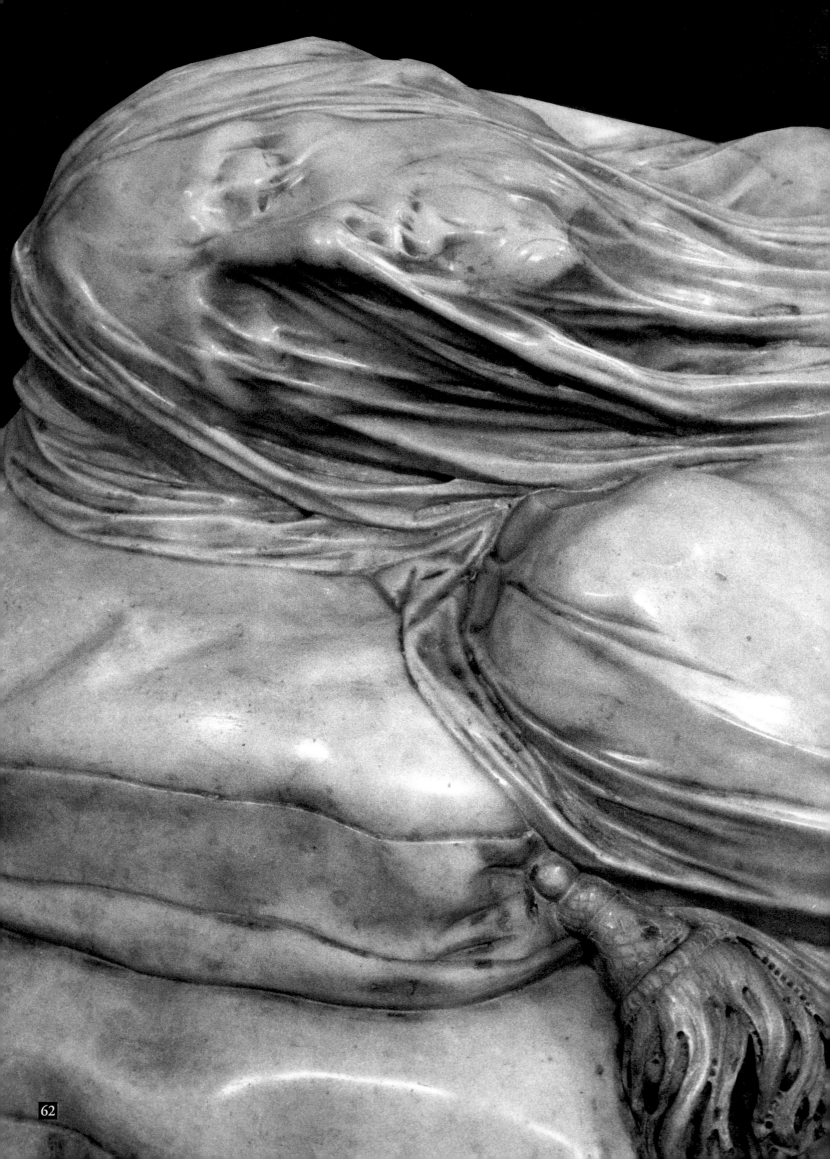

Encouraged by the success of *A Time of Gods*, Roloff turned immediately to his next project, a photographic interpretation of the classic travel book *Pleasure of Ruins* by Dame Rose Macaulay.

In December 1962 he set off on a marathon around-the-world tour of thirty countries from the Caribbean to the Mediterranean encompassing 140 archaeological sites. Nine months would pass before he again saw Tiber Terrace. On his journeys Roloff encountered adversity, adventure and fabled beauty beyond his wildest expectations:

Before Dame Rose died in 1958, we had lunch at the Connaught Hotel in London and discussed an edition of her book to be accompanied with my photographs. After her death, her brilliant niece, the biographer Constance Babington Smith, and I decided to carry on. I had only a £500 advance from the London *Sunday Times*, obtained thanks to Mark Boxer, $2000 worth of film subsidized by Jack Heinz, a tattered copy of the original book, a packet of air tickets and practically no clothes. I was setting off on a shoestring to circle the world.

Haiti was a dazzling initiation to my voyage – bamboo, bananas and butterflies, pigs, poinsettias and poverty.

In Lima I was the guest of Blevins Davis, a well-connected gentleman who had lost his fortune and retired to Peru to found a theatre company. Before attacking the ancient cities of Cuzco and Machu Picchu, I met and photographed a number of the beautiful society ladies of Lima.

My goal in British Honduras, on the Caribbean coast, was to photograph Copán, the splendidly baroque and intricate Mayan city, lost in dense and swampy jungle.

Flying north, I made a quick visit to the Mayan ceremonial cities of Chichen Itzá and Uxmal in the Yucatán, which I had first seen with Nellie van Doesburg.

After stopovers in Texas and New York, I travelled with a group of Japanese pilgrim-tourists along the Imperial Highway. I fell under the spell of the Japanese landscape and knew I would return.

From Hong Kong I travelled to Macao on the Chinese coast and negotiated, in vain, for entry into Red China. Air France lifted me neatly to Pnom Penh, the capital of Cambodia. Here, buried in the jungle, were perhaps the most romantic and grandiose ruins in the world. I spent days exploring and photographing every angle of the vast city of Angkor Wat. Since then much has been defaced and destroyed by war, and my archives constitute perhaps a unique record of their past beauty.

56–57 Two views of the carved marble face of the handsome fifteenth-century warrior, Guidarello Guidarelli, by Tullio Lombardo, originally placed in the Basilica of San Francesco, Ravenna, reveal Roloff's remarkable ability to bring stone to life.

58 Medieval stone sculpture of a female figure on the thirteenth-century Sun Temple at Konarak in the eastern state of Orissa, India.

59 Massive head of a bull capital from the main palace at Persepolis, Persia, the ritual centre of the Achaemenian Empire which ruled from the sixth to the fourth century BC.

60 Chiselled stone skirt of Surya, the Sun God, at the magnificent Konarak temple dedicated to his glory and constructed by Narasimha-deva Ganga on the coast of Orissa, India, in 1238–64 AD.

61 Elaborately carved costume of a guardian of the door from the twelfth-century Hoysaleshvara Temple at Halebid, identified with Dorasamudra, the capital of the Hoysala rulers, in southern Karnataka, India.

62–63 Two views of the marble body of Christ covered by a shroud, the work of the prolific Neapolitan Baroque sculptor Giuseppe Sammartino in 1753, inside the Sansevero Chapel, the tomb-chapel of the Sangro family, in Naples.

64 Colossal image of the sleeping Buddha carved from a wall of solid granite in the twelfth century at the Gal Vihara sanctuary, Polonnaruwa, Sri Lanka.

101

As we came down over the tattered tapestry of Rangoon sprawling on the edge of the Bay of Bengal, we circled the awesome and fabled Shwe Dagon pagoda which thrusts into the air like a three-hundred-foot golden sword.

In the sacred city of Pagan, I was so absorbed in the glittering and ruined vision on the edge of the river that I forgot to catch the weekly plane. The jeep driver suggested I take a rice boat to Mandalay and rushed me back to the quay.

There stood an ancient ramshackle paddle-steamer, tented in torn, filthy awnings and brilliantly illuminated by the saffron robes of a hundred monks. Lying on thin bamboo mats, they were to be my companions for the next two nights. One aloof pair unrolled exotic velveteen rugs with peacock and lion motifs and never moved for the entire voyage; the others remained swathed in their robes like orange cocoons.

I shared the only cabin with an ancient priest who continuously received the younger Buddhists for special prayers or blessings. My only nourishment was sticky tea made from the indescribably murky water of the Irrawaddy, laced with whisky, which I always carry for just such emergencies. There was no question of my trying the food brought on wilting banana leaves by chorus lines of bearers at each stop along the river. I opened coconuts and popped Benzedrines.

Perhaps this diet partly explained the extraordinary intensity of my sensations during that three-day voyage. Every sound was distinct and vivid. All night the monks relieved themselves noisily over the sides, and the huge brown beetles roamed audibly among the cigar butts and refuse on the deck.

When we docked at Mandalay, I was inexplicably sad to leave these monks, who had shown me that privacy was not such a precious commodity after all.

After a brief interlude in Siam, I flew to Calcutta, which was to be my headquarters for the next month. It is perhaps the most terrifying city in the world. Hundreds of thousands of people, wrapped in grey shrouds, sleep amid the dung of the sacred cows that roam the endless avenues. Unlike some western photographers who would have imposed themselves on this private horror in the name of social consciousness and realism, I could never bring myself to photograph these piteous figures, but threw my rupees into their waving bowls and hurried into the dark temples with a sense of discomfort . . .

How does one approach the Taj Mahal for the first time? With the naiveté of careless rapture known only to adolescence? Exhausted and febrile from the horrors of Calcutta, I arrived bad-tempered in the dust and relentless heat of April. Agra was awash with hordes of

sweating, camera-slung tourists. I felt cheated, inexplicably angry with the bead and souvenir sellers who attacked like hornets, and the vulgar emporiums surrounding the sacred tomb, forcing their ghastly alabaster models on pilgrim and tourist alike. I vowed never to return.

But before dawn the next morning some force within guided me, magnetized me, to sneak back, before the guides and vendors were awake. I slipped almost guiltily, unobserved through the hidden gateway to the river where I found a boatman, like Charon on the Styx, to row me across the mist-lit Jumna. There I collapsed on the sand, still steel-hot from yesterday's scorching, and waited for dawn to give form to the marble miracle which was now my own possession, like a precious manuscript as yet unopened. This moment of aloneness, lying in a protective barrage of sugar cane facing the elaborately distilled perfection of the great red sandstone river-wall which backs the Taj, broke the spell of rejection. Over the years, I was to return again and again, and each time the Taj grew in stature in my imagination . . .

Roloff crossed Pakistan and entered Iran, where he was swept up in violent demonstrations in the streets of Tehran. Dodging bullets and against the advice of the Canadian ambassador, Roloff crossed the last armed barrier to reach Saadabad Palace, nestling in the foothills of the Elburz Mountains, the only safe haven in the burning capital, where he photographed the Shah and Shahbanou in the Imperial gardens.

Roloff had absolutely no sense of personal danger; he was a bit reckless at times, but certainly courageous. It paid off. Ten years later he was back in Tehran, and the memory of his valour helped pave the way to a royal commission for two major books on Iran. He journeyed on through Iraq, Jordan, Lebanon, Turkey and Cyprus, reaching Tiber Terrace in August.

Exhausted by his global odyssey, Roloff now faced the daunting task of developing and printing hundreds of rolls of film. The greatest discovery of the book, however, was not archaeological but human, when Roloff decided to give his films to Franco Bugionovi, a talented young technician and printer, who had just opened his own photographic laboratory. Franco had learned printing at the Vittorio Mazzo Studio which Roloff had used for *Thrones* and *A Time of Gods*, and he had often delivered photographs to Tiber Terrace. He recalled that although Roloff seemed in the beginning a 'strano tipo' (a strange chap), it was clear that he was also a true 'maestro' of photography:

Signor Beny was not a theoretician, nor was he highly technical, but he had something special. He knew, felt and breathed light – much

of his genius was pure instinct, and he used the camera like an arm, an extension of his body. His black-and-white negatives were almost always perfect.

Franco had infinite patience and could interpret every nuance Roloff wanted drawn from his negatives. They would sit for hours together on the leafy green terrace overlooking the Tiber reviewing prints, with Roloff circling the areas he wanted heightened or subdued. Franco once hesitantly showed some solarizations he was working on to Roloff, who immediately adopted the technique to create the decorative motifs and linecuts that appeared in many of his later books and exhibitions. It was a brilliant and creative collaboration, each encouraging and inspiring the other, brought to a close only by Roloff's death in 1984.

By now the editorial and art department at Thames and Hudson shuddered when Roloff arrived from Rome with his revised layout and costly last-minute changes, expecting and getting everyone's complete attention. Ian Mackenzie-Kerr, a senior designer at Thames and Hudson who worked on five 'Beny books', remembered how Roloff was always looking for new and unusual printing techniques, some of which bordered perilously on the kitsch. He would present pages torn from airline magazines or advertising brochures declaring that if they could achieve these effects, why couldn't we? Thames and Hudson, to their eternal credit, were remarkably tolerant, both exasperated and amused by his antics. They allowed Roloff as much freedom as the budget could bear and then more. Mackenzie-Kerr felt that he pushed the company to try new things; some worked and some did not, but everyone learned in the process.

Roloff introduced colour for the first time in *Pleasure of Ruins*, 12 hand-tipped images to accompany the 146 gravure prints, silver endpapers, 29 maps and plans of the sites and foldout pages for the captions. From now on every book had to have more colour, special effects and be more sumptuous than its predecessor.

The cost overruns on *Pleasure of Ruins* were providentially offset by the enthusiastic 'appetite' of international publishers for Roloff Beny books which 'appeared insatiable' according to Trevor Craker, who witnessed the early expansion of Thames and Hudson and remained with the firm for many years in the sales department. There were eight foreign editions – including Japanese and Yugoslavian editions for the first time – more than a 100,000 copies in all, an amazing figure for the early sixties, and it was also chosen by Time-Life International as their Book of the Month in the United States.

Pleasure of Ruins established Roloff as one of the world's finest travel photographers. No one could match his lyrical interpretations of the architecture and sculpture of the ancient and Classical world, and he was

also widely respected for his innovation and creativity in book design. He would often be criticized for the absence of people in his photographs, and in the early books they appeared like grace marks in music to give scale and to underscore the timeless quality of the image. His reputation as a photographer had become inextricably bound to his books and in no small way derived from the support and encouragement shown by Thames and Hudson.

I remember Roloff being fascinated by the Sanskrit word *samvega*, which loosely translates as 'aesthetic shock' – the dramatic siting of a shrine around the bend of a river, an unexpected dance step, the daring asymmetry of a carved stone screen – images that could break down spiritual coagulations in the soul of the beholder. He wanted his photographs to possess this same quality – to be able to move and nourish people, bringing them a little closer to the eternal and universal beauty he searched for in all his work.

Roloff was also a 'lucky' photographer. I have travelled and worked with many photographers, but only for Roloff did the peacock spread its tail, the camel caravan arrive as the sun was setting and the rainbow embrace the Taj Mahal.

Luxury books on art and photography were still a rarity in the sixties and the public thought twice before buying them as gifts. Roloff played a significant role in bringing the 'coffee-table book' into broader acceptance and respectability. Lorraine Monk, colleague, friend and authority on Canadian photography, once quipped, 'Roloff's books are the world's largest thank-you notes, but at the same time he made the whole western world begin to see photography as an important art form. He made everyone, even royalty, feel it was a privilege and an honour to possess photographic books.'

Roloff's career had reached a crossroads with the publication of *Pleasure of Ruins*. His archive of black-and-white negatives and colour transparencies had grown enormously which gave him the possibility of doing a variety of books. Over the years he had built up a large and extensive reference library on art history and archaeology and whenever he had the chance he would research and develop new ideas and themes for books, making elaborate layouts and presentations to publishers. 'In the Footsteps of the Buddha', 'Architecture of Dreams', 'Mogul Mysteries', 'Pavilions of Nature' and 'Legendary Cities of India' were only some of the possibilities that found their way into the 'Under Consideration' file.

The basic problem he now faced was primarily one of economics. Because of the high costs of publishing art books, and a 'Beny book' in particular, publishers were hesitant to produce the general thematic books that were Roloff's forte. A fresh approach as well as outside sponsorship and support were crucial.

TO EVERY THING THERE IS A SEASON: ROLOFF BENY IN CANADA

Motivated by the depth and complexity of his photographic archive, Roloff visualized a book that would focus on the art, architecture, people and natural beauty of a single country, and what better place to start than his native land, Canada.

My Canadian publisher, Longman, had been urging me to do a book on my own country. I certainly had nothing against the idea – in fact, I felt that the book of a returned expatriate, who could see Canada with eyes trained by Europe and Asia, would make a real contribution to waking up that somnolent soul, and if I could succeed in capturing the beauty of a land where I was unlikely to see anything older or more venerable than a moose skull, it would represent a genuine breakthrough for me, a maturing of vision.

I was already at work on the book when Longman informed me that they had not succeeded in raising the money to finance the project. By this time, however, I was hooked and I decided I'd have to find the money myself. After being turned down by endless banks and companies, my original Canadian patrons and old friends, John David and Signy Eaton, came to the rescue, knights on the great white horse of capitalism. By promising to buy several thousand copies of the book for donation to libraries, they ensured its survival. Now I could devote myself to the visual mission.

I methodically traversed Canada with the same visual hunger that had driven me through jungles, deserts and across remote valleys and mountains around the world. The landscape of the prairies and of my childhood had marked me more than I knew.

The stark simplicity of the prairies had given me both a sense of solitude and of spiritual desolation and a perception of abstract beauty. Farm machinery, grain elevators and silos made me aware of aesthetic form and of its universality. The unpeopled vastness of the place brought me close to the elements, and the distant uncluttered horizon has always remained in my memory like a temptation to go beyond, to get on the road and keep moving, keep exploring.

I searched out far corners of Canada's landscape, society and industry. I toured the Yukon where no one had the foggiest idea who I was, and I got along splendidly with everybody, like Oscar Wilde lecturing the cowboys on aesthetics and then drinking them under the table. In Whitehorse they still remember me as the first person in the Yukon Territory ever to taste a bottle of wine in a restaurant and send it back.

By January, when I arrived at the Arctic Circle, the eternal night of winter had set in. I'd had my cameras injected with graphite and special oil to keep them from freezing, but even so could only take them out of their fur-lined bags for about a minute at a time.

I was snowed in at Coppermine for almost three weeks. I lived in a little shack that was half-igloo, with a portico of solid ice. Some days (or nights) the blizzard was so fierce that I couldn't set foot outside, and I'd been warned not to breathe deeply out-of-doors, lest my lungs freeze; on such occasions I survived on cans of beans. As I thought of the luncheons I'd enjoyed with Jack Heinz, I chopped the frozen cylinder of beans into roundels with my handy hatchet.

Mounties and Eskimos introduced me to the mysteries and pleasures of dog-sledding – next to a Venetian gondola, the most pleasurable mode of transport I know. Separated from the crystal ice by only a basket of caribou skin, one sweeps over the rhythmic waves of the white landscape, pulled by the handsomest animals in creation. Everywhere I looked, I saw poor Nikkou's relatives!

My old classmate from the University of Toronto, Milton Wilson, was the ideal choice to edit the anthology for *To Every Thing There is a Season*. The book is structured on the symbolism of the four elements – again a very personal image for me, and one which I have used more than once. He gathered together many of Canada's leading talents, including Marshall McLuhan, Leonard Cohen, Glenn Gould, Gordon Lightfoot and Irving Layton. The result may be a bit like buckshot – scattered but effective. On the whole, I prefer to work with a unified text, provided it really complements and enhances the photography (and vice versa), as with *Pleasure of Ruins*. Milton did a miraculous job of quintessentializing Canadian culture.

Lorraine Monk, head of the National Film Board's Still Photography Division, was not a collaborator on *Seasons* but rather a sort of competitor who became a friend. We were both racing to turn out the Centennial book but, solely by chance, I won. Her book was not ready in time. The Secretary of State, Judy La Marsh, flew to Rome with a bevy of ministers to inspect my book. They came, saw and were conquered – and ordered a special Centennial edition of five hundred boxed copies for foreign heads of state. Over the years Lorraine and I have carried on an utterly frank dialogue on photography, and her opinion counts with me, as it does with every other Canadian photographer. I think it's fair to say she respected me for winning this round – just as I respect her for the rounds she's won. We're in a state of constant reconciliation. I owe her a great deal.

Mother had predicted that my Canada book would be my most difficult yet, and she was right. It was also, ultimately, one of my more successful. In skimming over the reviews that greeted its publication in 1967, I can find not a single dissenting voice – all Canadian critics for once agreed in praising it, and forgot for the moment their resentment (or fascination) with me as a 'media figure', eccentric expatriate, or whatever it is they usually want me to be. As my esteemed and future Canadian publisher Jack McClelland was to say in later years, 'Roloff, you never *read* your interviews, you only *measure* them!' I had come full circle, given my homeland a long, long look and was now ready to move on.

Seasons, dedicated to John David and Signy Eaton, was ranked number one on the Canadian bestseller list for months and in addition bagged the Silver Eagle at the 1969 Nice International Book Fair. Roloff was awarded a Centennial Medal and created a Knight of Mark Twain in recognition of his outstanding contribution to history. In spite of his resentment of the media criticism he received, Canada was good to Roloff. When Hamilton Southam, chairman of the Rome-based Mediterranean Institute, was interviewed in Ottawa, he made the comment, 'Canadians always have problems with successful expatriates, and Roloff's exotic dress and Continental mannerisms didn't help. He did the right thing. Ignore them and get on with his photography which was brilliant.'

More colour, 56 illustrations in all, crept into the Canada book, along with 144 plates in photogravure. The final images of industry, nature and people were excellent, but the transition from ancient to modern had not come easily, and Roloff did indeed owe much to Lorraine Monk. Insecure about breaking new ground, Roloff had journeyed to Ottawa to show Lorraine his nearly completed dummy. She tore apart many of the photographs, pointing out hackneyed parallels from the same uninspired angles shot for the Film Board twenty years earlier. Roloff loathed criticism but he always weighed the source and, after becoming violently ill, he agreed. 'Somehow,' Lorraine recalled, 'he beguiled me into helping him convince Signy Eaton to pay for a reshoot. She agreed and the book was far better for it. He could get anybody to do anything, for a time.'

NATURE

65 *Sunset through the reeds and grasses along the southern coast of Spain near Malaga.*

66 *Dawn at Matsushima, islands of weathered volcanic rock, near Sendai on the northeast coast of Honshu, Japan.*

67 *Tree trunks submerged in the large artificial lake at the Periyar Wildlife Sanctuary in the Thekkady District of Tamilnadu, India.*

68 *Cherry blossom in April mist at Gora, Hakone, near Mount Fuji, Japan.*

69 *A monkey rests on the frescoed balcony of an eighteenth-century temple dedicated to Lord Krishna, at Galta on the outskirts of Jaipur, the capital of Rajasthan, India.*

70 *Washing the family buffalo at the Keoladeo Ghana National Park, near Bharatpur, Rajasthan, one of the largest bird sanctuaries in Asia.*

70

72

73

While working on the Canada book Roloff staged an elaborate exhibition, 'Pleasure of Photography: The World of Roloff Beny', which opened at the Sekers Gallery in London in the autumn of 1965 as part of a fund-raising campaign for the Winston Churchill Memorial Trust. Roloff's usual London crowd, including Vivien Leigh, Sarah Churchill and John Gielgud, turned up for the opening with a surprise late arrival by Ingrid Bergman. The architectural theme of the photographs was complemented by a series of silk brocade textile panels inspired by photographs Roloff had taken of Renaissance and Mogul monuments. The following year 'Pleasure of Photography' toured five Canadian cities with the additional attraction of models wearing gowns fashioned out of Roloff's fabric by the New York couturier, Scaasi.

In the spring of 1966 the city of Toronto was trying to acquire *The Archer*, a massive bronze sculpture by Henry Moore. Roloff pleaded their case with his old friend over drinks at the Athenaeum Club in London, and Moore agreed to reduce his price and the deal was agreed.

Roloff had the knack of combining photography and publicity. In 1967 he donated twenty-two black-and-white photographs of Renaissance sculpture to be auctioned at an 'Aperitivo Party' held at the Art Gallery of Ontario in Toronto. The sale raised $19,000 for the local Save Italian Art Fund.

Perhaps the most spectacular of all Roloff's photographic exhibitions was 'A Visual Odyssey: 1958–1968'. The mammoth show, two hundred large-scale prints and brocade curtains, some more than eight feet high, dubbed 'walk-in pictures' by Roloff, sprawled over eight rooms and several balconies of the Huntington Hartford Gallery of Modern Art in New York. The exhibition also toured Canada and was ultimately acquired by the Siebens family for the University of Calgary in 1973. According to Arthur Nishimura, professor of photography at Calgary who grew up in Alberta, Roloff's early photographic exhibitions, and in particular his black-and-white work, influenced a generation of young Canadian photographers.

The 'national heritage' approach to photography seemed to be working. Roloff had discovered that governments, ministries, national airlines and tourist boards were willing to assist the books through direct subsidy or guaranteed purchase order as well as free travel and hospitality inside the country. His social connections and natural instinct for locating the right patron at the right time did the rest.

JAPAN IN COLOUR

Roloff's fifth book, *Japan in Colour*, was published in 1967, the same year as *Seasons*. He had done the photography two years earlier during a three-month break from his tour of Canada as a special guest of Japan Air Lines and the Ministry of Tourism. *Japan in Colour* won the Gold Medal at the International Book Fair in Leipzig and was praised as the 'world's finest book' with special recognition given to the book's typography and design. It was a magnificent book, all in colour, with the added luxury of hand tipped-in plates. Roloff relished his Japanese experience and the book remained one of his all-time favourites:

Japan is a world in miniature, and nearly as modernized as Switzerland, so travelling around it was a piece of cake compared to Canada or India which would come next. And yet, despite the modernization, there is no country in the world where the past is as deeply revered, where craftsmen and artists are declared 'living national treasures'. The Japanese were deeply in tune with the wisdom of their land, which I wished to evoke, and I met with none of the incomprehension and obfuscation which had hounded me all over Canada.

Moreover, for all its aestheticism, Japan is far from being an ascetic country. Nowhere else except perhaps in Renaissance Italy has an entire people given itself over equally and paradoxically to the otherworldly refinements of culture and the pleasures of the here-and-now. Of course, Japan also had in common with the Renaissance a fascination with violence, but that was not part of my itinerary, needless to say.

Sir Herbert once again wrote the preface, and (with references to D.T. Suzuki) said better than I could exactly what I was trying to do in Japan: '"This world of particulars" – this gives us the clue to Roloff Beny's approach to Japanese culture, to Japanese art and the Japanese landscape. It is a world of particulars (not of panoramas, of general views, of vast monuments) and it has to be seen with the eyes of a poet . . . Beny sees such things as old ponds, broken stones, the iris and the cherry blossom, shadows on walls and the texture of a moss garden, all "on the other side of eternity," as all the great Japanese artists have seen such particulars. It is quite astonishing to observe the way in which this camera-eye from the West can identify itself with the Zen vision of the realm of the unthinkable, the world of pure vision, free from all attempts at an intellectual interpretation of such things.'

I was also blessed in the author of the harmonious main text, Anthony Thwaite. A long-time on-and-off resident of Japan and a

fanatic Japanophile, Anthony provided just the sort of personal as well as deeply informed essay that I most admire. Our meetings took place in Benghazi, on the fringe of the Gardens of the Hesperides and in London. From beginning to end the book was pure pleasure, sheer ease and enjoyment.

INDIA

As each book neared completion, Roloff would be ready with at least two or three candidates for the next. India, Islamic architecture and Ceylon were the most likely contenders for the next book. The Indian government seemed ready to give its support, and Roloff began a year-long photographic tour of a country that had always fascinated him and to which he would often return. Unfortunately, the book proved to be one of the most controversial and politically sensitive of all.

I had sworn never to return to India, a country, culture and people that so devastated me on my first visit in search of ruined cities. Yet when the Government of India approached me to do a book on its country, the opportunity was too great to resist.

Peggy Guggenheim agreed to start out on the journey with me, and on 23 January 1969 we flew from Rome to New Delhi. It was the beginning of a three-month intensive exploration of almost every corner of the vast subcontinent. James and Carol George, the Canadian High Commissioner and his wife, were our hosts at the palatial Aurangzeb Road residence in Delhi, scented with frangipani and fountains.

My favourite diplomats, the Georges immersed themselves totally in whatever eastern culture they'd been assigned. While other ambassadors hide themselves in their air-conditioned ghettos, the Georges sally forth in Land Rovers or limousines, beard holy men in their dens, dine with dervishes and maharajas, and collect sacred art. Ceylon, India and Iran were James's major assignments, and he is remembered in all three as the tall, suave and mystical ambassador from Canada, even by people who are none too sure exactly where or what Canada might be. Moreover, the Georges took me under their wings in India and Iran, smoothing the way and providing everything from glorious dinners and soft beds to interviews with the high and mighty. They believed in me and never stinted their incredible energies in furthering my work. In the end, they turned out to be even more than friends. They became virtually my adopted family.

Our first night out from Delhi had been arranged by the erudite Minister of Tourism and Civil Aviation, who also happened to be

the Maharaja of Kashmir and Jammu, Karan Singh. Off we went with an invitation to stay with his old friend the Maharaja of Bharatpur, who administers one of India's finest game reserves and inherited one of the world's most fanciful palaces at Dig.

The palace was fairylike with minarets and balconies, in a private park with armorial coats of arms and armed sentries. I slept in a bed not long since vacated by the Duke of Edinburgh. It was flanked by seven stuffed rampant tigers. Peggy's bed was suspended from the bellies of four mummified water buffaloes. In horror, she retreated to my room. 'I can't, I simply can't!' – and we spent the night huddled together between the tigers.

To become initiated, one must participate – get on the road and see first hand India's human opera against its varied backdrops and trappings. The erotic temples of India contrast sharply not only with modern ugliness but also with the present-day Victorian squeamishness of the people, who often seem more British than the British. Gymnastic-amorous combinations in stone appear to defy the laws of gravity, but are saved from the monotony of pornography by the exquisite craftsmanship and anatomical appreciation which compares favourably with Michelangelo's Sistine Chapel frescos (without the added drapery over genitalia).

At Sanchi, associated with the life of the Buddha, I went straight to the stupa to do my favourite twilight photo. En route, I asked Peggy, 'Have you left vanity behind, as is customary when approaching the core and essence of Buddhism?'

'Minxie', she sighed, 'I've left vanity behind ages ago – I'm just afraid we'll have to leave hygiene behind as well!'

When I think now of India, I first recall the women, bejewelled and in brilliantly coloured saris. The women are the workers, but they also provide the greatest joy to the eye. Even the poorest women toiling in the fields often manage to look like brides arrayed for a wedding, since in fact they wear the entire family wealth welded close to their limbs to protect it from thieves.

As for the men, none of the fashionable male jewelry I'd seen in the boutiques of Europe could outshine the simplest peasant in certain parts of India. They wear bracelets and collars of beaten silver and chiffon turbans. A man in the bazaar at Udaipur wore garnet earrings and ruby rings and he had pink nail polish on. These men, by the way were warriors, not professional models. A long way from Alberta, indeed! (What would Father think? Men are not supposed to be beautiful.)

As we drove south into the Deccan, the landscape became suddenly and alarmingly reminiscent of the road from Medicine Hat to Irvine: flat, wheat-covered prairies with low hills and a 360-degree

horizon. I insisted on stopping for a photograph of the setting sun in this haunting childhood landscape. 'Why are you wasting film on this desolation?' asked Peggy. 'Surely you don't find it beautiful?' I didn't know how to reply. All the loneliness and lostness of my fifteen years on the Canadian prairies came surging back, the desperate need to escape through reading, the solemn promise to myself to rectify this error of birthplace. Every time I returned there, I reflected, I realized all over again the sense of my iron determination to escape and embrace the world . . .

I photographed the Dalai Lama at his mountain retreat in Dharamsala where the rhododendrons were in blood-red full bloom. When I asked His Holiness, the leader of the Tibetan people in exile, why he stayed in India, he said, 'I prefer to deal with the wolves I know rather than be exploited by those I don't know'. I found him an inspiring person: the light of his smile filled the room, and seemed to fill all nature. He said goodbye with a bear-hug embrace, and I felt an aura flow through me, as if I were a harp being strummed.

A few weeks later near Shillong in the frontier state of Meghalaya, I had a brush with death: I plunged over the edge of Mawsmai Falls at Cherrapunji (trying to take a photograph, of course; as Peggy always said, I am visually greedy). The plunge to the bottom would have been two thousand feet – but I was saved by a tropical vine. I told the hysterical driver to take a tyre off the car and lower it to me. He pulled me up out of the abyss, feeling reborn and full of enthusiasm.

I had a wonderful time in the game preserve of Kaziranga in the far eastern state of Assam. I was present at the birth of a baby elephant, about three feet long and weighing 45 pounds. The fuzzy creature was covered in a caul which the mother removed with her trunk; then she pressed the baby to her breast and showed it how to take milk. I looked deeply into her small topaz eyes, so cunningly shaded by her bristly eyelashes, and felt I had attained a rapport with another world. When she curled her trunk about me, I felt more than rewarded for months of loneliness.

On the whole, the observation and recording of new sensations (visual and physical) is a perfect substitute for sex. In fact, the beautiful animals one enjoys with the eyes, the trees, the vines, the flowers, the mist and rain, the colourful people one glimpses briefly – all this is by far superior to the fleeting, frustrating, stumbling attempts at sensual expression that so often disappoint one in lustful encounters . . .

I wondered what I would do for excitement when I left India. I remember a story in an Italian magazine some years earlier, alleging

that Cecil Beaton really took all the Roloff Beny photographs and was paid by my father to keep quiet about it. I grinned to myself as I wondered what Cecil would have charged to 'do' India . . . I was sure I had a splendid collection of film, despite all the magical things I'd missed (how can one photograph an entire cosmos in three months?).

On my return I found the India book in very hot water. Aubrey Menen had been chosen to write the text, and though his approach was witty, it was laden with criticism of the very people who had commissioned the book. The Indian government requested certain revisions but Aubrey refused to change a single word.

Karan Singh, who was also director of Air India, flew to Rome and had the VIP lounge at Leonardo da Vinci Airport turned into an Indian pavilion, with curry feast laid out and waiting. I was commanded to appear, and listened helplessly as he pleaded the government's case in vain.

If the Indian government withdrew its support, I would lose the special Air India edition, the Government of India edition, free travel on Air India, and the chance to produce more books on the country with official help. I would also lose the respect of other governments when they heard I'd been banned in India. I would be the unwilling cause of diplomatic tension between Canada, which had supported my cause, and India.

In the end, the book appeared without any official support. I had to rewrite my acknowledgements, an embarrassing and humiliating task. I changed my foreword to read: 'Mr Menen's views are as personal as mine, and on reading his essay I find that his interpretations of India differ from my own.'

India, published in 1969, remains my least-known and appreciated book. It was banned in India and could only be bought there under the counter. A book with a split personality is doomed to obscurity.

Thames and Hudson stood solidly behind Aubrey Menen and his bitchy though intriguing analysis of India and would have done the same for Roloff and any other of their authors under similar circumstances. In typical Roloff fashion, he obscured the moral and political issues, fearing the potential loss of prestige and patronage. Although the Indian government never lifted the ban on the book, they did ultimately forgive him, and three years later Roloff was invited back to do a book on Rajasthan.

One significant development that emerged from the publication of the India book was a change of Canadian publishers. Thames and Hudson had originated all of Roloff's books, and his Canadian co-pub-

lisher from *A Time of Gods* onwards had been Longman, but after the death of Ted Browne, the head of the firm, Roloff turned to a different company, McClelland and Stewart, to publish his India book. Jack McClelland, director of the company, became not only Roloff's publisher, but also a close friend and trusted adviser. He clearly remembers their first encounter:

> I first met Roloff at a party given by John David and Signy Eaton to launch his very successful book for the Canadian Centennial in 1967 – *To Every Thing There Is A Season*. I knew of him before that, of course, and in fact had bought copies of most of his books from my friend Ted Browne at Longman, Green. I say 'bought', probably I mean 'traded', because Ted Browne and I did a lot of that as very good friends sharing the Canadian publishing market.
>
> My first reaction to Roloff was that he certainly looked the part of the committed artist. I thought his apparel was a bit on the bizarre side, but if there is one thing that Roloff made clear on our first meeting it was that he was not your normal human being. He lived in a different world and his interests – all artistic – were on a different level.
>
> I did not at that time anticipate becoming his publisher, in the long term, let alone in the very near future. It came about as the result of Ted Browne's unfortunate death and the fact that Roloff was not really friendly with those who replaced Ted at the senior level at Longman's. This was not altogether surprising.
>
> Roloff, as a general rule, showed very little interest in anybody but the boss, and as a consequence there was an overwhelming tendency at Longman's to treat him as a 'pain in the ass'. To a degree the same thing happened when he joined M & S except for the fortunate fact that we had a few key individuals who genuinely admired his work and were sensitive to his needs and his somewhat unique way of life.

Jack McClelland actively publicized Roloff from the outset and arranged a cross-Canada tour to promote the India book. Roloff was interviewed on radio and appeared on a number of television talk shows organized by Beth Slaney, a professional public relations manager, who wrote to the publisher with details of the forthcoming tour, and about 'handling' Roloff:

> Jack, please don't feel that I am trying to pass the buck. We both know that our organization will give full value and then some. One of the most important things in this programme is that Roloff Beny

will be as calm, satisfied and co-operative as it is possible for him to be, which is a giant step in the right direction . . .

She continued:

Park Plaza Suite: Two bedrooms, tell everyone he is coming. Beth Slaney to check suite for champagne, flowers and 'food' goodies. Cadillac car and chauffeur and Jack to meet him. Beth Slaney to be in attendance, to re-meet Mr Beny and to go over arrangements with him for the following days. Then she will quietly withdraw and Mr McClelland will take over the balance of Wednesday. TV interviews, cocktail parties, interviews with newspapers and magazines. Mrs Slaney will travel with Mr Beny at all times during his stay, including the Chisholm party. If he wishes, he may come home alone . . .

ISLAND: CEYLON

After India, Roloff turned to Ceylon, known today by its ancient name of Sri Lanka, as the subject for his seventh book. He had been negotiating with various government ministries in Colombo for several years, and he finally convinced them to give him the support he needed by ordering a special edition of three thousand. John Lindsay Opie, author of the plate notes for *A Time of Gods*, accompanied Roloff on many of his trips within Ceylon and contributed a scholarly text and anthology for the book. Many years later he relived one of their most frightening moments together:

Roloff and I had been in Ceylon for about two weeks when the accident occurred. Except, of course, it wasn't an accident at all. It was the Curse of Lord Kataragama.

Kataragama is the most important Hindu shrine in Ceylon. When we finally managed to persuade the Tourist Board to give us a car, guide and driver, I urged Roloff to begin in the southeast with a visit to the shrine. As it happens, Kataragama is right next to the Yala Game Reserve, with hundreds of wild elephants and other exotic animals, so Roloff liked the idea of starting there.

I had been told that according to ancient custom anyone arriving in the area of the shrine should *at once* pay the deity a visit and possibly make an offering of a coconut. This is observed not only by Hindus but also by Buddhists and even many Muslims. In any case, I was consumed by curiosity and eager to see the shrine. So, as soon as we arrived at the guesthouse where we were to stay, I suggested that we make a brief pilgrimage and pay our respects. It was already late afternoon, however, and Roloff had other ideas. He wanted to

get to the game reserve before it closed at sundown. He wouldn't hear of my idea, and the more I insisted the more stubborn he became, determined to get to the animals as soon as possible.

Reluctantly I agreed. But now our driver was missing. Search proved useless. Finally our guide, a Muslim named Hassan, found a barefoot cook's assistant who said he could drive, and we set out for Yala in a rundown zebra-striped jeep. As we drove down the guesthouse road, I noticed the whole staff had silently gathered to see us off and were glaring oddly.

As the sun sank lower, it gradually dawned on us that we were lost. Hassan didn't seem to know the way, nor did the silent driver who was apparently moving at random. The road had become a rutted track. Roloff grew more and more agitated at the thought of missing his twilight shots, and started harassing the driver and the guide. I lapsed into gloomy silence in the back seat with the cameras. 'We should have gone straight to the shrine,' I said.

'Faster . . . faster,' Roloff kept repeating, and grimly the driver obeyed. We plunged along the bumpy road as if pursued by Furies. Neither Hassan nor I said a word. The shadows deepened.

Suddenly I had a clear pre-vision. In my mind's eye I saw the driver's skinny toes press the gas pedal to the floor as we rounded a bend, and there right ahead of us was an enormous *jak* tree, towards which we were hurtling out of control.

As I was about to open my mouth and tell him to slow down, the whole thing started happening just as I'd seen it. The driver's foot pressed spasmodically to the floor; we shot forward, out of control, around a sharp curve. And there, almost in the middle of our path, stood a huge *jak* tree.

The driver screeched on the brakes but it was too late. *Bang!* We nicked the tree. Hassan and I, in the back seat under the canvas roof, were flung forward but were unhurt. The driver literally flew out of his seat, described a perfect arc through the air and, landing on his two feet, ran off. As for Roloff, he too was hurled over the windscreen through the air, straight at the tree. The jeep followed him, crunched itself into the trunk and pinned Roloff in position.

Deep silence fell. Hassan and I clambered out and shook ourselves to make sure we were undamaged. We heard a moan from above. 'Are the cameras safe?'

Yes, the cameras were safe. But what about Roloff? 'I don't know,' he answered dimly. 'I can't seem to move, and there's an awful pain in my leg.'

It was now almost completely dark. From somewhere near us in the jungle we heard the shrieks and bellowings of animals. Quick-witted Hassan said he would run to the entrance of the game park –

not far off – and try to find a car, since the jeep was clearly finished. Off he ran up the road and vanished. Silence fell again, except for Roloff's moans echoing through the cathedral-like trees and shadows. And of course that bestial screeching coming closer and closer. I had a good look at Roloff, and saw that he was impaled on a bayonet-like spike of the *jak* tree, which went in one side of his thigh and out the other. I felt shocked yet curiously calm. But what if Hassan didn't come back?

Half an hour eked by when, lo and behold, Hassan pulled up in a tiny car. He jumped out and looked anxiously into the jungle thicket. Together with the bewildered owner of this absurd vehicle, we managed to unpin Roloff from his tree and fold him into the car like a sort of foetal pretzel. Hassan and I squeezed into the back seat, and we set off for the nearest hospital. When I asked about the animal noises, he said, 'Yes, well, I didn't want to frighten you, but the reason why they close Yala at sundown is that the animals come down to drink at the waterholes and sometimes they fight and stampede. You were near a waterhole – but what could I do?'

We now bumped our way, with terrible groans from Roloff at each ditch in the road, for almost an hour through the pitch-black jungle, till finally we reached a village with a hospital. This turned out to be a large shed, mostly open, with one roofed ward for the serious cases. Roloff wouldn't move from the car until someone had come out and injected him with a crooked needleful of morphine. At last we got him in a bed, checked for snakes and bird droppings, and decided there was nothing else we could do till morning.

Next day we found that Roloff had been strapped into tight bandages and all but devoured by mosquitoes. I managed to get him moved into the one bed with netting, ordered another shot of dope and left him swathed loosely like an immobile cocoon. 'Now, Hassan,' I said, 'take me at once to the shrine of Lord Kataragama.' Hassan broke into a toothy smile. 'Yes, sir. At once.'

I spent the rest of the day at the shrine which was as fascinating as I'd hoped. I carried out the customary rites to the letter, smashing a coconut (which popped like a skull on a cremation pyre), handing out pennies to the rows of sitting beggars, even (to please Hassan) stopping at the little mosque near the main shrine.

Now the stories began to come out. Roloff was far from the first to be punished for showing disrespect to the god of Kataragama. Terrible things had befallen other sahibs, memsahibs, atheists and foreign tourists who had failed to propitiate the god upon arrival in the district. Hassan, good Muslim though he was, told me a score of such tales, and back at the guesthouse the staff regaled me with more. It struck me that they all seemed curiously *relieved* about

something. I finally realized they were overjoyed at this dramatic evidence of the god's power. They would have been deeply disappointed if Roloff had got away with his disrespect. They were edified and confirmed, and they had a fresh, infallibly true story to add to the repertory.

These events had an ironic twist in that, following Roloff's disastrous 'punishment' by Lord Kataragama, John Lindsay Opie had a rather more pleasant experience of local faith in the god:

The day after Roloff was laid up in the hospital near Kataragama, a young woodcutter was brought in from the jungle and put to bed in the same ward. Like Roloff, a large palm-splinter had ripped up the flesh of his leg and lodged there. He was clearly in great pain and remained so for several days while waiting for the wood to be removed by surgery. He would groan softly, faint away, then wake up again, but – unlike Roloff – seemed otherwise resigned and uncomplaining.

When I came for visits I always greeted the woodcutter and he smiled back merrily. Each time I left the room I gave him something: cigarettes, 'refreshing tissues', sweets – subtracted as a rule from Roloff, whose protesting voice would rise from a small mountain of flesh and bandages, almost wholly concealed behind heavy mosquito netting. The slight, unassuming woodcutter was obviously touched and encouraged by the attention.

On the last day but one I brought the woodcutter a picture of Lord Kataragama from the shrine. It was placed reverently on the table by his bed. Raising himself as best he could, he venerated the image with joined palms, then, to my surprise, with the same gesture he venerated me, his eyes filling with tears. Later that day he was operated on – successfully, as it turned out – and when I saw him for the last time he took leave of me with profuse expressions of awe and gratitude that astonished me.

When I got back to Colombo, I mentioned the woodcutter to my friends at the Tourist Board. They said that he had taken me for Lord Kataragama. Gods are thought of as fair-haired and white-skinned, and, coming from the jungle, it was probably the first time he had ever seen such a person. My benefactions were entirely in keeping with a divine manifestation, and when I delivered the image my identity was revealed and confirmed.

When the woodcutter returned to his remote village, they said, he would tell the story, and a long poem would slowly grow out of it, which would be recited by the villagers in future generations . . . Two hundred years later, another Lindsay Opie would come along,

discover the poem and publish it, to the delight of readers, in another book about Ceylon!

Meanwhile, following calls to the Tourist Board requesting an ambulance for Roloff, whose leg had begun to swell up and whose three broken ribs caused considerable pain, as well as numerous complaints from the invalid, someone finally arrived from the Tourist Board to take Roloff and Lindsay Opie back to Colombo.

'We couldn't find an ambulance, you see, so we brought this instead . . . hope it will be all right . . .'

'But that's a *hearse*.'

'Yes, sir, you see, we can slip Mr Beny in here where the coffin goes, and he will be comfortable . . . yes?'

There was nothing else to do. Roloff was given a massive dose of morphine and strapped in place. The hearse set out, followed by Hassan and me in one car and official representatives of the Tourist Board in another. We had to drive as slowly as possible so as not to bump Roloff unnecessarily. It took nearly six hours to reach Colombo. Because of the black hearse and the procession of cars, we looked exactly like a funeral; and as we passed through the town, people would come out to bow in reverence or silently stop and stare. Roloff, he says, helped by the morphine, thought he was dead and had gone to paradise: all he could see through the glass top of the vehicle were palm fronds and flower trees sweeping past under the still blue sky and he knew he was in a hearse – hence he must have been dead.

At last we arrived at a beautiful garden-set hospital in Colombo. Unfortunately, however, it was New Year's Eve and the accident wards were filled with drunks and casualties. The only room available was in the maternity ward. So all night long Roloff heard mothers screaming and fireworks blasting off outside his window. This time he decided he was in hell. Actually, though, it all went to make up a symbolic rebirth. He survived.

Roloff returned in *Island: Ceylon* to his great strength – black-and-white photography – after using only colour in the Japan and India books. The moody photographs of monumental Buddhist sculpture accentuated by meditating monks were some of his best work since *A Time of Gods*. The majority of the colour images were superb but Roloff could not resist using coloured gelatin and net filters which gave a contrived and artificial look to some. Franco Bugionovi's 'solarized' linecuts interleaved through the prose and poetry anthology gave a strong sense of graphic design to the book.

PEOPLE

78 *Drawing water from the village well at dusk near Alwar, Rajasthan, a daily ritual.*

79 *Inside the historic Vakil Bazaar in Shiraz, Iran, a storyteller, bathed in the light of stained-glass windows, begins to weave his timeless tales.*

80 *One of India's countless wandering ascetics, a sadhu respectfully approaches the entrance to the Brihadiswara Temple in Tanjore in the southern state of Tamilnadu.*

81 *Dancers celebrate a Buddhist festival at the temple of Kelaniya near the Sri Lankan capital of Colombo.*

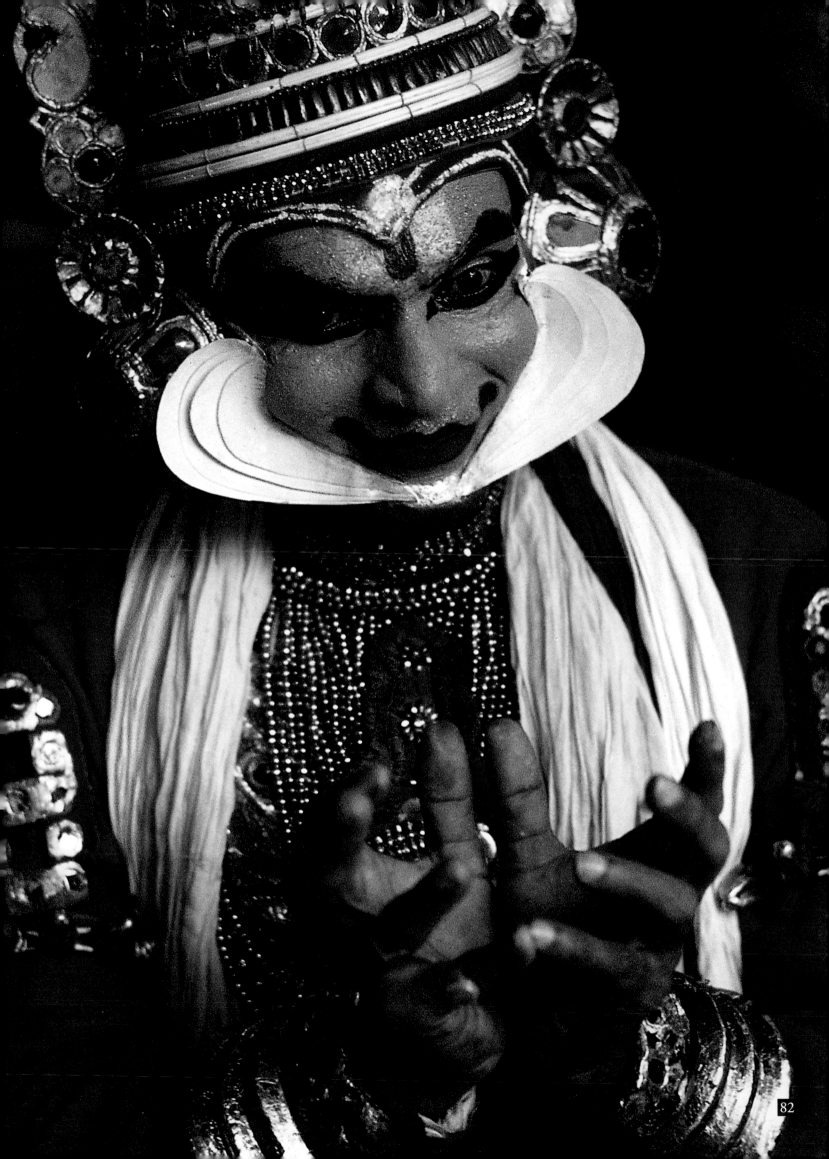

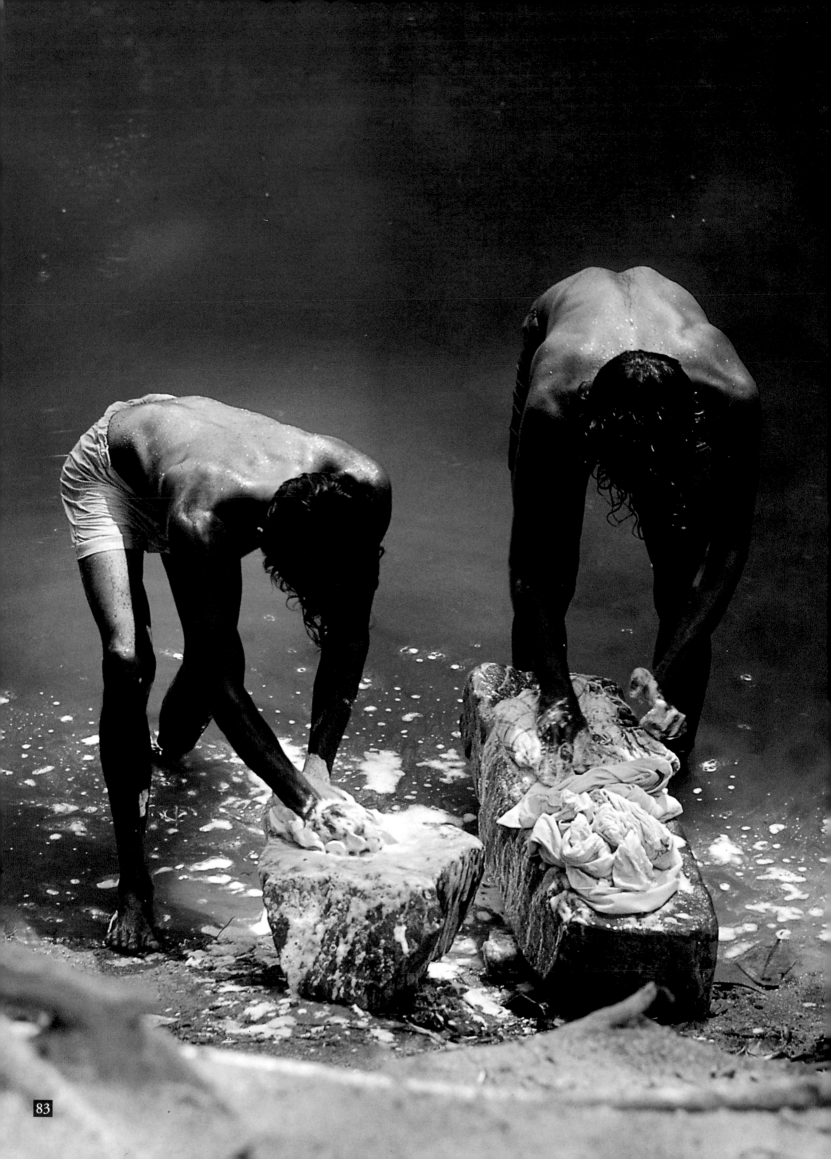

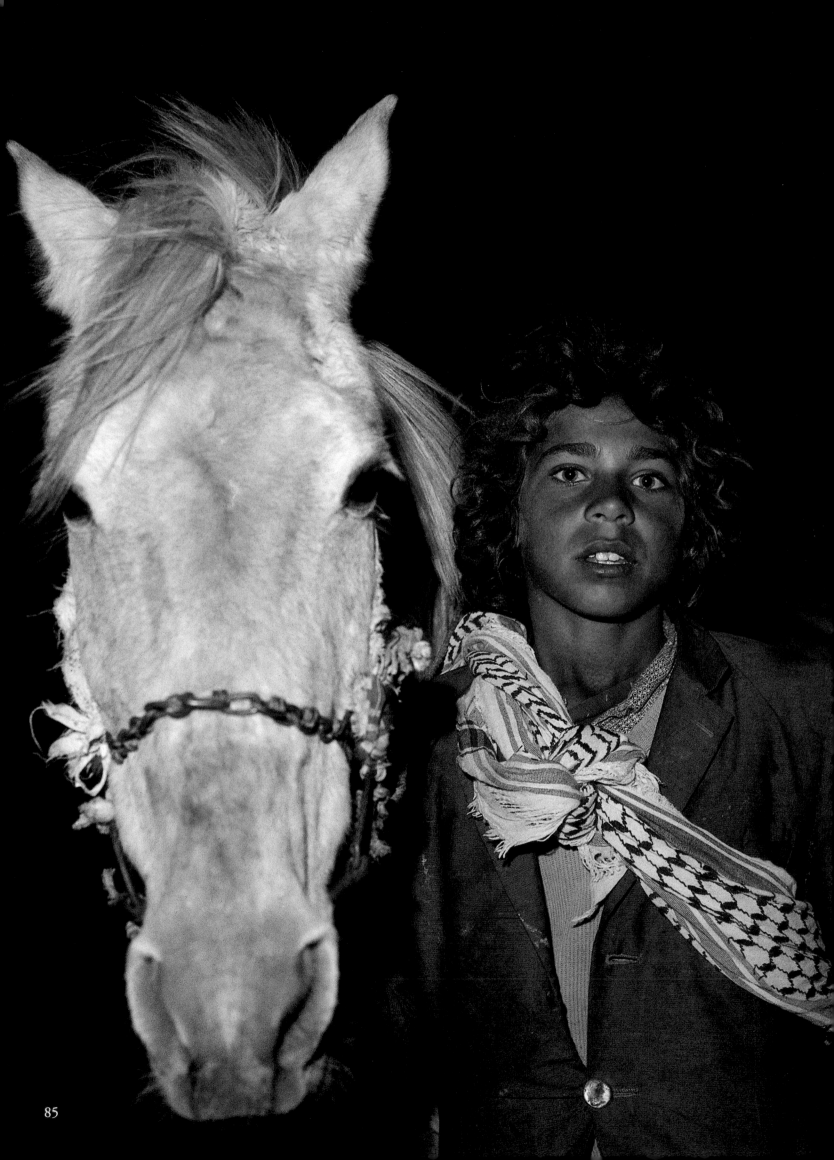

IN ITALY

On his return to Rome, Roloff signed a contract with Thames and Hudson to do his eighth book, this time on his adopted country, Italy. By now he was running a small business employing a secretary, art director, researcher and, of course, Maria, his devoted housekeeper and guardian who remained with him for more than twenty years. Renowned for his stinginess with salaries, tips and picking up restaurant tabs, Roloff was generous with his contacts and connections and opened many doors to the young people who passed through Tiber Terrace.

Italy had long been waiting in the wings. In 1967 Italian President Giuseppe Saragat was presented with a Centennial copy of my book on Canada, *To Every Thing There is a Season*.

At a reception at the Quirinale, the presidential palace in Rome, he embraced me and boomed, 'Why are you avoiding Italy? When are you going to do *my* country?'

I felt three books – or even ten – on this country would not be enough. It is so rich. I agonized over what to exclude. 'Art is made of conflict,' said Arthur Miller. 'It is not made of what we call pleasure. The pleasure comes from the resolution of the conflict.'

This has been the case with the countries in which I was most involved emotionally: Greece, Canada and Italy.

One evening Gore Vidal, my neighbour across the Tiber, listened to my problems. 'Don't resist doing precisely what your most self-indulgent instinct would dictate!' he said. 'Roloff, your books are not topographies, they're not art histories, they're not social commentaries. They are collections of images that please *you*. I imagine it will be a one-man show of your favourite things.'

I had already made up four outlines for the book. With each I was convinced I'd found the final solution, that I could really begin work – which means a period of daydreaming, making endless memos to self and staff during sleepless nights, field trips, research and generally walking around in a daze of euphoric excitement.

The problem of too many titles is always agonizing, and in this instance, it was worse than ever. 'Italian Gallery', 'Column, Tower, Dome and Spire', 'Italian Notebook', 'Reflection on an Antique Land', 'A Time to Love and a Time to Die', 'Obelisks of Fire' . . . I couldn't make up my mind.

All this agony was ended at last by calling the book simply *In Italy*. The next two or three years were devoted to travel, with one major burst of sustained activity and a number of smaller bursts. I zigzagged up from Sicily to the Alps. In between trips I returned to Tiber Terrace to relax, spoiled as usual by Maria, my devoted

82 *After hours of preparation, a traditional Kathakali dancer from Kerala is ready to perform one of the oldest and most spectacular of the dance dramas of India, based on the epic poems, the* Mahabharata *and* Ramayana.

83 *Two young men wash their sarongs after work in a pool below Adam's Peak, a rocky summit in south central Sri Lanka venerated by Buddhists, Hindus, Muslims and Christians.*

84 *Road builders in the northern Italian town of Genoa.*

85 *During the annual Persian New Year celebration (Nau Ruz), visitors to Ahvaz in southwestern Iran picnic near the warmth of open gas flares. This young boy, his face illuminated by the flames, earns a little extra money by allowing the city folk to ride his horse.*

housekeeper, and to try and impose some order on the massive accumulation of images.

A large cast had been assembled for the project. The text, comprising essays and an anthology of selections from Italian writers and travellers to Italy, was compiled by my reliable expert Anthony Thwaite and another distinguished Italophile English poet, Peter Porter. George Mott, a young student photographer, and my faithful friend and secretary Shelley Donnelly, accompanied me up and down the peninsula. Christine Imhoff ably assisted me in the design and layout of the book, while Brian de Breffney, a charming and witty baron who specialized in heraldry, sometimes travelled with us, and composed the superb commentaries on the plates. Gore contributed his Afterword, like a heady snifter of brandy after a large baroque Italian meal . . .

My most haunting night was spent eye-to-eye with Giuliano and Lorenzo de' Medici. I floated above the recumbent but alive attendants at the feet of the merchant princes of Florence in the Medici Chapel, on a moveable scaffold, tempted to leave the imprint of my hand in the dust of centuries on *Night* and *Day, Dawn* and *Twilight*. Later, when a reviewer praised me for risking my life in search of beauty, I had to think twice before I saw what he meant. Apparently, I do not have a well-developed sense of danger . . .

While preparing the Italy book, Roloff was twice honoured by his native Canada, receiving an honorary Doctorate of Laws degree from The University of Lethbridge in 1972 and being made an Officer of the Order of Canada the following year. To promote the Italy book, he embarked on a back-breaking tour across Canada to fourteen cities where he lectured and appeared on television chat shows and radio programmes.

Evelyn Lambert, a gracious hostess, patron of the arts and a kindred spirit, organized from her villa in the Veneto the most elaborate of all launchings for the Italy book. This was suitably celebrated in Venice and attended by both New and Old World aristocracy. The gradual unfolding of that event has been fondly recreated by another friend and colleague Lorraine Monk:

Memories of Roloff Beny come in many shades and colours. Mostly they are happy memories and, nearly always, they make me laugh – or smile. I have some particularly multi-coloured remembrances of Roloff in Italy, especially Venice, probably the place he loved most in the world. Partly, I think, because of his long friendship with the colourful and fascinating Peggy Guggenheim, partly because for almost everyone who has fallen under the spell of Venice, it forever remains one of the most glamorous and seductive cities of the world.

It began one summer's day with a phone call from Roloff. He was calling from Rome. He was calling, as always, 'collect'.

'My book, on Italy, which I have been working on for over twenty-five years, is about to be launched in Venice. You must come!'

'There's just no way I can get away,' I told him. 'I have a show opening.'

'You must come! I've told everyone you'll be there. I've told *everyone* the head of the National Film Board of Canada will be there.'

'Roloff – I'm not the head of the National Film Board.'

'You're head of still photography. That's even better. Besides, *everyone* is expecting you!'

Roloff never, ever took 'no' for an answer.

'I'll think about it . . .'

'Fly to Rome first. I'll give a party for you at Tiber Terrace. I'll have the Canadian Embassy meet you at the airport. Later, we'll fly on to Venice. Peggy Guggenheim is *dying* to meet you. Everyone in Venice is giving a party for me. You'll have a ball. *Time* magazine is covering the launch. *People* magazine is doing a story. You must come!'

Roloff was a master manipulator, a shameless flatterer and relentless.

'I'll think about it . . .'

'Bring all your best clothes,' he ordered. 'I've told everyone you're the best dressed woman in Canada.'

Roloff told extravagant tales about all his friends. You were either terribly rich – or terribly important – or terribly elegant. He called my office almost daily with up-to-the-minute reports on the festivities and events being orchestrated in his honour.

'Bring your finest ball gown,' he advised me. 'There's to be a great masked ball following the official launch of my book in the Doge's Palace. I'll be the first *living* artist ever to be celebrated in the Doge's Palace. Before me, you had to be dead!'

Roloff had an astonishing ability to cajole, charm and bewitch the rich and famous and Italian hostesses, who were now aggressively in competition to outshine each other in extravagant entertainment dedicated to the celebration of Roloff Beny and his latest book: *In Italy*.

Witty and droll, effervescent and effusive, Roloff radiated charm, confidence and charisma. He dressed with great style and a movie star's sense of theatre, often attired in suits of multi-hued velvet or exotic fabrics custom-made to his personal specifications. One such black-and-white material was elaborately designed by him to

incorporate the intricate pattern of a pierced marble screen from Mogul India into his own exclusive suiting material. His flamboyant mode of dress was a dramatic personal statement which he created with a great sense of style and flair.

He could be disarmingly self-deprecating or over-bearingly haughty. Switching unexpectedly from one conversational mode to the other, he could arouse in his confused and uneasy fans a state of apprehension bordering on dismay.

When he was good, he was very, very good.

When he was bad, he was often irresistible.

True to his word, Roloff had an Embassy limousine waiting for me at the airport and I was whisked in great comfort and luxury to his spectacular penthouse in the historic centre of Rome. The evening following my arrival, he gave a small party at Tiber Terrace where everyone danced with great abandon on the balconies where his garden was luxuriously in bloom.

I had confided earlier in the day to Roloff that I had no appropriate attire for such a bohemian party. He immediately went to his bedroom and returned bearing an exquisite black silk and chiffon gown, elaborately encrusted with silver beads – a valuable period dress from the 1920s. When I appeared on the terrace, Roloff cast a nervous glance and warned, 'Don't rip it! It's worth a fortune.' Since at the time I weighed barely 110 pounds and Roloff had on occasion worn the gown himself, I was not unduly worried. The next morning, in one of his rare but sweet gestures of generosity, he insisted I must keep the gown since it looked so 'ravishing' on me.

After three days in Rome, Roloff and I flew to Marco Polo Airport. There we boarded a small motor launch for the short ride to Venice. It was a heavenly day. Roloff was ecstatic to be returning to his beloved Venice.

I was ceremoniously installed in my room at the Bauer Grünwald Hotel where Roloff, gallantly attentive, admonished everyone from the desk clerk to the chambermaid to take good care of me because I was a very important Canadian. Then we took a gondola ride across the Grand Canal to the Palazzo Venier dei Leoni where the legendary Peggy Guggenheim resided in great state.

During the crossing, Roloff cautioned that I should be aware that Peggy was very 'fragile'. She had recently broken her wrist and was somewhat prone to breaking bones. I was admonished to treat her with the utmost consideration and tenderness. When we met, Peggy was indeed recovering from a broken wrist, but apart from this temporary incapacity, which she bore with equal parts of disdain and indifference, I could not imagine a more unsuitable word to describe Peggy Guggenheim than 'fragile'.

BUDDHIST AND HINDU

86 *A Buddhist monk in silent meditation near the Great Stupa at Sarnath, on the outskirts of the sacred city of Varanasi, India, where the Buddha preached his first sermon.*

87–88 *Two views of the sprawling ruins of Angkor Wat in Cambodia, the great temple city of the Khmer rulers, for centuries overgrown by roots and trees and rediscovered in the middle of the nineteenth century.*

89 *This body-shaped pool was cut from solid slabs of granite and used by Buddhist monks for bathing the sick from the area known as the hospital at Mihintale, eight miles from Anuradhapura, the cradle of Buddhism in Sri Lanka.*

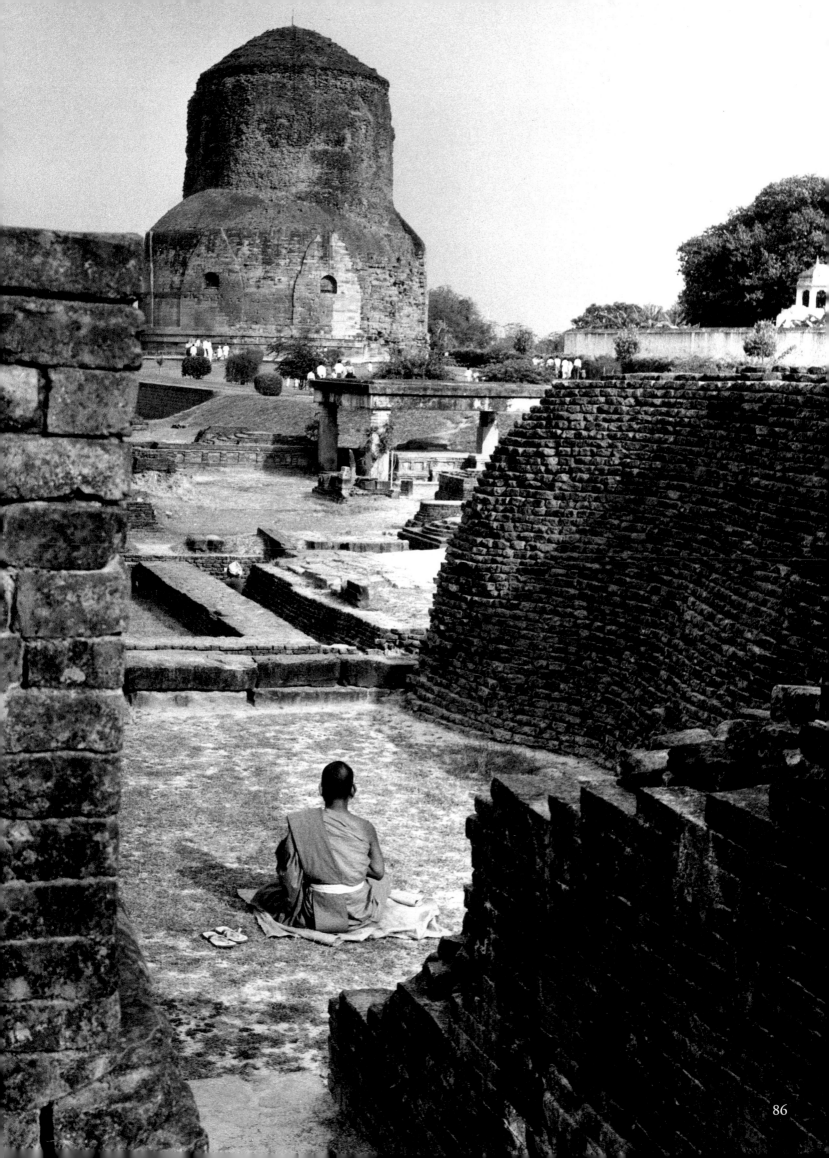

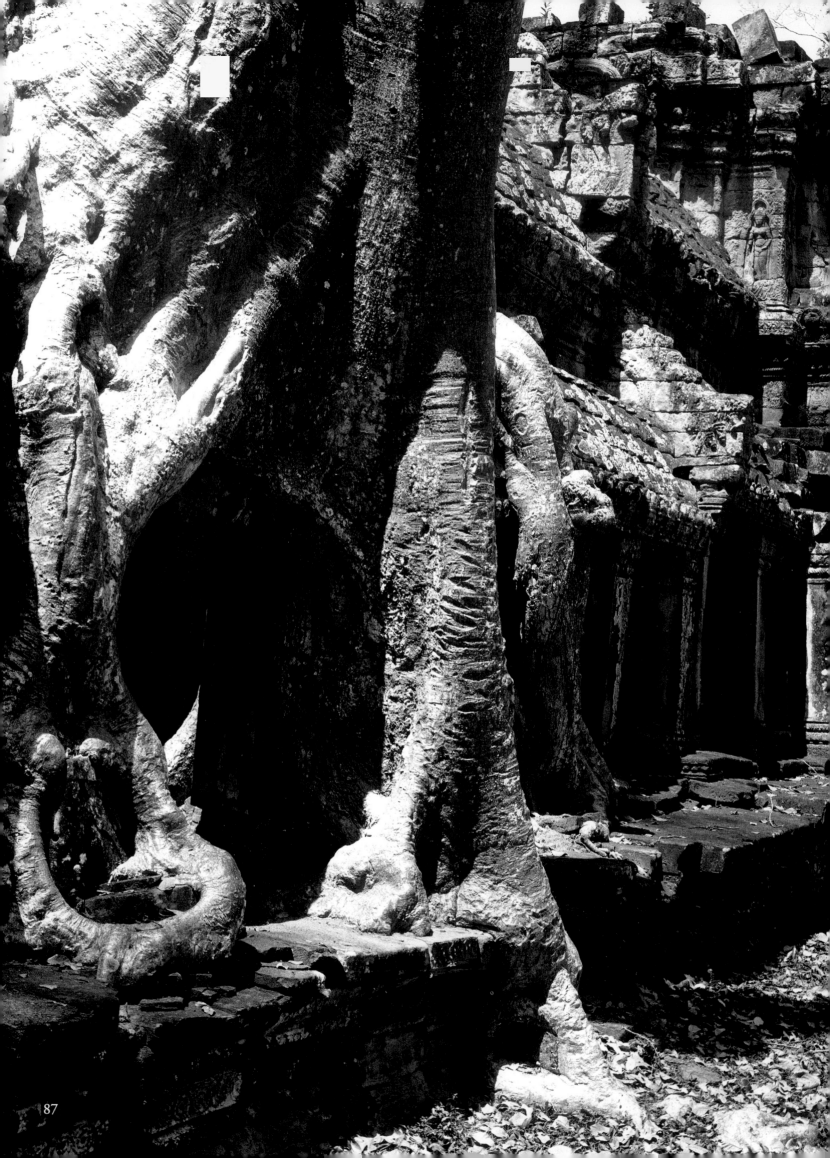

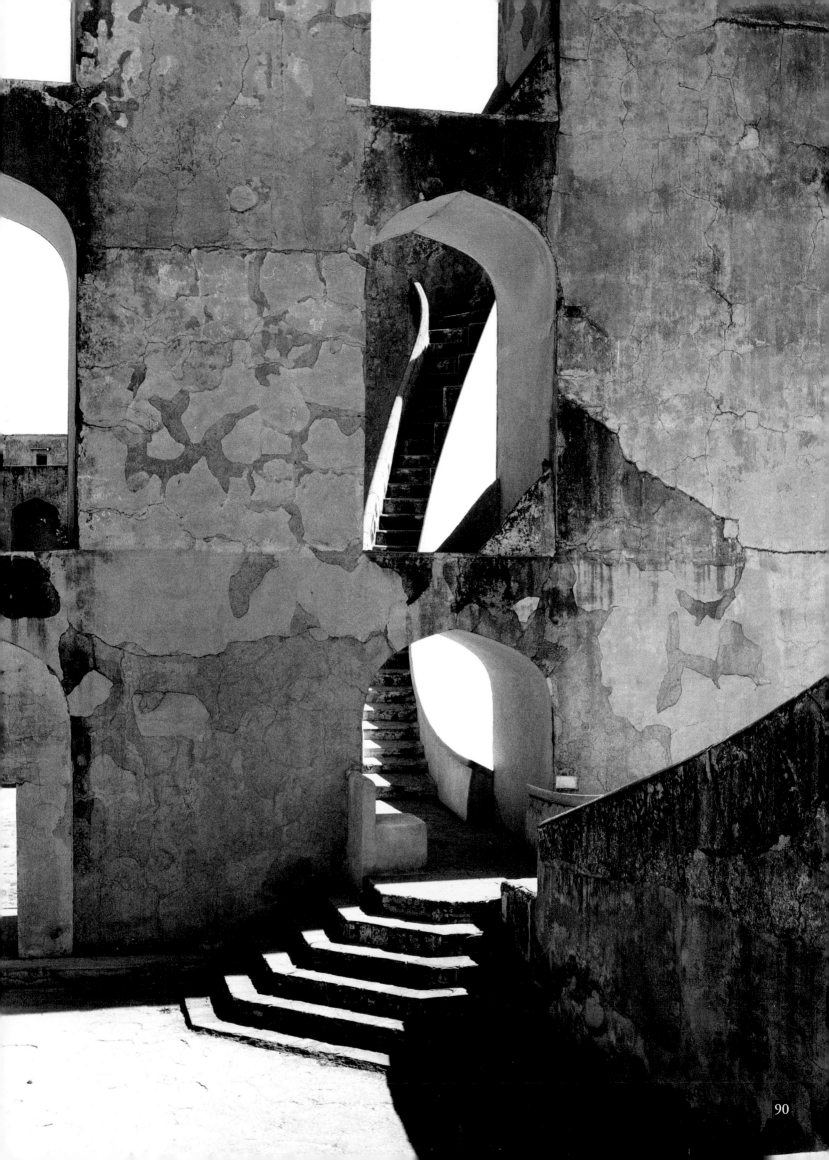

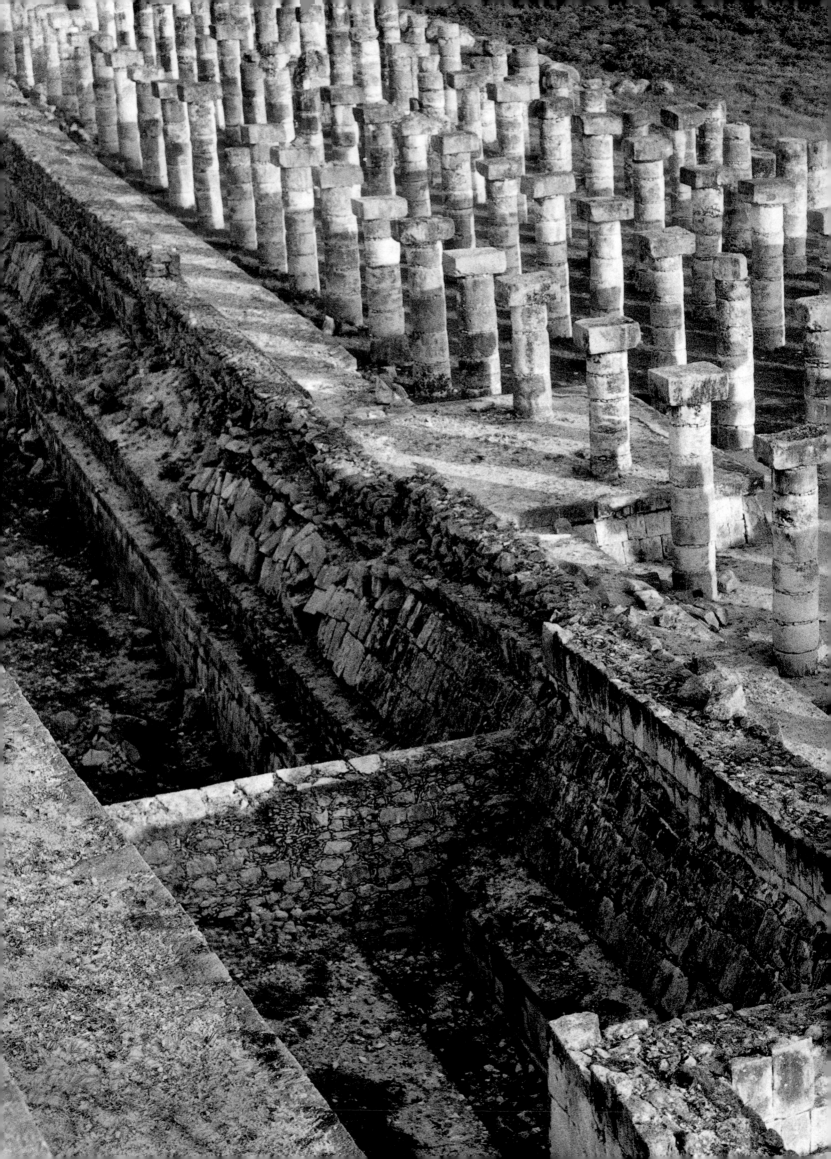

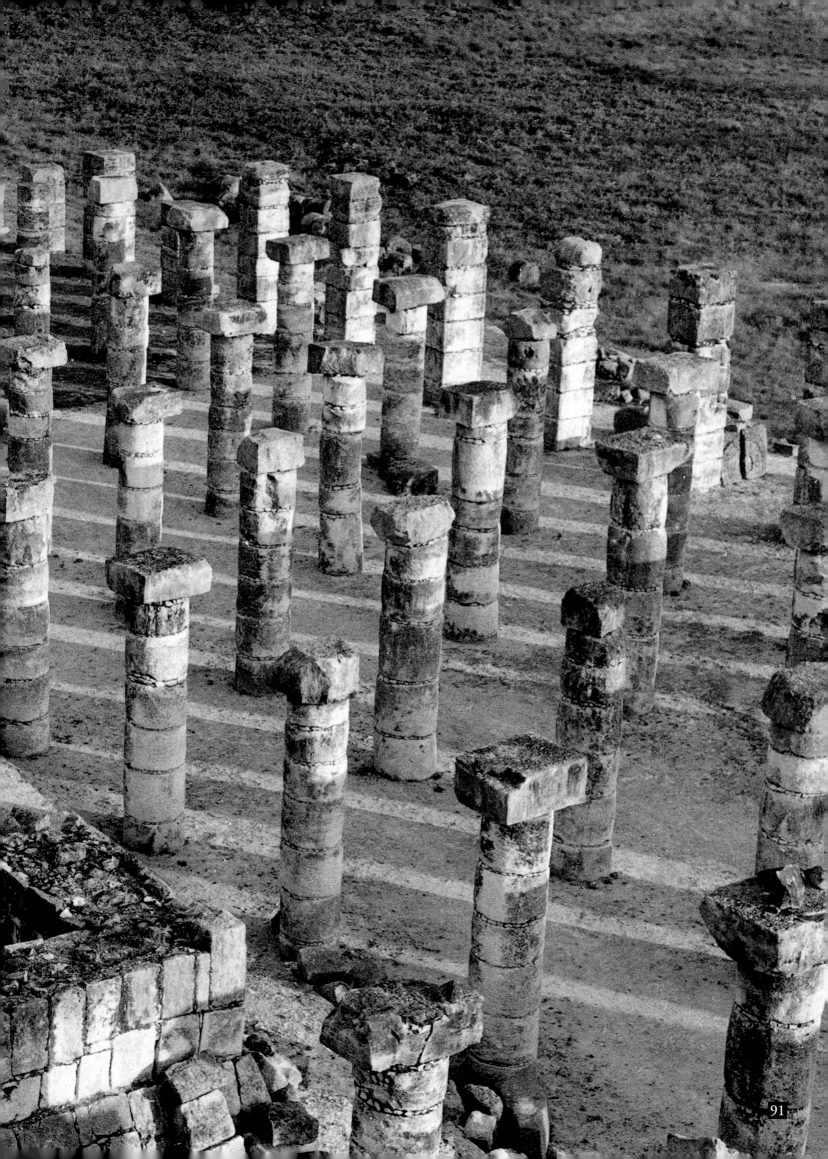

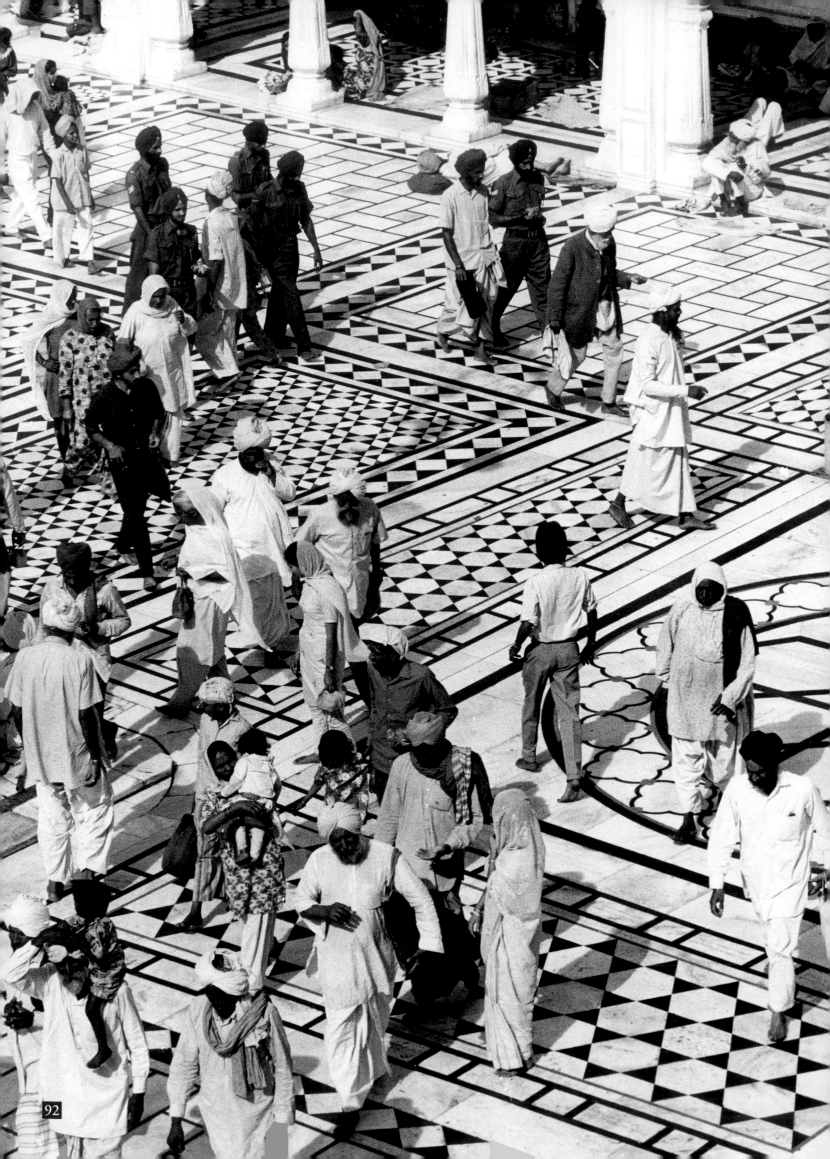

She was bursting with vitality. Her whole being seemed to vibrate with vigour and unstoppable energy. Immediately, she demanded that Roloff tell her *all* about his recent travels and adventures. She had an insatiable curiosity and her face and eyes – still bright and alive though she was in her eighties – would sparkle with pleasure as Roloff, an incomparable raconteur, would enchant her with colourful tales of intrigue and romance in the private quarters of the royal palaces of the Shah of Iran and his beautiful but lonely Queen, the Empress Farah Diba.

The weather was warm and sunny and Peggy gave instructions that lunch should be served in the garden, where her famous collection of modern sculpture was displayed to great advantage. I was seated directly beside Brancusi's lyrical *Bird in Space*. This was patio dining at its most sublime. A rumpled butler served fresh local fish, salad and a platter of fruit – accompanied by hearty Italian bread and a white wine. It remains in my memory as possibly the most memorable meal of my life.

The schedule of events planned in celebration of Roloff Beny's forthcoming book was daunting.

Festivities began with breakfast and continued through lunch. This was followed by late afternoon cocktail parties and climaxed with lavish dinners where spectacular displays of opulence were *de rigeur*. A large contingent of Texans were in town. Known as 'The Friends of Venice', they energetically went about their mission to 'save Venice' from the ravages of air and water pollution – concern for the damage caused by excessive waves of tourists would come much later. As all of them were enormously rich – much of their wealth from Texas oil – I imagined vast sums of money being donated for the admirable purpose of rescuing Venice from its impending fate. On the eighth day of official ceremonies (few could resist observing that seven days had been sufficient for the Lord to unveil his divine creation: heaven and earth) Roloff's book was to be majestically 'launched', as he had promised, in the venerable and stately Doge's Palace.

Roloff, resplendent in a velvet suit of many colours, was on the platform along with the Mayor of Venice and other important dignitaries. A spokeswoman for 'The Friends of Venice' marked the occasion by solemnly presenting a cheque to the Mayor for the 'restoration' of one of Venice's historic buildings. After the cheque had been presented and acknowledged, I leaned over and quietly asked Peggy, who had been seated in an ornately carved antique chair in the front row, 'How big do you think the cheque is?'

She cupped a tiny, sunburned hand over bright red lips – 'Three thousand dollars,' she whispered. Then added with a wry smile, 'if

90 *The architectural abstraction of the Jantar Mantar, a monumental astronomical observatory, built by Maharaja Jai Singh II in his new city of Jaipur founded in 1727, today the capital of the western Indian state of Rajasthan.*

91 *The symmetrical remains of a colonnaded hall at the ritual site of Chichen Itzá, in Yucatán, Mexico, built by the Toltec rulers in the tenth century* AD.

92 *Pilgrims cross the black-and-white marble courtyard of the Golden Temple in Amritsar, the holiest of Sikh* gurdwaras, *rebuilt in the eighteenth century.*

153

someone had passed a hat, and the 'Friends of Venice' had simply dropped the jewels they are wearing into it, we might save Venice overnight.'

On a sunny August afternoon, the colourful annual Regatta was to take place. Dozens of gaily decorated boats and gondolas slowly floated down the Grand Canal manned by hundreds of sailors in striped period costume. It was a splendid spectacle, climaxed by the historic ceremony of the Doge of Venice, magnificently attired, symbolically tossing a gold ring into the Adriatic as a reaffirmation of the ancient, mystical union which has for centuries existed between the Port of Venice and the Sea.

The finest view, of course, was from Peggy Guggenheim's palazzo, and she kindly invited Roloff and me to witness the spectacle from the vantage point of her terrace. Roloff was in high spirits, amusing himself and us by dressing one of Peggy's sculptures in a large summer hat and scarf. We were in a merry mood, snapping pictures of one another as well as the parade, when Peggy suddenly jumped to her feet in great agitation, yelling 'Quick! Quick! The nuns are coming. Someone unscrew his penis!' It took a couple of seconds for me to realize she was referring to the great erect bronze phallus flaunted by the life-size rider on the stunningly beautiful Marino Marini horse which held pride of place in the centre of the terrace. Roloff and I rushed to do her bidding, and, in spite of some playful tactics by the fun-loving Roloff, we managed to remove the rider's penis just as a covey of smiling nuns appeared in the open archways of the palazzo. Nodding graciously to Peggy and her guests, they stopped for a brief chat with Roloff, the Marini penis safely concealed in his jacket pocket, before sweeping down the corridor en route to the art galleries of the Guggenheim Museum which were open to the public on that afternoon.

Peggy hopped about the terrace in a state of childlike delight. 'I always take it off when the nuns come,' she explained mischievously. 'You never know,' she flashed a smile, 'it might upset them.'

'Or worse', Roloff added, rolling his eyes heavenward.

Work had been completed on the Italy book in 1971 and for once Roloff was at a loose end for a few months, so he did what he liked best – travelling! He had a commission from Time-Life Books to photograph the Indus Valley ruins of Harappa and Mohenjo-Daro in Pakistan and had decided to include side trips to India and Nepal as well.

His photographic archive was by now in great demand from international publishers, and Roloff regularly contributed to Time-Life, Tundra Books, Horizon, Cambridge University Press, Habitat and many others. As usual, his first stop was Canada House in New Delhi.

By 1971 the fall-out from the India scandal seemed to have settled, and I found the courage to set foot once again on the subcontinent.

Prime Minister Trudeau had just flashed through Delhi on a state visit, and as my old friend James George greeted me, he said with a twinkle in his eye, 'Well, Roloff, we purposely didn't have the cushions plumped up on the sofa where you're sitting since we knew you would choose exactly the place Trudeau warmed last evening. And, incidentally, the sofa you've chosen to rest your feet on is where your friend Mrs Gandhi sat. After the Aubrey Menen episode, I hope she's still speaking to you.' As a further stimulus to my romantic sense of occasion, he flicked on the tape recorder and I heard the *raga* played for Pierre Trudeau and Indira Gandhi by Ravi Shankar.

That evening a party was held in my honour, and a dance concert by the Georges' daughter, Dolphi, who was in the midst of studying Indian classical dance. A few days later we were invited to a reception by the President of India in the beautiful Mughal Gardens. Mrs Gandhi landed in a helicopter, having just returned from some distant state where she'd been campaigning at the most critical moment of her career, and made her entrance surrounded by hundreds of guests, including the press and the diplomatic corps. In the midst of the confusion, she spotted me, raised her hands in traditional greeting, and said, 'A most interesting book, Mr Beny . . . and what really beautiful pictures . . .' Her words gave me courage to face any challenge India could offer.

My first trip, a solo, was to Kathmandu, Nepal. The flight from Delhi on Royal Nepal Airlines took two hours. The flat plain of India gave way to the jungle of the Terai, Nepal's lowland, then to crumpled foothills, which scarcely prepared me for the sudden jagged circle of frosted peaks circling Kathmandu Valley. Looking down I could see separate little terraced worlds, interconnecting with shell-like grace, each enclosing a valley, cut across by the silver ribbon of the river.

My guide to Kathmandu was an English convert to Tibetan Buddhism, whose new name was Lodro-Thaye. Despite a streaming cold, bouts of diarrhoea and arthritis (I wore fur gloves all night to keep my fingers warm in bed), I set out to photograph as much of the beautiful filthy city as I could – including the fascinating villages around the valley, each one with its own special character.

One evening I decided to try an experiment. In those days hashish was legal in Nepal, and I'd found a bizarre printed leaflet advertising what purported to be a government-sponsored drugstore, an emporium licensed to deal in charas, bhang and opium. This turned out to be a tiny none-too-clean hole in the wall

in a sinister back alley, reeking of hashish, which was lying around in great black-green blocks. An amused clerk sold me a few crumbs and instructed me how to consume it. Feeling adventurous, I took it back to my hotel and lit up, then lay back wondering if anything would happen.

My room bloomed. All that night I wandered in endless kaleidoscopic fields of wild flowers and emotions. When I returned to earth the next morning, I felt so pleased with myself that I resolved never to indulge in hashish again. I realized the temptation of spending forever in the land of the lotus eaters, but like Ulysses I tore myself away and made it back to the ship . . .

During early February James and Carol George explored Pakistan with me. We travelled up to the rugged but beautiful little kingdom of Swat in Northwest Pakistan and were received at his miniature palace set in a forest of poplars by the Wali who covered us with fur coats against the rigours of winter. We tried to cross the Khyber Pass into Afghanistan, hoping to make it to Kabul, but were driven back by storms and snow.

As is often the case, some of the most interesting sights eluded the camera. In the Punjabi village of Pakpattan not far from Harappa in Pakistan, at the shrine of the mystic Shaikh Farid-ud-din Ganj-i-Shakar, I was refused permission to photograph the 'doors of paradise', a solid silver gate which is opened only once a year: whoever passes through is assured a place in heaven.

Being busy haggling with the guards, I also missed the swarms of pilgrims and the picturesque dervishes swirling around the shrine, and the children diving after the showers of white candy scattered as *baksheesh* by the cheerful custodians of the Sufi shrine. If only I'd been a Muslim . . .

'But I am a Muslim!' I protested.

'We thought you were a Buddhist,' whispered Carol.

'Like Alexander the Great, I worship all the local gods,' I answered. 'Wasn't this town founded by Alexander himself?' But the shrine officials were not convinced.

In early 1972 Roloff had been invited by the Indian government to prepare a book on Rajasthan which was also the subject of my own doctoral research. While in Delhi I had become friends of the George family and was delighted when Carol asked me to accompany her and Roloff on an exploratory trip through Rajasthan. We travelled together for one month while Roloff photographed the remarkable natural beauty, architecture and ritual life of one of the most magical parts of India. Carol contributed her usual gracious hospitality as well as much original research for the book which was, after numerous delays,

published shortly after Roloff's death in 1984. James and Carol George remained the closest of friends, opening many doors to both Roloff and myself over the years, and were keenly aware of what he was striving to achieve in his photography:

As Roloff became a part of our family, we helped him with his contacts with the local authorities. He helped us to learn not only the technique of taking photographs, but a deeper art – he taught us to see.

Yes, he understood that the art of seeing is as individual as the psychic lens through which it must take place in each of us, a lens that reflects the observer as inevitably as it reflects the observed. He had learned early on not to be bashful about the uniqueness of his own lens, his ability to see in his own way, independent of what any one else might think or say. And he had the innate mission of the artist, so well described by Rainer Maria Rilke, to pursue relentlessly the truth and the beauty within him in outer forms that met his rigorous standards of taste which would not yield to the dictates of any publisher or critic.

Others would accuse him of being self-serving – and he knew how to drive a shrewd bargain and reap the rewards of his labours. But the vision he served went beyond self. He saw a world of traditional arts and crafts, extending from Greece to Japan, disappearing before his eyes as he grew older, submerged by the floods of Western 'development' and tourism, war and revolution. He wanted future generations to be able to see that world of great beauty, and greater fragility, through his eyes, because tomorrow it might not be there to see and to honour. Indeed, that world has been disintegrating in the past twenty years far faster than either Roloff or we could have foreseen at the time he was recording its glories for posterity.

What wonderfully rich memories we shared in South and West Asia! Perhaps the most significant thing about these times is that so many of them were last times, last chances to bear witness to the beauty of people and traditional cultures. And if Roloff's romanticism led him to 'improve' a sunset or two with golden gelatin filters, we can nevertheless be grateful that we were with him to experience directly the splendour of the living original before it set. Without him we might never have learned how to look, which is at least a step towards seeing.

PERSIA: BRIDGE OF TURQUOISE

By the end of 1972 Roloff had completed work on the Italy book and dispatched all the photographs and texts to the printers. He was now faced with a dilemma. How could he equal the magnificence of his latest book? Where could he go next? After some deliberation, he decided to visit Iran. After all, James George had just been posted to Tehran as Canadian ambassador, and, by combining his diplomatic expertise with Roloff's earlier contacts in Iran, surely something could materialize in the land of the Peacock Throne. It seemed a chance worth taking.

I had recently joined the Tiber Terrace team as a researcher and archivist and accompanied Roloff on the first of our many trips to Iran. We stopped on the way for a ten-day photographic tour of Israel as the guest of Ayala Zacks, a friend of Roloff's and an important Canadian art collector, who lived part of the year in Tel Aviv. We reached Tehran in late January and received the traditional warm welcome of the Georges at Canada House, and as usual, Roloff's instincts were flawless.

James and Carol were just moving in when Mitchell and I arrived during a snowstorm. All the treasures from Aurangzeb Road in Delhi had been transferred to the diplomatic residence in Shemiran, in the quiet foothills in north Tehran. And not surprisingly there was a plot afoot: a Beny book on Iran.

My fascination with Iran began about ten years earlier when I travelled through Tehran, working on *Pleasure of Ruins*. I had been caught in a revolt and had photographed the Shah and his Queen. In October 1967 I had been invited to the Imperial Coronation. The Shah, happily married and with an heir, his White Revolution a *fait accompli*, and the oil flowing in his land, had decided to crown himself and his Queen. I found myself inside the Golestan Palace and felt I was drowning in a sea of diamonds.

Overwhelmed, I lurked behind potted palms. The visual feast was staggering – emeralds and rubies strewn about – medal-bespangled dignitaries, priceless carpets spread out in the streets for the Imperial feet to tread upon, gilded coaches drawn by turquoise-studded horses, chandelier-lit dinners with pots of Caspian caviar – crowns dripping with Aladdin's diamonds and the Peacock Throne.

I think I realized even then that I was being given a unique opportunity to become part of that strange world of power and beauty. Everything I'd ever dreamed of was there, in such profusion it took my breath away.

Within a few days of our arrival James had arranged a meeting with Cyrus Farzaneh, director of the Iran National Tourist Organization

(INTO), who seemed enthusiastic to commission a Beny book on Iran. We toured several historic cities in central Iran photographing and researching as the guests of INTO, and preliminary discussions were held on possible authors for the book. Roloff, now convinced that a major book on Iran was indeed within his grasp, flew back to Rome to plan his strategy.

For several years Roloff had been vexed with Thames and Hudson over royalty disputes and other problems and, following months of complicated negotiations guided by Michael Shaw, Roloff's skilful and resourceful literary agent with the firm of Curtis Brown in London, he was released from his contract with Thames and Hudson and could now choose any publisher he wanted to originate future books. Legitimate issues appeared to be at stake, but in a characteristically ungrateful gesture, Roloff chose not to recognize the not inconsiderable debt he owed to Thames and Hudson. He ignored as well the degree to which his increasing demands for ever more luxurious books and his disruptive and frequent visits to the publisher and printer contributed to the overall cost of producing a Beny book, an element which had to be built into all contracts.

That spring Roloff flew to Toronto to meet with Jack McClelland, his Canadian publisher, who agreed that McClelland and Stewart would originate the Persia book if Roloff could secure a solid commitment from the government.

Armed with support from Jack and a portfolio of his latest photographs from the winter trip, Roloff returned to Iran and, in his usual fashion, went straight to the top, securing an audience with the Shahbanou to try and convince her that only he could do the ultimate book on her country. And he did.

> My next trip to Iran was in September [1973]. That spring I had been stunned by being the first photographer awarded the Order of Canada. I was peacock-proud, and now if I were to be invited to a party by the Shah, I'd have something to pin on my lapel just like everyone else in Persia! We were joined by Lesley Blanch (formerly Romain Gary's wife), author of that favourite of fireside (or rather bedside) travellers, *The Wilder Shores of Love*, the story of five Western women who succumbed to the romantic lure of the East.
>
> She arrived from Paris in a cloud of jasmine perfume, bearing trunks of frocks and caftans with belts of amethyst and gold and glittering bangles of Balkan crystal (like me, her hotel rooms are invariably turned into an Eastern bazaar) . . .'My dear, I never make the mistake of travelling too light . . . I need my special comforts . . .' Lesley and I had a commission, from Beatrix Miller of *Vogue*, to interview the Shahbanou.

The audience lasted two and a half hours, and I realized then that I had found a strong and sensitive ally in my struggle to produce a book on Persia. 'If you could do something like this on our country . . .' she said, producing my Canada book and *Pleasure of Ruins* from her library. We found ourselves kneeling on the rug, sipping drinks and pushing portfolios and photographs around, exploring the smallest details of design. It was the beginning of a friendship and a dream which would consume the next five years of my life. I felt like that character in the *Arabian Nights* whose caravan had finally arrived: Iran was my pomegranate to open and extract its hidden garnets.

A few days later, near the Caspian Sea as guests of Ali and Leila Sardar-Afkhami, who were to be among my closest Persian friends, our fortunes were told. Ali took the *Diwan*, the collected poems of Hafiz, and let it fall open at random. 'Follow the Path, no matter how difficult.' The same day my horoscope read 'everything will resolve itself without effort'. The Persian poet and the stars turned out to be correct. Jack McClelland, who had been drawn into the Persian adventure, was summoned from Toronto. Whether he knew it or not, he was signing on not only as publisher but as guardian angel as well.

Encouraged by Roloff's initial meeting with the Shahbanou, Jack McClelland agreed to journey to Tehran, recalling years later his initial reluctance and irritation with Roloff's frantic telegram declaring 'Her Imperial Majesty *commands* you to meet in Tehran to discuss the book'. Jack's working premise to the Iranian bureaucracy was simple: 'Roloff Beny is one of the world's leading photographers and he isn't going to be cheap . . . The one thing I have been able to do for Roloff is to help him make money out of his books. I have, in a broad sense, been his manager. We have made the international community realize that if they want his work, they have to pay him properly.'

After days of Byzantine negotiations with the Deputy Minister for Tourism, the contract was finally agreed. Roloff would receive a fee of $25,000 to do the photography, unlimited first-class travel on Iran Air between Italy and Iran, and within the country Roloff and I would be guests of the government wherever we wanted to go. Generous subsidies were also given to ensure the high quality of the book, and various government ministries and agencies guaranteed to buy more than twenty thousand copies of the book to present as state gifts and distribute to libraries and cultural institutions at home and embassies abroad.

Roloff established 'base camp' at the Intercontinental Hotel in Tehran and set about finding an author for the book and making local friends. Iran became home for the next five years.

160

ARCHITECTURE

93 *The glazed turquoise dome of the Imamzadeh Yahya shrine at Semnan in central Iran rises above the crumbling mud-brick walls of nearby buildings.*

94 *Nature and architecture merge at the magnificent tiled tomb and Sufi sanctuary of the thirteenth-century mystic Shaykh Abd al-Samad Esfahani in the mountain town of Natanz, Iran.*

95 *The tiled geometric splendour of the Isfahan Friday Mosque in Iran, one of the world's greatest mosques, whose foundations date back to the twelfth century, was added more than five hundred years later.*

96 *The huge wooden image of a Nio, Kongo-Rikishi, the Buddhist guardian figure, dwarfs the pilgrim visitors to the Todaiji Temple at Nara, Japan.*

97 *Calligraphy and architecture meet in the great* torii *gateway at Miyajima constructed in 1875, centuries later than the nearby ninth-century Itsukushima Shinto shrine.*

98 *The superb elliptical cupola flooded by light from concealed windows inside the church of S. Carlo alle Quattro Fontane in Rome was completed by Borromini in 1667.*

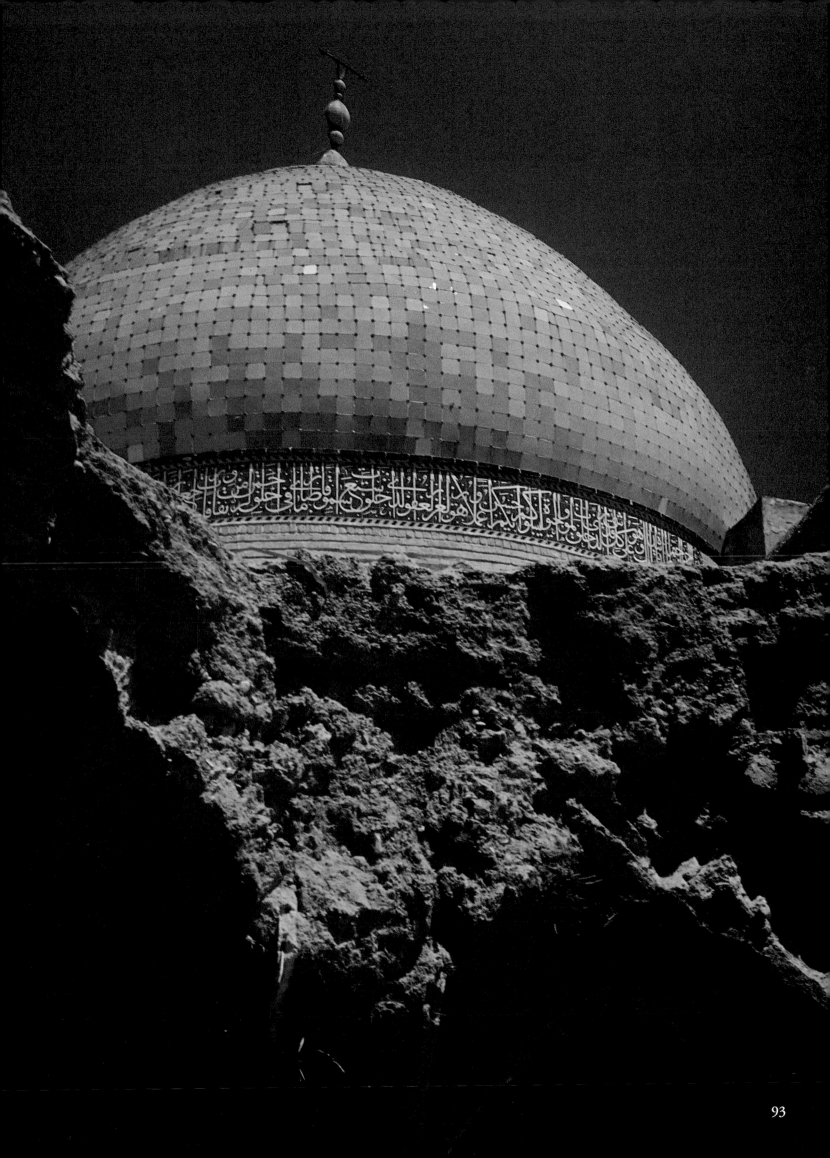

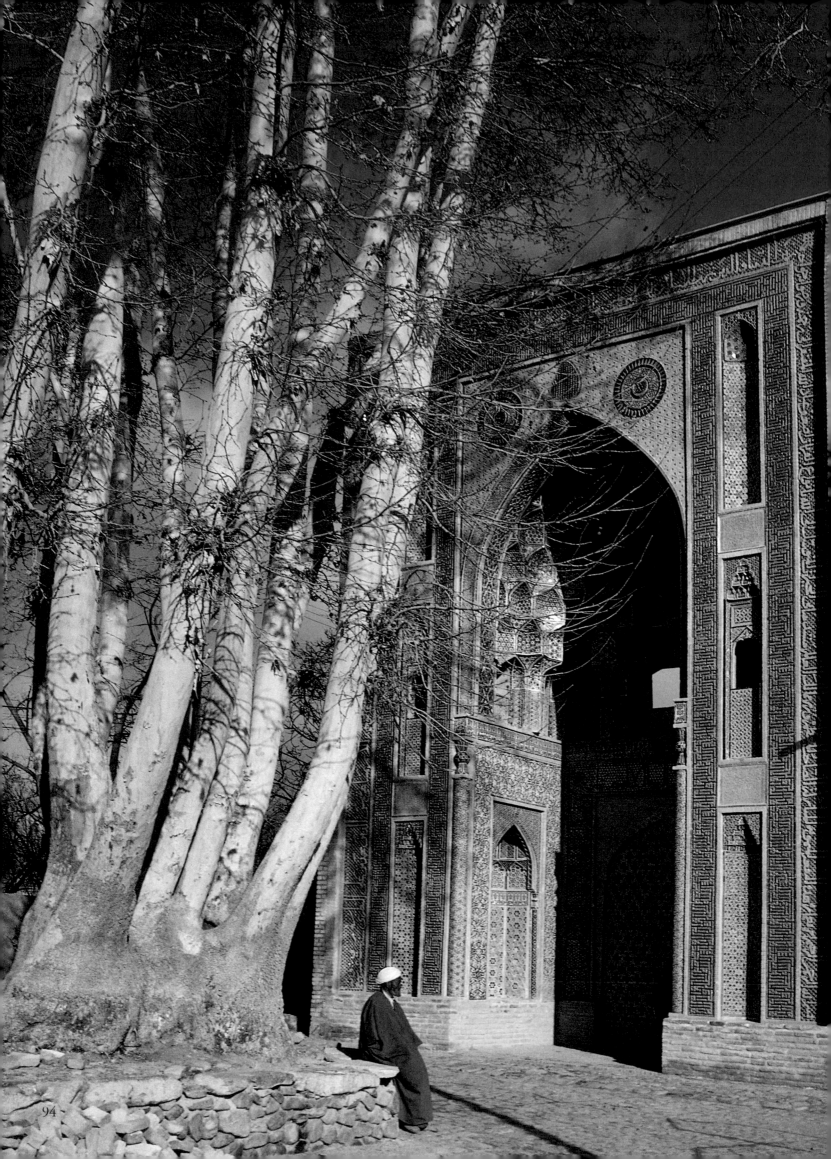

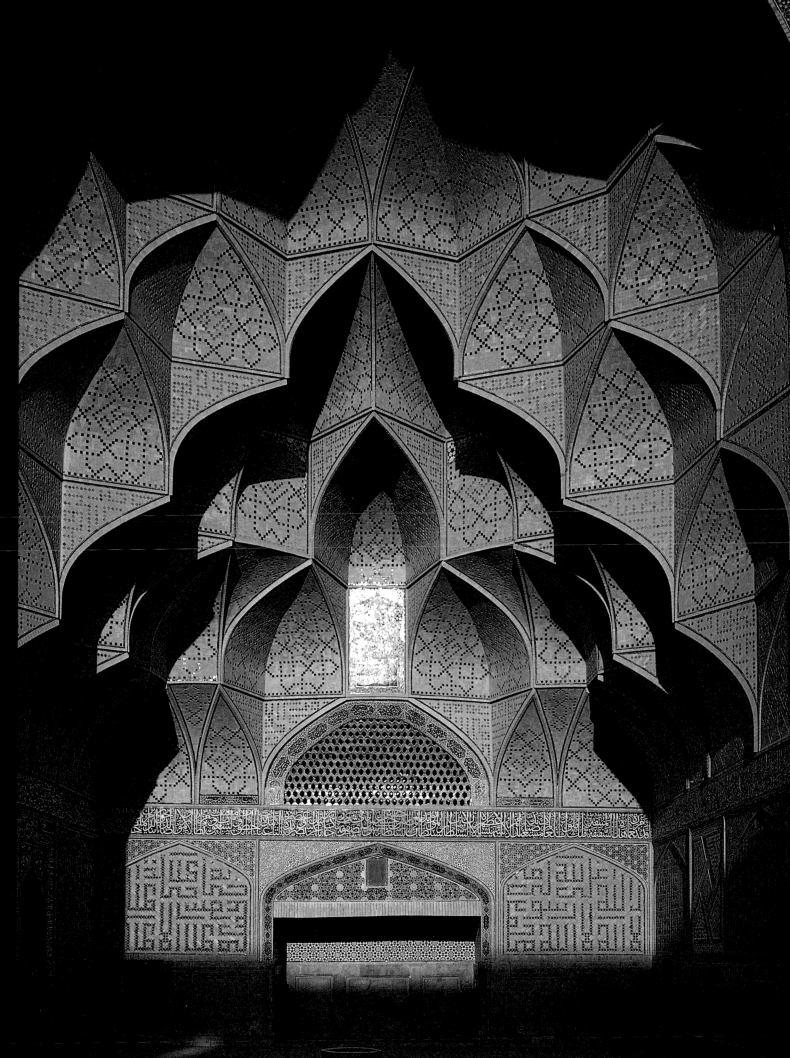

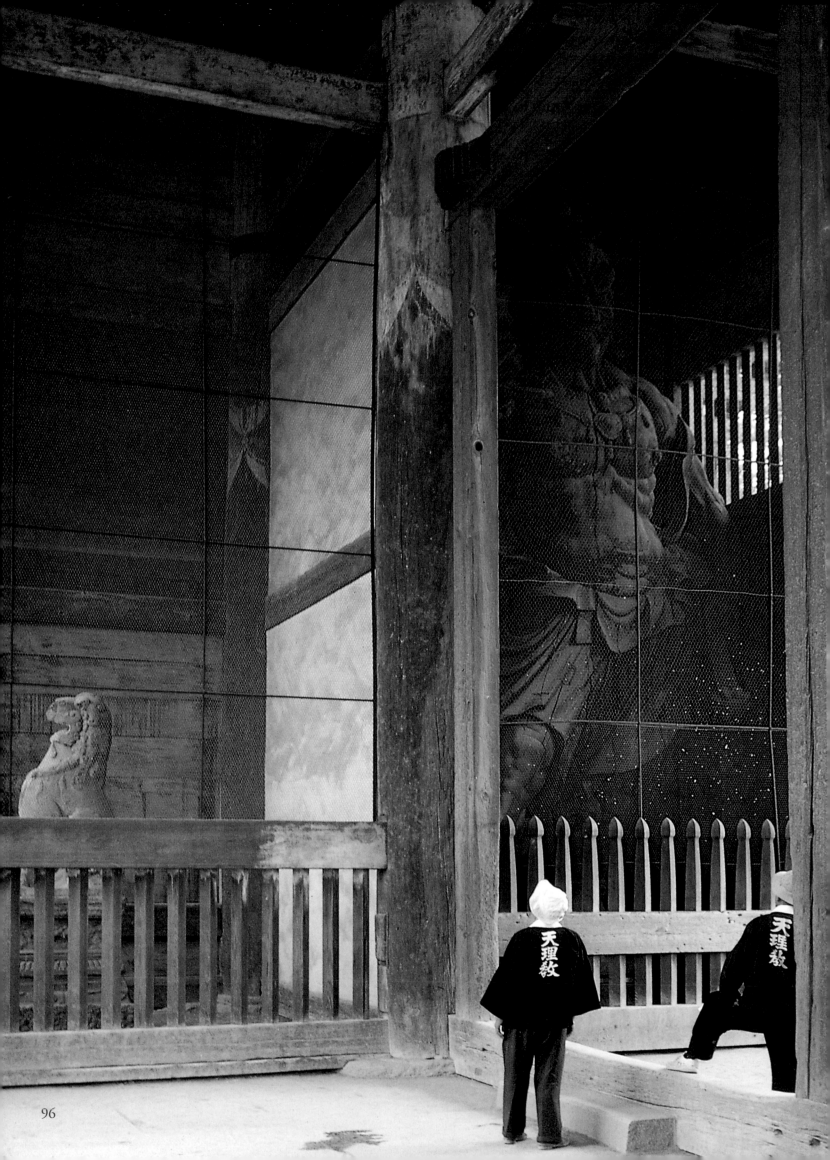

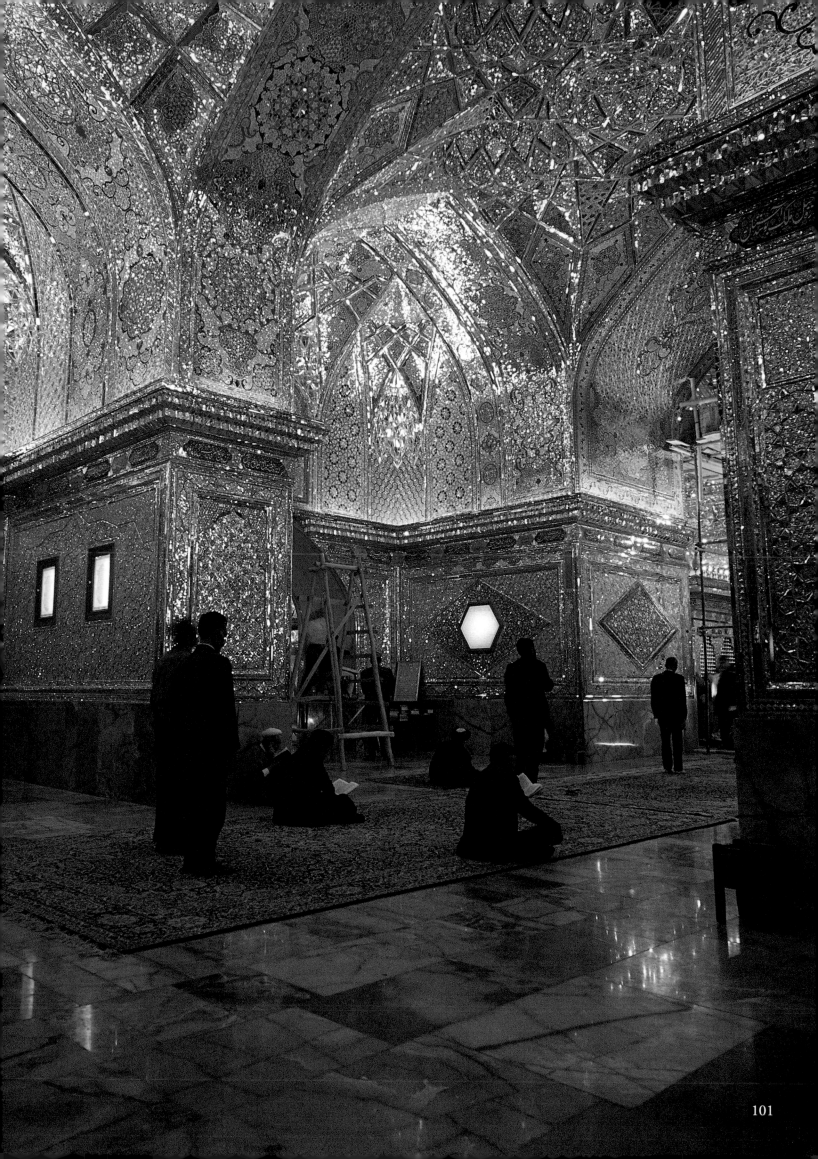

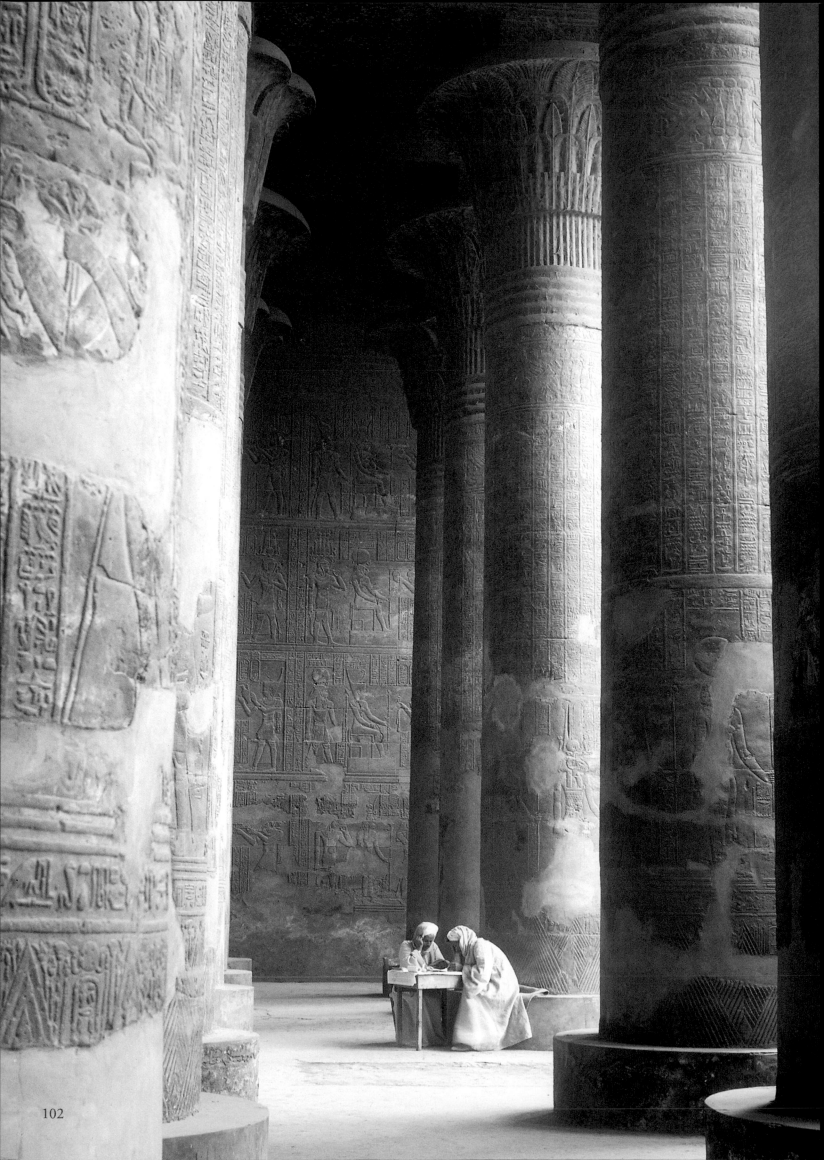

The 'Intercon' was to become my permanent headquarters in Tehran. After much negotiating, string-pulling and budget-juggling, I was able to acquire a suite of two rooms that was held open for me at all times, where I could allow my luggage to explode and not have to worry about packing it each time I left town. I soon came to look on the Intercon as a home, and to feel a real affection for it.

Now James George was contacting the *crème de la crème* of local mystics, and sped me off in his Land Rover to Tehran University to attend a lecture by Seyyed Hossein Nasr. Educated at Harvard and MIT, Nasr struck me as an ideal link between his country's past and present, and his lecture, given spontaneously, was brilliant. I asked James to invite him to dinner, and began to pry open his mind on the subject of a 'coffee-table book' on Iran. Would he consider such an endeavour? Nasr seemed well aware of his position, and of his ever greater future role. He was grand and going to be grander, but seemed quite taken with the idea of collaboration. Peter Wilson, a gifted poet and mystic traveller, with the able assistance of Nasrollah Pourjavady, was chosen to 'transcreate' the Persian poetry and prose selections which would accompany the text.

By January 1974 Roloff and I were out on the road. It took four years to complete the photography for the two books on Iran which Roloff ultimately created. We flew fifty times between Iran and Rome, and within the country our faithful driver 'Chunky' Hossein Yavari steered us in his jeep station wagon across 500,000 miles of desert, forest and mountain. Tens of thousands more were traversed by bus, plane and helicopter. Roloff photographed every major town, hundreds of remote villages and virtually all significant historical and archaeological sites from the Persian Gulf to the Caspian Sea. He was happiest out on the road photographing and relished the ritual midday picnics and simple hospitality of the village as much as the splendour of the Imperial Court.

For me, an itinerant archaeologist, it was exhilarating. I researched and planned each trip and, armed with letters of introduction bristling with imperial seals from the palace, every door opened. We saw architectural and artistic treasures that had remained sealed for hundreds of years. For Roloff, it was his destiny, had it not been 'written on his forehead' as they say in Persian? All the roads he had travelled, all his visual journeys, had finally led him here and he would at last create the book of his dreams. He had found his ultimate patron in the Shahbanou, a benefactress of Medicean proportion, who deeply admired his work and was determined to remove as many obstacles from his path as possible. She met with Roloff weekly and took a keen interest in every aspect of the book's development, contributing suggestions and introductions to sites, projects and people we should meet and visit.

99 *The majestic central dome of St Peter's in Rome, the mother church of Christendom, suspended above the twisted bronze columns of Bernini's masterpiece, his* baldacchino *constructed between 1624 and 1633 over the high altar and the tomb of the Prince of the Apostles.*

100 *Mirrored banquet table, nearly thirty feet long, in the Palazzo Carrega-Cataldi in Genoa, with its lavish gilded stucco decoration.*

101 *Craftsmen in Shiraz, Iran, embellish the central chamber of the shrine of Sayyed Amir Ahmad, known as Shah Cheragh or the King of Light, inlaying thousands of pieces of cut mirror.*

102 *Two ticket takers bent over the day's receipts in the temple of Khnum at Esna, Egypt. Begun in Ptolemaic times, the building was continued by the Romans and bears the names of many emperors, including Claudius and Vespasian.*

103 *The grandeur of rows of papyrus-bud columns illuminated at night within the hypostyle hall of Amenophis III at Luxor, Egypt, early fourteenth century* BC.

104 *The Sanctuary of the Addolorata of Castelpetroso, in the Italian province of Campobasso, a large nineteenth-century sanctuary and hospice built in the French-Gothic revival style and surrounded by dense woodland.*

Roloff was a consummate storyteller, a born weaver of legends and tales, and I remember how he would enthral friends, family and guests back home in Rome or Canada with his Persian adventures and life with the Pahlavis:

Christmas 1973, I found myself at the Imperial ski resort high in the Elburz Mountains above Tehran. The Shah and Shahbanou had adopted me, and I was rapidly becoming something of the Court jester:

'Hold it please, Your Majesty. Let me just get one more shot of you there . . . just as you're about to zoom off down the slope. Ah, wait a second, I can't get all of you in against the snow . . . just let me step back a bit . . .'

'Dr Beny, do be careful. There's a cliff behind you. We don't want to lose you.'

'Don't worry, Your Majesty, where I come from in Medicine Hat . . . Oops . . .'

Here I was, falling over a cliff again, with no jungle vine to catch me this time. Rather exhilarating, bouncing off clumps of snow in my muskrat coat, shooting up big bursts of crystal.

From far above, the Shahbanou cried, 'My God, is that *blood*? Is he alive?'

The bodyguard had saved me by criss-crossing his skis over my body and pinning me to the ice with his spiked aluminium ski poles. One of these had slashed my trousers, and my leg was red from boot to thigh. 'It's just my long johns,' I whined. 'But my Hasselblad. It's crushed!'

In the Imperial lodge the Shahbanou broke out into irrepressible laughter. The Shah popped in, grinned and sighed.

Next day a package arrived at the hotel, wrapped in turquoise paper with the Imperial seal. Inside was a new Hasselblad and a note from Her Majesty: 'For inventing a new way of going down our ski slopes!'

Between Kazerun and Bushehr on the Persian Gulf it had been raining steadily for ten days, and it seemed as if the entire Zagros mountain range had melted into a vast morass of mud, and we cascaded into the valley. On the edge of a flooded river, several transcontinental trucks and cars were lined up, their drivers standing under the sheets of rain, staring at the excremental holocaust. One of the truckers offered to rope our jeep to his fender and tow us across.

'Well, Mitchell, you take the box of film and if I don't make it, you can finish the book. Do you want to ride in the truck or jeep?' We had nicknamed our driver Hossein Yavari 'Chunky' because he

was solid and sensible. Now he was hysterical, so Mitchell stayed with him in the jeep, while I clambered with my cameras into the truck with its crew of half-naked mudmen. As we set out, I looked at Mitchell, who had followed orders and now appeared to be a living caryatid, balancing the film box on his head – literally up to his neck in mud! In mid-stream the jeep ahead of us turned over and disappeared. The driver's body was never recovered, but somehow we survived . . .

At Chahbahar on the Persian Gulf coast – where Alexander the Great lost much of his army to heat and dysentery, I reached a stage of exhaustion. There I was on the beach, feeling dizzy – perhaps from the curried lobster eaten the night before – waiting in the blinding sun to catch a perfect image of waves crashing on rock . . . crash . . . crash . . . crash . . . I finally slipped and fell on the sharp barnacles and coral, opening a gash in my right hand. Mitchell disinfected and bandaged it, but as I became increasingly ill, we were forced to return to the inn.

In my travels, I have become accustomed to all types of accommodations, but what we found at Chahbahar was beyond expectation. During the night I came to know the 'plumbing system'. Each time I approached this hole in the floor, a crew of vicious-looking rats greeted me. Soon they mounted a counterattack, creeping into my room and knocking things over. A glass shattered. I hurled a coke bottle into the dark. The battle continued till five, at which point I passed out. Later I found they'd eaten my toothpaste and vitamin pills. With such nourishment, they would probably mutate into super rats. Informed of my condition by the Governor, Prime Minister Hoveyda sent his personal plane to whisk us back to Tehran.

I was sufficiently recovered the next day to attend the annual Nau Ruz Salaam celebrating the Persian New Year at Golestan Palace. The red carpets were spread out, the crystal and mirrors sparkled, senators and generals decorated with medals and gold braid waited to bow to Their Imperial Majesties and be given a Pahlavi coin, the traditional New Year gift.

The procession continued all day, and the Shah and Shahbanou retired to a private salon to rest between shifts of dignitaries. His Majesty fell on a red damask settee. The Empress, in a diamond tiara, glided to the windows overlooking the park where the palace band played martial tunes in full brass. She stood, a silhouette slender and vulnerable, peering through the parted curtains. I wondered if she wouldn't rather escape this gilded cage. As the Empress returned to her duties, she called out, 'See you in Kish'.

The next morning I was in the plane with the Imperial Family, as the Shah piloted us towards the hideaway vacation island they were completing in the Persian Gulf. After my rugged adventures of the past months, Kish was paradise. I wandered in the woods and made notes in my diary, 'Met Martha on a bicycle'. Mitchell and I had decided that for security reasons we needed a code name for the Shah and Shahbanou, and we came up with 'George and Martha', the father and mother of their country.

'Slept until 9 – what a luxury. Swimming with Their Majesties. Then cocktails and dinner – caviar, grilled prawns, filet mignon, swans baked with ice cream and mangoes inside. After returned in minibus with Her Majesty, who gave us a guided tour of Kish by night and sang many French-Canadian songs. Potent drinks with brandy and egg and forced to dance with the ADC to His Majesty.

'Next day. Martha sent for me to photograph the sunset from the balcony of her bedroom. As the sun slips into the Persian Gulf, the new moon appears and Martha reminds me that the Persians say you must look at someone who will bring you good luck. Without hesitation, I look at her! His Majesty agrees to pose with his crystal horse in his office before I leave. Court Minister Alam gives me two kilos of caviar . . .'

Roloff was at his best and his worst. Inspired by the Shahbanou and her personal interest in the book he was taking some of his finest photographs in years. Abandoning for the moment an earlier predilection for net and tinted gelatin filters to 'jazz up' the image, his colour photography was delicate and restrained, and the black-and-white pictures, especially those that explored the geometric splendour of Persian architecture – 'frozen ether', to use a mystical metaphor that Roloff enjoyed – were magnificent. He also loved the bustling bazaars and village life, and some of his most sensitive photographs of people and ritual life are from Iran.

On the other hand, imperial patronage had made him arrogant and demanding, and we made enemies everywhere. Through friends and connections at the Court, Roloff was able to humiliate and infuriate the lower echelons of power by going directly to the Shahbanou, a tactic he was quick to discover and exploit.

On one occasion Roloff desperately wanted a helicopter to fly over Dez Dam in the southwestern province of Khuzestan. The Ministry of Information and the Iranian Air Force finally ran out of patience. They ganged up on him and blocked the request. Roloff always remembered, seldom forgave and never gave up.

ISLAM

105 *The robed figure of the imam stands at the wooden door of a small mosque in Kairouan, Tunisia.*

106–107 *Two views of the interior of the Great Mosque at Kairouan, Tunisia, the key monument of Aghlabid architecture and one of the most important mosques in the Islamic world, originally constructed in the ninth century AD. The imam is seen counting his prayer beads sheltered by the great* mihrab *or central prayer niche, and climbing the carved wooden* minbar *pulpit from where the traditional sermon is delivered.*

108–109 *Views of the outer walls of the Great Mosque at Kairouan, Tunisia.*

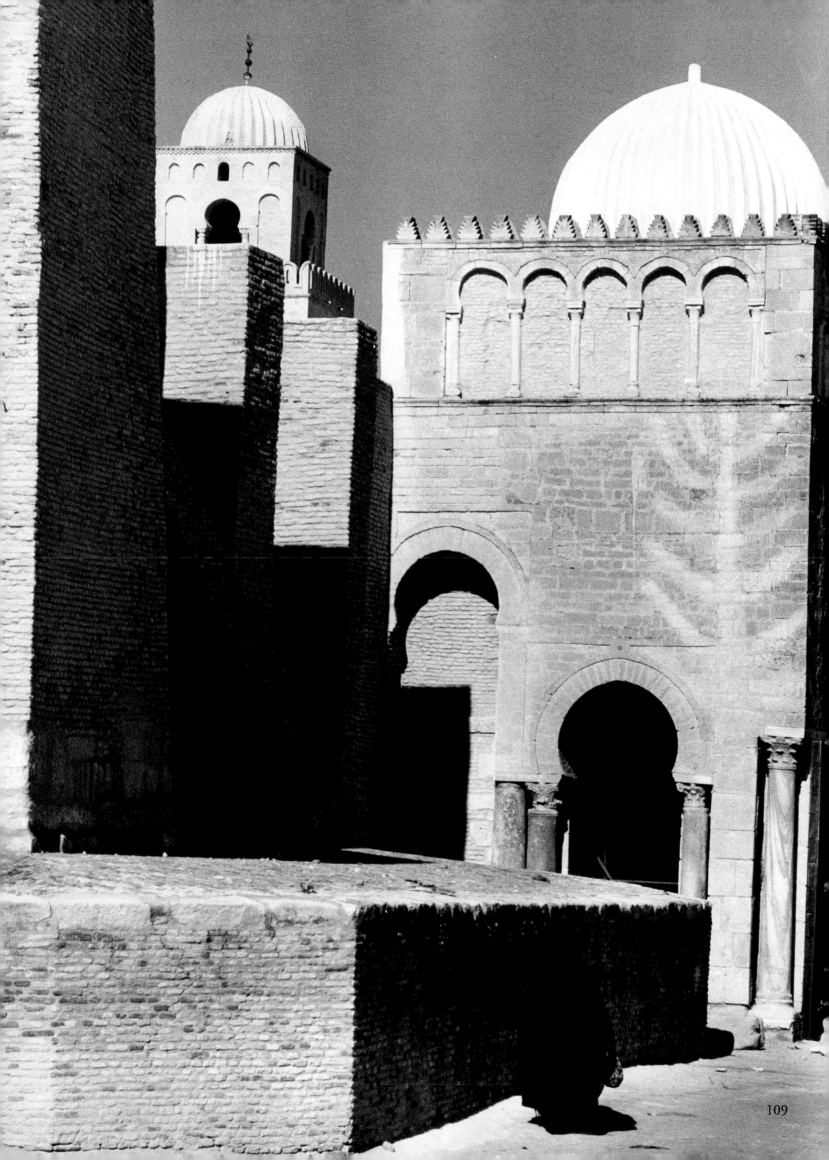

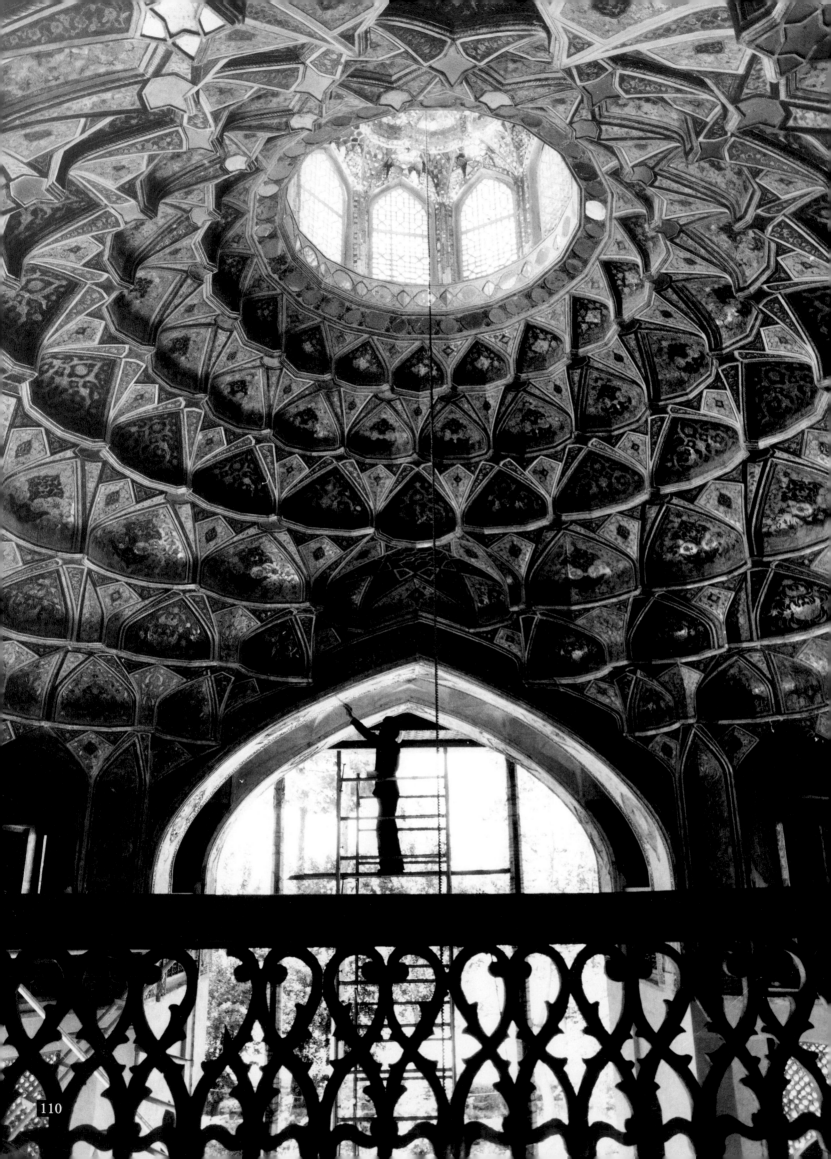

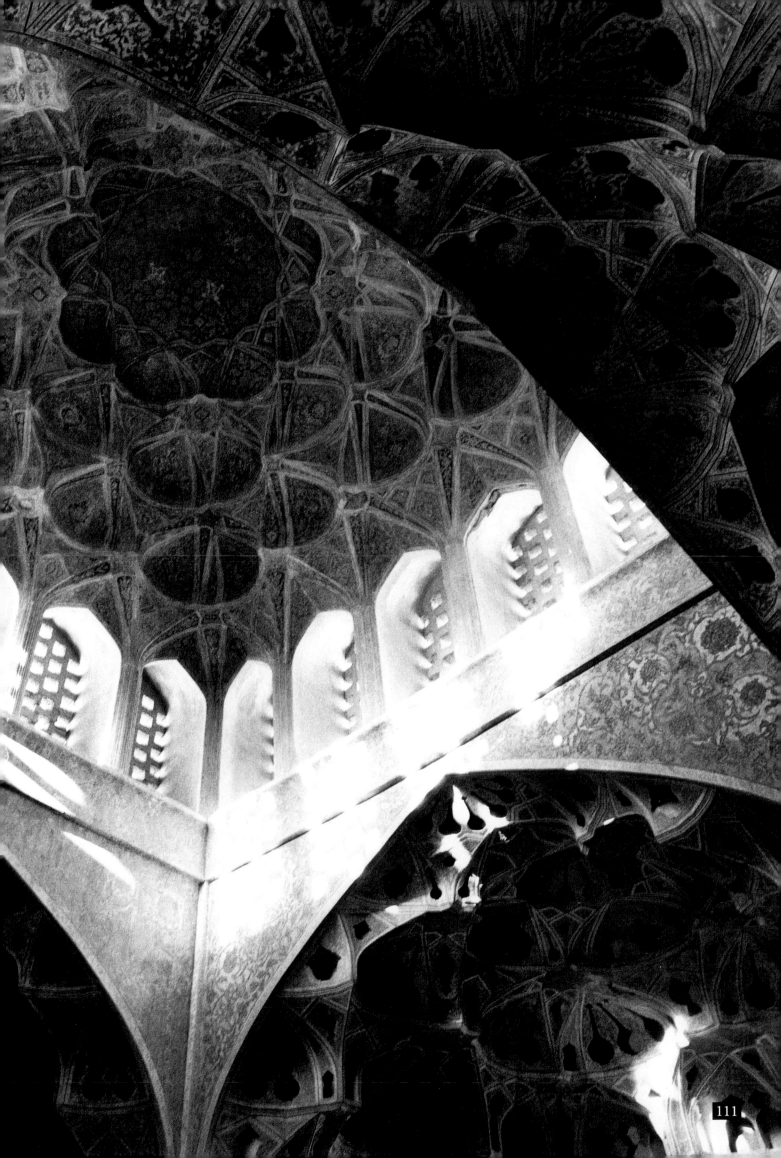

110 *A young craftsman lovingly restores the delicate stucco and mirror decoration inside the dome of the Hasht Behesht, the Palace of Eight Paradises, built by Shah Soleyman in about 1670, situated in one of the loveliest and most tranquil gardens in Isfahan, Iran, the historical capital of the Safavid Dynasty.*

111 *The play of light and shadow inside the carved wood and stucco ceiling of the Ali Qapu Palace, constructed in the early seventeenth century by Shah Abbas I as a royal reception hall in his capital city of Isfahan.*

112 *The drama of contemporary dance and traditional architectural space:*
'John Butler, the dancer-choreographer always turned up at the right place at the right time with the right dance – New York, Athens, Spoleto, Rome. He is totally photogenic and fell in love with my camera. Perhaps my best-known shot of him was taken in an abandoned church in Spoleto where he posed with a tatty workman's curtain turning it into magic, and this photograph was later used as the poster for the 1964 Festival of The Two Worlds.'

A few weeks later during the annual Shiraz Arts Festival, the Shahbanou had invited us to an enchanted evening of Persian music and dance in the eighteenth-century Bagh-e-Eram gardens. It was well past midnight and all the guests had gone, leaving only Roloff and me, the Shahbanou's mother and the ever-present guards. I kept telling him it was time for us to go as well. He was sitting beside the Shahbanou and suddenly, to my total amazement, put his head on her lap and started sobbing. She gently stroked his hair and inquired what the problem was; hadn't every door been opened? Roloff replied, 'I want my helicopter'. Slightly bemused, she told him not to worry.

The next morning the helicopter had indeed been arranged and we took off. I was terrified. I told him helicopters crashed easily and everybody hated us. 'Nonsense,' he huffed. Hovering over the great dam, Roloff suddenly proclaimed, 'Tell the pilot to turn the water on!' I told him he was mad. 'Her Majesty said I could have anything I wanted.' Incredulous, I translated the demand into Persian; five minutes passed. Then it came – an aquatic avalanche and clouds of shimmering foam ascending from the parched desert below. I never dared ask how many villages we flooded. Triumphant at last, Roloff returned to Tehran and the first person he called was the Minister of Information to tell him about his 'special snaps', which did little to reduce the constant tension around us.

In 1991 I interviewed the Shahbanou in Paris about Roloff and the books on which they had worked so closely. When questioned about the criticism she received for giving him so much attention and the very considerable cost of the books, she observed how much his wit and charm were missed and then went straight to the point:

Dr Beny was a true artist. Of course, he was very moody and could be difficult, but he always saw the light over the hill. He was obsessed by his work. Everything had to be perfect – the coloured paper, the calligraphy we commissioned and the printing of the images. He suffered, sweated and felt every picture in his soul. He wouldn't rest until everything was perfect.

I knew the books would be expensive but in the end they embodied, like no other publication, the beauty of our past, the realities of that present and the dreams we had for the future . . . He captured it all.

After nearly two years of photography, Roloff painstakingly prepared an elaborate series of layouts for the book in the Tiber Terrace studio working with Trisha Mitchell, a gifted graphic designer from London, and, of course, Franco Bugionovi who once again created the luminous black-and-white prints. The various dummies, swaddled tenderly in

'Delhi velvet' like newborn babes, were transported many times from Rome to Tehran where Roloff and the Shahbanou made final adjustments and refinements to the book.

At last, everything was approved, and Roloff flew to Toronto to turn over the final layout of the Persia book to the art and editorial staff at McClelland and Stewart. *Persia: Bridge of Turquoise* was the most complex photographic book that McClelland and Stewart had ever put together and they were determined to equal his earlier achievements. Stunned at first by the tantrums and scenes that had become second nature to Thames and Hudson, the staff gradually grew closer to Roloff and came to admire his technical expertise and eccentricities as well as his devotion to quality.

Peter Scaggs, in charge of production, recalled how impressed he was with Roloff's knowledge of colour separation and printing:

> Other photographers knew what a good photograph was but couldn't sense the final result. Roloff could visualize how each image would appear on the page. Of course, he was maddeningly expensive and always wrecked all my costings. He was forever demanding new decorative elements stamped in gold or silver (we dreaded the day he would discover platinum) but by and large he got his way, either by wearing us down or by saying Her Majesty wants it like this.

The art director, David Shaw, liked Roloff's off-beat, less structured approach to his work and recalled his amazing attention to detail and his way-out appearance, a 'rhythm and blues' look far more radical than he actually was. Lily Miller, who supervised editorial aspects of the book, was amazingly patient and supportive even when Roloff called her from Toronto Airport to clear his excess luggage. 'I'm his editor and now I'm supposed to edit his luggage as well!' Behind them all stood Jack McClelland who somehow managed to weave together the myriad threads of ego and art, budget and bureaucracy stretching from Toronto to Tehran.

Persia: Bridge of Turquoise at long last rolled off the presses and Roloff wrote to me in Delhi on 4 July 1975:

> The Persian baby was born yesterday . . . Trisha suitably enough was the first one to view the child. It arrived at 7.30 a.m. and I opened it in bed with Nerona [Roloff's black poodle]. Truly Mitchell, I found it so compellingly different and even beyond our expectations because of the harmony of every element . . . well, I felt that very rare sensation that one experiences when falling totally in love . . . it's a sort of spiritual ecstasy mixed with a breathlessness in the diaphragm, and the final test was that I felt elated all that day, for the next three days, and still do . . . !

Persia: Bridge of Turquoise appeared in seven foreign co-editions, including translations into French, German and Italian and ultimately a Persian-language version commissioned by the Shahbanou. The total print-run of more than 75,000 was one of the largest of its time for a luxury photographic book. Specially signed and bound volumes were also commissioned for the Shahbanou and Imperial Court.

It was a beautiful and splendid book which gracefully captured the timeless beauty of Persia, unveiling for the first time a number of architectural and artistic masterpieces, and was in addition a major event in Persian literature, with its newly translated anthology of prose and poetry specially selected to complement the photographs.

Bridge of Turquoise received the Charles Blanc Medallion from the Académie Française and a special award for excellence from the Stuttgart Book-Week. The *Architectural Digest* was typical in its praise:

> One of the most sumptuous and lavishly designed books to come out in recent years about Persia . . . Beny is an old hand at visual *bel canto* . . . his pictures cannot be explained; they must be experienced. In them one finds more of an atmosphere of the land and its people than one does by reading or travelling there . . .
>
> He uses the camera much as the great nineteenth-century photographic landscape pioneers used it – with a wondrous joy in recording the very existence of people, places and scenes far from our experience . . . Although much more than a coffee-table item, this book also deserves comment as a beautiful piece of bookmaking . . . a lovely exercise in elegant and aristocratic presentation.

Canadian journalists, habitually more critical about Roloff and his books than their European or American colleagues, attacked with a series of stinging articles accusing him of being a propagandist for the Pahlavi Dynasty. They, of course, had a valid point of view, but Roloff, who could be maddeningly myopic where his patrons were concerned, was furious. He had grown accustomed to his life style being questioned but now it was his ethics and morality as well. 'Roloff Beny and the King of Iran' by Marci McDonald, one of the first articles to target Roloff's expatriate flamboyance and political naiveté, appeared in *Maclean's* magazine in May 1976:

> Can a poor boy from Medicine Hat find happiness in the court of the last great despot-king? Sure, if he plays his cards right . . . Roloff Beny, jet-set photographer, creator of lavish coffee-table books and current darling of the Persian court . . . For what good is grandeur without the lens to record it? What use is pomp and ceremony and progress without the ultimate eye to capture and enshrine it in time?

. . . Poverty, ugliness, discontent, all signs of a military or police presence – these things are not part of the Shah's vision, and so they will not find their way into official records, just as they must not find their way into Roloff Beny's pictures.

Some photographers might chafe at such restrictions, but they do not seem to faze Roloff Beny who answered queries about why he hadn't included pictures of poverty in his last Persian book with the rejoinder that, 'We know poverty exists. I don't have to photograph it. I prefer trees.'

Rattled but unbowed, Roloff got on with plans for a gala celebration in Tehran to unveil the book.

Jack and his darling wife, Elizabeth, arrived from Toronto along with Lorraine Monk, having linked up with all the foreign publishers and friends in Europe. Evelyn Lambert swept in from Italy with a trunkful of her best enormous chunky jewels and Edith Sitwell-like turbans. Everyone was wined and dined and fed on such heaps of caviar and buttery rice that they began to look glassy-eyed before the book was launched in the Imperial presence on 18 October 1975. Fifty thousand copies were now on their way to all parts of the world . . . I didn't dare dream of a second book, yet . . .

Another audience with the Shahbanou: 'You know, Dr Beny, this book is really our Iran, the traditional Persia. I think my husband feels rather left out of it. How would you react to the idea of doing another book on Iran, this one on modern Iran?'

A sleepless night. How can I bear to do yet another book? How can I bear not to? How can I refuse an invitation like that? I toss and turn, toss and turn . . .

Roloff had, of course, been dreaming, plotting and planning for a second book on Iran almost from the time *Bridge of Turquoise* commenced. Jack negotiated the contract, this time directly with the Ministry of Information, tripling Roloff's fee to $75,000, with an even larger guaranteed order and a government subsidy amounting to well over half a million dollars. This time the Shah was involved. The international reaction to *Bridge of Turquoise* had been overwhelmingly positive; however, not everyone in Tehran was pleased. I well remember the head of the Shahbanou's Bureau, Karim Pasha Bahadori, calling me to his office when the second project was being considered: 'Please convey this message to Dr Beny. I am not sure Iranian-Canadian relations can stand a second Beny book!'

Iran: Elements of Destiny, conceived from the beginning as a companion volume to *Bridge of Turquoise*, focused not on the past but on the

present and future of modern Iran. The Pahlavi presence, scarcely visible in the first book, was given a major chapter entitled 'Majesty', and the book opened with a message from His Imperial Majesty the Shahanshah Aryamehr followed by an introduction by the Prime Minister. Photographs of the Shah, Shahbanou and the royal family depicted an extraordinary range of public and private activities including court rituals, the opening of universities and art galleries, entertaining heads of state, skiing, horseback riding and the birthday party of Princess Leila held each year on Kish Island. No photographer, foreign or Iranian, had the access to the Pahlavi family afforded to Roloff.

The pressures were enormous, with every minister, colleague and friend wanting their own pet project or factory in the book. There were many favours to repay, and the results were predictable: a patchwork-quilt effect of too many small images, 457 colour plates in all, although Roloff's full-page industrial photography was superb. The book was further weakened by a collection of sycophantic texts composed by a team of University of Tehran professors which had to be severely edited.

Iran: Elements of Destiny, although not a beautiful book, was certainly a handsome one, augmented by rich tones of khaki, dark brown and silver. The masterful printing of the images, overseen by Roloff who insisted on many costly modulations of the colour plates, was done by the British firm of Balding and Mansell. *Destiny* was judged the most beautifully printed book in the UK, although the judges took pains to point out the fact that it was highly subsidized.

The emphasis on industrial Iran and the role of the Pahlavis forced many foreign publishers away from the book, although it managed to appear in Canada, Britain, America and in a slightly puzzling Belgian edition. Rumour had it that the Belgian publisher who had also published *Bridge of Turquoise* could not resist the second gala ceremony in Tehran which was already being planned.

Iran: Elements of Destiny was launched at the newly inaugurated Museum of Contemporary Art and to celebrate Roloff created two spectacular exhibitions entitled 'Patterns of Persia' and 'Metamorphosis of the Book' which traced the evolution of both books. Later the same year a third even grander exhibition of enormous colour panels entitled 'Iran: Roloff Beny', created by Lorraine Monk and the Still Photography Division of the National Film Board of Canada, was displayed at the Toronto Science Centre.

Saturday Night, critical of the first Persia book, compared Roloff to the German film-maker Leni Riefenstahl in his attempt to glamourize and cover up the 'tyranny and poverty of Iran' and ended with a warning:

One must stop this mass numbing of the minds of our social elites. Perhaps a ringing Marxist cry could do the trick: 'Coffee tables of

the world unite, you have nothing to stop popping but your Benys.'
One could, in the middle of the night, sneak into the homes of the
Canadian Establishment, and saw off the legs of their coffee tables,
leaving them no place to put their Beny drivel.

Like many who lived and worked in Iran during this turbulent period,
Roloff expressed some private doubts about what was going on, but
basically he was an artist, not a politician. He knew he had been seduced
but simply loved being there:

Something of a beautiful hodgepodge, *Iran: Elements of Destiny*
lacked the unity of *Bridge of Turquoise*, partly because of the myriad
of authors, partly because it reflected the confusion of the modern
Iran it was meant to depict. Primarily, it was a paean of praise to the
vision of the Pahlavi dynasty. Perhaps it was in a sense another of
the Shah's *coups de théâtre*. I confess, despite my unwavering
admiration and even love for the Shahbanou, I was growing rather
uneasy about certain aspects of the work, and what I had seen and
experienced during the preparation of the book.

Nevertheless, it was not my position to criticize. Like many
people in the circle of the Empress, I lived in something of a dream
world of beauty, art and philosophy. The rest of the country was
viewed through the perspective she created – a world of royal
patronage, which survived nowhere else on the face of the earth.

Elsewhere, however, something was going wrong, and as I
studied my layouts I sometimes thought I caught a glimpse of
disturbing, even dangerous undercurrents. I'm not claiming to be a
prophet. I was only too glad to forget passing thoughts such as these
when faced with – for example – the flamingos of Lake Rezaiyeh
and a night on an island game-park with crescent moon painting
the midnight lake in silver and a dawn of pink clouds and my last
ever royal holiday on Kish Island . . .

King Hussein of Jordan was there again, friendly as always.
Princess Leila had her birthday party and I photographed the
Shahbanou riding an almost life-sized stuffed camel. In a little
bazaar I saw a watch I liked and rushed to my room to get some
money. Back at the shop I was told that someone had popped in a
moment before and bought the watch. That night, during a dance
with the Empress, she presented me with a special gift: the watch!
And that was the last I ever saw of Kish . . .

In Tehran again, a final audience with the Shah, and yet another
with the Shahbanou. A round of parties, congratulations, gifts,
Cartier gold pens and medals from ministers, farewells, see-you-
next-years, goodbyes. And that was the last I ever saw of Iran . . .

In June I was informed that there would be 'delays' in payments for *Destiny*. In August there was the horror of the cinema-burning in Abadan followed by violent demonstrations in Tehran and other cities, and the next month, the oasis city of Tabas vanished, shaken into dust by one of the worst earthquakes ever to hit Iran. On 4 October, 4,800 copies of *Destiny* were shipped by air to Tehran, and a week later 10,000 copies of the Persian edition of *Persia: Bridge of Turquoise* followed. Not a single copy of either of them was ever seen again.

On 16 January 1979 the Shah and Shahbanou left Iran for exile, abandoned by many of their 'friends'. The American hostage crisis and the heroism of Ken Taylor, the newly-appointed Canadian ambassador, and the staff at the embassy residence would soon follow. I saw many of my own Iranian friends and acquaintances swept away or trapped in the revolutionary whirlwind of fanaticism and hatred sweeping over Persia, turning back the clock, and threatening to engulf the entire Middle East in a religious war. Many in the West had long reviled and mocked the Shah – perhaps they are happy with what succeeded him.

Roloff never got over losing Iran. He had been genuinely devoted to the Shahbanou, adored the country and desperately missed the social whirl of the Pahlavi court. Roloff had also pinned his financial and artistic future on the creation of a series of books on various aspects of Persian culture, life and art. Jack McClelland had been negotiating for some time with the Bank Markazi Iran to do a major book on the 'Persian Bazaar' which was already at the dummy stage with most of its photography completed. Other books under serious consideration were the fruits and flowers of Iran, the architecture of mosques and caravanserais, and an esoteric but fascinating study of sacred art and contemporary ritual life.

During the last increasingly chaotic months of the Shah's reign, McClelland and Stewart tried desperately to recover the final payments for *Elements of Destiny* and the Persian version of *Bridge of Turquoise* from the Ministry of Information and other government agencies in Tehran. But they could not break through the crumbling bureaucracy. Thousands of copies of both books managed to reach Tehran airport during the early days of the revolution and were assumed to have been burned until mutilated copies began appearing in the market a few years ago minus the pages that directly illustrated or referred to Pahlavi rule.

In a genuine gesture of support, though also hoping to revive his contacts, Roloff made a trip to Morocco in March to meet the Pahlavi family in exile. He photographed the Shah on the golf course and had the film politely but firmly removed from his camera by King Hassan's

guards. Later, in a moment of unbelievable audacity even for Roloff, he asked the Shahbanou if she could help the publisher secure the balance owed to them. She, who had lost her country, gently replied, 'Dr Beny, I am sorry but it is no longer a matter under my control. They are no longer my Ministers.' For a few brief moments, however, it was like old times.

> His Majesty thanked me for the 'great service' I'd done Iran. I spoke to him about the huge archive of Persian material I'd assembled, and my concern that it find a permanent home. 'You must preserve it,' he encouraged me, 'some day, we'll know what to do with it.'
>
> The Empress and I sat beside a pool which was alive with graceful swans. 'Dr Beny, do you remember the pelican in Tabas, how we thought he must be lonely without a mate? Do you know, I ordered that a wife be found and sent to him. I hope she arrived before the earthquake . . .' And so for a while we immersed ourselves in memory.

For the first time in years, Roloff had no major project to embark on and began to think about the future for his kind of books. During the years he had been working in Iran, sheltered by a government subsidy, the cost of producing large-format photographic books had escalated greatly, and publishers were more wary than ever of initiating a Beny book without outside support, and few countries remained that could afford one.

Roloff had always lived a comfortable life, grand but not profligate, thanks to his royalties and support from his father when he needed it. The blow of losing Iran was especially hard because he had based a publishing dream of his own on the fees and royalty income that would have arisen from his future Persia books. This dream was the publication of his Visual Journals, an ambitious trilogy of photographs and excerpts from his diaries, letters and writings exploring three major themes of his photographic work: nature, architecture and people.

The Journals were to be his final visual and literary testament, the distillation of his life as artist, author, photographer and maker of books. They would present cherished unpublished images from the archive and reveal views, conflicts and feelings that for the most part he had kept hidden. The books would be his conception from start to finish, laid out and designed exactly the way he wanted. Roloff knew they would be exorbitantly expensive to produce and that external funding would have to be secured in order to interest major publishers in the project. He resolved to subsidize the books himself which could cost at least half a millions dollars for the three, and not even his father could provide support at that level.

The most obvious solution to raise money for the Visual Journals was to find a new patron. During a state visit to Iran in 1977, Roloff had met

President Anwar Sadat who admired *Bridge of Turquoise* and invited him to visit Egypt and discuss the possibilities of a book. Anticipating the problems facing Iran, Roloff took up the invitation the autumn before the revolution, but Egypt was not Iran and Sadat was not the Shahbanou:

I checked in with the chief of the President's Cabinet, to find warm greetings from Sadat and his wife Jihan waiting for me. After a day-trip to Memphis, I was granted an audience with President Sadat at the Delta Barrage. We talked for an hour, and I photographed him. He seemed in favour of my ideas for a book on his country . . .

My next voyage to Egypt took place the following February when I was joined by my publisher, Jack McClelland. After a couple of days of settling in and partying with old friends, I returned to my hotel to find the maid in an agitated state; 'the President' had called while we were out. Another audience with Sadat had been arranged. This time Jack and I found him at his headquarters at Naryout, dressed in a grey flannel suit, black silk shirt and Wellington boots, seated in a simple plastic chair on the garden terrace. He was animated and warm, as usual, and his infectious smile made us feel that the Egypt project was blessed.

Of course, reality was something else in this land of lotus eaters. Despite Sadat's patronage, not a single permit was ready after ten days of waiting. I began to wonder if I didn't have an enemy in this country. Next day I discovered who it was.

I was summoned to the Academy of Arts to meet the director, Dr Rushdy. He kept me waiting for an hour, then launched into a speech that left me speechless. Even Mitchell – who also accompanied me on this trip – was struck dumb. The doctor raged at me – why, he asked, since I had already spent a whole month in Egypt, had I returned for more photography? I must bring all my photographs to him for official approval. I must provide him with a detailed outline of the book. I must present a contract for him to study. Until all that was accomplished, I was *forbidden* to photograph even the humblest obelisk.

In short, I had run into the same bureaucratic malevolence that had plagued me over the years in Iran, but there was no Shahbanou to part the waters. I held myself in check and icily took my leave, dashed back to the hotel and pressed all the panic buttons. Jack McClelland back now in Toronto, the ambassador, all my highest contacts – I phoned them all for advice. Then there was nothing to do but lock myself in my hotel room, a virtual prisoner, and take a bit of petty revenge by snapping a few shots from my balcony. I thought of a new title for the book: *Cairo From My Window*.

In a frenzy I wrote up a complete proposal for the sinister doctor, only to have him cancel my next appointment. An old Cairo hand to whom I poured out my story told me it sounded as if a plot were brewing against me and my book. While I pulled every string I could think of and ignored those of my friends who advised me to try bribery, I managed to take a few clandestine shots around town, feeling like a wanted criminal. I summoned my assistant Trisha Mitchell from Rome with a batch of Egyptian photographs, and she, Mitchell and I prepared for my next battle with Rushdy.

He refused to see me, and sent one of his flunkeys instead. To use a term popular in that era, he stonewalled me. He refused even to look at the photographs delivered from Rome. He refused to read my proposal. He refused to give me permission to continue work until a contract was signed, 'which will take *weeks*, so why not give yourself a break?'

I was feeling horrible. Next day we left. The plane was delayed for several hours after we boarded, and the purser on Egypt Air told me the captain was so pious he not only didn't allow alcohol to be served, but was in fact praying at that very moment. On the wing, no doubt. Perhaps I should have joined him!

My last trip to Egypt was in 1980, when I visited the Shahbanou following the death of His Majesty. It began with a press conference in Rome for the Vice-President of Egypt, Mubarak. I found him intelligent, without artifice, and not at all pompous. 'See you in Egypt,' he said to me. 'You must finish the book. The President expects you to do it.'

Sadat was not to live to see the project carried out. In those few meetings with him I'd formed a strong opinion of his goodness, humility, spiritual attainment – qualities almost unheard of in a world leader. I admired him for giving refuge to the Shahbanou and for his heroic attempts to put an end to the senseless and tragic hatred which once again threatens to destroy not just the Eastern Mediterranean but the whole world. Perhaps some day my book will see the light. And if that day ever comes, there is no doubt that I will dedicate it to the memory of a great man – perhaps in some ways the greatest I've ever known.

Roloff's reputation from Iran of being difficult, petulant, demanding and expensive had preceded him, and Egypt did not have the resources that Iran had had. He was forced to turn elsewhere.

Back in London, Michael Shaw, Roloff's literary agent, had secured a contract for another book on the Mediterranean with his mother publisher Thames and Hudson, who received their somewhat-chastened prodigal son back from Persian exile. The project was to be an updating of Roloff's first book, *The Thrones of Earth and Heaven*, published over twenty years before, with new text and colour added. All through the autumn of 1979 and the following spring, Roloff retraced his steps through Algeria, Greece and Spain.

Although relieved to be back at work, Roloff was fully aware that his latest book could not generate sufficient funds for the publication of his Visual Journals that were by now an obsession. After much deliberation and soul-searching he resolved to sell his most precious and valuable possession – the entire photographic archive – a step he would never have contemplated without the fall of Iran.

If possible Roloff wanted the archive to go to his native province of Alberta, and preliminary discussions were initiated by Bernard Fahy, a trusted friend and financial adviser to Roloff and his father, with the Alberta government representative, Mary Le Messurier, a junior minister of culture. The preliminary negotiations held in early spring 1979 got off to a smooth start. Roloff agreed to relinquish his photographic and literary archive for the sum of $229,000. During his lifetime he would retain the use of all relevant material necessary for the completion of his Visual Journals and any other projects that were under way. The bulk of the archive would gradually be transferred to Edmonton over a period of several years for archiving and preservation.

Alberta sent a senior archivist to Rome and also appointed an independent appraiser based in Italy to examine the archive. Not surprisingly, their report was positive. Roloff had been a hoarder his entire life, and they were startled by the range and depth of the collection which included not only the original transparencies, negatives and hundreds of foreign editions of Beny books, but also private and business correspondence, book dummies, diaries, royal invitations, albums of clippings and reviews and an extensive research library of books on architecture and art history.

The range and depth of the archive – nearly one hundred thousand colour transparencies, black-and-white negatives and prints – was re-markable. It represented the art, architecture, daily life and rituals of forty-three countries from Guatemala to Turkey, photographed over the last thirty years. Roloff's passion for the Classical and ancient world had taken him to some of the world's most remote and fabled sites, many of which had been destroyed or altered by natural and political upheaval and over-zealous restoration.

The Iran archive, with its comprehensive coverage of five thousand years of Persian art and architecture up to the last days of Pahlavi rule, was the most complete in existence. Many records, especially of the Shah, Shahbanou and court rituals, had been destroyed during the first years of the revolution.

In September 1979 the Alberta government announced in a press release that they had decided to acquire the Beny archive. Deeply relieved, Roloff persevered with the Mediterranean book, disturbed only by the death of Nerona, his beloved black poodle. He made several trips to Spain accompanied by Sylvia Matheson, a specialist in the archaeology of West Asia, who was also writing the text for *Rajasthan*.

Roloff had met King Juan Carlos and Queen Sophia in Tehran, and before long he was photographing the Spanish royal family and there was talk of a book just about Spain.

In the aftermath of the collapse of Persia, I was determined not to despair, and feverishly planned books and drew up proposals. But for a while nothing seemed to work. It was as if my stars were linked with those of the country to which I'd devoted five years of my life – somehow Iran's disaster was my own.

In September 1979 I returned to the country where I had first discovered my métier of photography. The King and Queen of Spain were close friends of the Shah and Shahbanou, and of course Queen Sophia was the sister of King Constantine of Greece. As with Egypt, I had reason to hope that the 'good old days' at Kish would lead to something big in Spain.

I was in top form as I made my way from Barcelona to Granada and Cordoba, on to Seville and Valencia. For once I had no cold or bronchitis or Traveller's Tummy to contend with. The days were clear and bright, and I ticked off the monuments, flowers, people and bullfights in my diary, like a hunter totting up his catch.

On 2 October I enjoyed my first audience with Juan Carlos and Sophia at Zarzuela (a modest affair in perfect taste; one of the nicest and homiest palaces I've ever seen). They were handsome and welcoming, and very flattering about my books on Iran. I had a new mission in life – renewing my long love affair with the Mediterranean, released now definitively from the spell of the Persian Court. For the first time in quite a while I was feeling happy, fulfilled and totally interested in life. Who wouldn't? . . .

One Sunday after celebrating Mass with the royal family, we went into the gardens where I distributed cowboy hats and maple-leaf pins among the children, the King took off his tie and relaxed, the children posed with their dogs, and the Queen with her Lhasa terrier.

MEDIEVAL TO MODERN

113 *The sculptured interior of the Cattolica at Stilo in southern Calabria, Italy, a tenth-century church, reminiscent of the Byzantine churches of Georgia, Armenia and Asia Minor.*

114 *Inside the vaulted hall of Krak des Chevaliers, the best preserved of the Crusader castles of the Holy Land, built in the twelfth century, in northwest Syria, a bastion of Christianity, which finally fell on 9 April 1267.*

115 *This great subterranean Roman reservoir, the Piscina Mirabile, fed by an aqueduct and capable of containing 12,000 cubic metres of water, was built to serve the Tyrrhenian fleet in the nearby harbour of Misenum in southern Italy. Its long lofty pillared aisles give it an almost cathedral-like effect.*

116 *The five great domes of San Marco, the main church of Venice, begun in the eleventh century, show strong Byzantine influence.*

117 *The elaborate cupola of the church of San Ivo alla Sapienza in Rome, designed by Borromini in the third quarter of the seventeenth century.*

Suddenly a footman appeared with an urgent message from the Canadian embassy: I was to call home, or my lawyer, at once. With great foreboding I left the palace immediately, returned to my hotel, and with difficulty put through a call to Canada. I learned that my mother had died four days ago, and that my family had been trying since then – unsuccessfully – to locate me. The telephone rang. It was Her Majesty Queen Sophia saying she'd had a premonition that something was wrong. I told her. She arranged at once for me to leave for Canada, saying, 'Be brave, go and do your duty. But come back to us.'

I left all my cameras in Spain, determined to obey her request. As when one is thrown from a horse, the best thing to do is get right back on and continue riding. It took me two days to reach home, while the funeral was delayed for my arrival. Because my route home at such sudden notice forced me to fly via Rome, then London overnight with my dear loyal friend Lady Joan [Duff Assheton-Smith], and finally across Canada to Edmonton, I arrived more dead than alive. When I saw the Cadillac lined inside with turquoise velvet, I thought it was I who was en route to my great reward. We covered the six hundred miles to Lethbridge in total silence. I was still carrying a bouquet of white roses which Joan had given me during my brief stop-over in London.

At a cathedral-like funeral home I found Mother laid out in pink velvet, wearing the necklace given her by the Shahbanou and a simple strand of pearls left her by her mother. As I wept I laid each white rose one by one in the coffin. A convocation of Cadillacs drove to the family plot in Medicine Hat. Even though Mother used to say she'd rather have flowers when she could enjoy them, Father had ordered a blanket of wild roses . . .

Roloff was deeply shaken by his mother's death and also worried about his father, who was rapidly declining in health and increasingly unable to look after his own affairs. On his return to Rome he experienced yet another blow, the death of Peggy Guggenheim in Venice.

Each phone call seemed to take on a more and more valedictory tone. Once, in March, when I reminded Peggy it had been thirty years since we'd met, she sighed. 'We have shared a world.' In June we spoke again, and I commented that she sounded better. 'My mind and my memory are great,' she said, 'and I look marvellous. But I feel terrible most of the time.'

We talked about her dogs, how she'd once had sixteen of them living with her, and a total of sixty over the years. I reminded her she'd been my first friend in Europe, and with a touch of her old

118 *The ceiling of the Sala de las Dos Hermanas (Hall of the Two Sisters) in the Alhambra Palace at Granada, Spain, its stalactite vaults constructed of carved stucco, in the fourteenth century.*

119 *The grand staircase and pools of the Jardin de la Fontaine at Nîmes in southern France were laid out in the eighteenth century over an earlier Roman pleasure garden.*

120 *Roloff rarely ventured into the twentieth century but when he did he was equally at home with industrial photography, as seen here with his abstract interpretation of the CPR High Level Railway Bridge at Lethbridge, in his home province of Alberta.*

121 *The pattern of scaffolding and workers inside the Baroque church of the Dolores at Cordoba, Spain.*

122 *Shadows cast on the ornamented walls of the Casa de las Conchas carved with scallop shells at Salamanca, built in 1512–14, during the last and most lavish period of Spanish late Gothic.*

spark she said, 'And don't you forget it, Minxie!' That was the last time I spoke to her.

That September, my work in Spain prevented me from making my usual visit to Venice. Just before Christmas I received the news of her death. At the memorial service her son, Sinbad Vail, gave me a bracelet of gold and turquoise which she'd worn almost constantly, and which she wanted me to have. Also her collection of books on Asia. The service was held in her garden, and I piled a heap of daffodils under the simple inscription, carved into the garden wall, commemorating Peggy and her favourite dogs, each one listed by name with its date of death.

In 1982 I went to Venice for the annual Feast of the Redentore (celebrating the city's escape from the plague) to visit Peggy's palace, now a museum. Everything had changed. The walls were white, of the stark tone that is thought to set off modern art. Her masterpieces were now hung in chronological order, instead of any-which-way, as she'd preferred them. There remained not a trace of the woman herself, who'd collected the art, bought the palace and put it all together – except for a few photographs I'd taken, showing her in all her moods and costumes.

Desperately I tried to dredge up from my memory something of Peggy, something typical, a happy, outrageous recollection. I remembered how we'd once been in Paris together, and Peggy was determined to buy a sable coat. She was ready to spend thousands on it, but I introduced her to a friend who could 'get it for you wholesale'. We went to the Louvre and photographed each other in the floor-length fur. Then Peggy said, 'Let's have a celebratory lunch!' Off we went to a modest restaurant, and toasted our triumph. The bill came. Peggy put on her glasses and totted it up – as she always did. Then she rechecked the waiter's arithmetic. Finally she announced, 'Now we'll split the bill. But yours is more because you had bread and I didn't.'

That evening the Venable family took me for a float on the Grand Canal in their motorized barge. At midnight the Canal was illuminated by a splendid fireworks display, and the lagoon was lit up with reflections, the whole floating city bathed in polychrome. As we passed the vine-entwined white marble facade of Peggy's palace, I gazed up at our adjacent bedroom windows, and couldn't believe she'd never be 'at home' again. I thought about all the remarkable people I'd met there – many of them now ghosts. Venice and its memories were now part of the past for me. I bade a final farewell to a person and a city whose fates were interlocked, and who came into my life together on a misty night in November 1948. I haven't been back to Venice since then. I don't think I care to . . .

Roloff eagerly embraced a new commission on the churches of Rome negotiated by Michael Shaw with Weidenfeld and Nicolson, a leading British publisher, who seemed anxious to do a Beny book. Architecture was Roloff's greatest love, and the tightly structured and localized subject of the book gave him a much-needed break from travelling and time to enjoy Tiber Terrace and the approaching Roman spring. Peter Gunn, the book's erudite author, drew up a comprehensive list of churches to be photographed and Roloff, together with friends and studio staff, set out three or four days each week to record the rich ecclesiastical architecture of Rome.

Trouble had unfortunately erupted back in Alberta following the announcement the previous autumn that the government had agreed to purchase the Beny photographic archive for $229,000. The Alberta art community had long resented Roloff's flamboyant expatriate status, refusing to recognize his remarkable international career and reputation in photography and book design. They were incensed that so much money should go to someone who did not even live in Alberta. Opposition members in the legislature immediately sensed the government was caught unprepared and off-guard. Scare tactics were employed to exaggerate beyond all reason the costs of preserving the transparencies and negatives in the archive, suggesting that it would come to over half a million dollars.

Memories of the Shah's regime were still politically sensitive and debate centred on why the Alberta government should acquire the historically significant Iran collection, although it was only one of forty-three countries covered in the archive. Roloff did not help much, giving conflicting views on copyright and pontificating from Spain as if he were doing a favour to the province. Mary Le Messurier, representing the government, had been in contact with Roloff, who was then busy with his Mediterranean book in Madrid, and both she and Roloff became 'poetic' targets in a heated parliamentary debate:

> *Mary, Mary quite contrary,*
> *How do your answers go,*
> *With friends in Spain*
> *And Shahs in train,*
> *And 82,000 slides in a row.*

Local newspapers had a field day and were replete with shrill editorials and cartoons of shady men creeping out of alleyways whispering to innocent tourists 'wanna buy a Roloff Beny picture?'

Stunned by the uproar, the government did a sudden about-face and offered to buy only the Canadian content of the archive for $27,500.

There were further attempts at compromise but the government would not budge and Roloff had no choice but to refuse. It was a 'provincial' decision, bereft of vision and a great cultural loss to Alberta. Roloff was humiliated, insulted and deeply hurt by the rebuff:

> One of my major ambitions is to find a permanent home for my archives. I cannot, as an individual, afford to give the transparencies the proper care they require. If they are not looked after scientifically, they will disintegrate within a decade or so. The Alberta government was unable to see that a record of a 'deposed monarchy' had any historical value. In fact, they were unable to see that anything I've done has any value, except perhaps my Canadian grain elevators! But in all humility, and quite aside from the question of aesthetic value, the Beny archive is undoubtedly packed with historical documentation that cannot be duplicated.

His spirits lifted slightly with a 1980 exhibition in Rome sponsored by the local Canadian Cultural Institute entitled 'To Every Thing There is a Season: Roloff Beny in Canada' and the publication of *Odyssey: Mirror of the Mediterranean* and *Churches of Rome* the following year. The Mediterranean book was a vintage Thames and Hudson/Beny creation, beautifully produced with lush colour images separated by tinted text paper, and was awarded the Bronze Medal at the 1982 Leipzig International Book Fair. It appeared in four foreign editions in addition to a signed and numbered presentation volume specially prepared for the Canadian Mediterranean Institute in Rome.

Churches of Rome, a small academic book stuffed with historical detail, lacked all the traditional decorative features granted to Roloff at Thames and Hudson. The photographs were superb, but the colour and black-and-white printing was not up to his usual standards, as Weidenfeld and Nicolson, fearing soaring Beny costs, had been reluctant to give Roloff the free hand in design he was used to – and it showed.

Roloff, stunned by the recent losses of family and friends and the archive scandal, began to draw inward and reflected soberly on the experience of creating his latest books, viewing them as rites of passage and a return to first loves:

> *Odyssey: Mirror of the Mediterranean* began its life as merely a reprint of *The Thrones of Earth and Heaven*, my first book, but ended up as a very different book indeed. All the trips outlined in the last chapter led to a massive expansion of my archive, and the archive itself also contained thousands of images of the Mediterranean world that had never been published . . .

ROLOFF BIOGRAPHY

123 *Roloff relaxing with Nerona, his beloved black poodle, on the verandah of Tiber Terrace, Rome, in 1975.*

124 *Toasting his guests in the 'Tiger Room' at Tiber Terrace in 1975.*

125 *A rare holiday with old friends, summer 1975, on the island of Giglio off the western coast of Italy during the preparation of the first Persia book.*

Editing and research for *Odyssey* was begun with his usual dedication by Mitchell Crites, but a higher romance than that of bookmaking called him away: he married a beautiful Persian aristocrat, Niloufar Afshar, and moved to London. The in-house work was finished by Antonella Carini, a talented Italian, and Helga Brichet (famous for the way she answered my phone, 'Roloff Beny Studios'), making me sound at least as grand as MGM. Sallie Marcucci, artist and friend from Atlanta, helped with design and decorative vignettes. And as always, I entrusted the work on black-and-white photography to no one else but Franco Bugionovi.

Perhaps a few quotations from my Preface to *Odyssey* best express some of the emotions I felt as I returned to my beloved Mediterranean:

'I have travelled and recorded the Mediterranean in word and image for over thirty years, saddled with paints, notebooks and always a combination of cameras as well as a minimum of guide books. Each night on the road I prepare for the day ahead. Thus anticipation becomes an essential element of the excitement of the next encounter, a fragment, a coloured stone of the total mosaic, which will later be exposed in my darkroom and pieced together on my drafting board overlooking the Tiber, to become a total graphic statement, a new design, eventually, perhaps, a book . . .

'It is a very humbling act to photograph in one sixtieth of a second a work of art, a walled city, a lonely castle, an ornate palace which required whole lifetimes to create. Yet a natural disaster or one single political upheaval or misguided restoration can destroy the subject – and perhaps the camera has preserved it. My thirty years of photography in the Mediterranean have conserved on film many of those fragile monuments of Time Past . . .

'Now, in this odyssey, there are no nightmare airports, no heavy cameras, tripods and expensive film, no turbulence – just a journey through history and beauty, forever, I hope, alive in these pages.'

If *Odyssey* was my re-entry into the world of the Mediterranean after so many years devoted to Persia, *Churches of Rome* represented my return to a concern with Christianity after years of Islam. My twelfth book was a surprising commission from Weidenfeld and Nicolson, and perhaps the most narrowly focused book I've ever produced. Concentration on a single subject (though certainly not a 'minor' one) seems to have enhanced the book's success.

In an interview for the BBC's programme 'Kaleidoscope', I told Roy Strong, then director of the Victoria and Albert Museum, that 'I particularly insisted on trying to recapture the feeling of when the church itself was created. I wanted the atmosphere of the candlelight ceremony, of the altars (whether medieval, Renaissance, baroque or

126 *Roloff, reflected in the mirrored walls of the Narenjestan Palace in Shiraz, photographs Lesley Blanch, myself and our faithful driver, Hossein 'Chunky' Yavary, who guided us across half a million miles of often treacherous roads during the photography for two books on Iran.*

rococo), brought to life by the shafts of light from the clerestory. So it was always a question of light. Ah, the day was wrong, the moment was wrong, it was raining . . .'

What I did not tell the BBC was how utterly saddening the task could be. How each church had its own rules, opening times, forbidden times, its own office of permissions which was seemingly never open. How gloomy interiors of neglected churches resisted attempt after attempt to capture their essence. How I set myself against the entire hierarchy of the Mother Church, begging for one more chance here or there, one more entrée into hidden secrets of the Vatican. In terms of my life's work, *Churches of Rome* is perhaps my 'Peter's Penny'. If I get to heaven and discover that Catholicism is indeed everything it claims to be, I'll produce a copy of *Churches* and try to bluff my way in, as I used to do with *Thrones of Earth and Heaven* when confronted with Middle Eastern bureaucrats.

Two striking photographic exhibitions were commissioned by the Canadian Cultural Institute of Rome to accompany the publication of the books and they toured a number of European cities. The 'Churches of Rome' exhibition had a prestigious venue at the Royal Institute of British Architects in London and 'Odyssey: Mirror of the Mediterranean', sponsored by Roloff's original patrons, the Eaton family, was displayed across Canada and was later chosen by the Smithsonian Institution Travelling Exhibitions to tour America.

During 1982 and 1983, the last two years of his life, Roloff threw himself with a frenzy into working on five projects at the same time: the gods of Greece, Rajasthan and Iceland as well as the Architecture and People volumes of his Visual Journals. Publishers, friends and colleagues were all urging him to take it easy but he seemed unable to slow down.

There are as usual about a dozen irons in the fire. A word has recently come into vogue which perfectly describes my way of life: I'm a 'workaholic'. I'm not happy without several projects going at once, and I can't remember the last time I took what most people would call a vacation. Until they cart me away, I'll still turn out books. That's what I do. I make books.

Weidenfeld and Nicolson, delighted with the response to *Churches of Rome*, asked Roloff to do another book, on a subject that he knew well – the gods and goddesses of ancient Greece. Roloff supplemented his large Greek archive with two more trips to Greece and visited museums in Rome and London. He got along well with his famous author, Arianna Stassinopoulos, and the book, dedicated to both their fathers, progressed smoothly and was published in 1983. Never treated with the same respect at Weidenfeld that he had been shown at Thames and Hudson or McClelland and Stewart, Roloff was irritated by the top billing the equally flashy Stassinopoulos received in the book credits.

Finding it more and more difficult to find publishers who would back his book projects, Roloff, through a chance introduction from an Indian friend, met Laurence King whose company specialized in putting books together and then marketing the completed 'package' to interested publishers. King took charge of the Rajasthan book which had been languishing in a near-final dummy stage for ten years and secured British, American and Canadian editions, and a book on Iceland followed soon after.

ICELAND

Lord Weidenfeld had met the three Wathne sisters in New York and convinced these wealthy and patriotic Icelanders to subsidize a book on their country which was to be photographed by Roloff and written by Pamela Sanders, wife of the American ambassador to Iceland. Somehow the book came unstuck at Weidenfeld and Nicolson and was taken over by Laurence King. King put the deal back together and Roloff began travelling to a country he had never visited and knew little about.

King grew genuinely fond of Roloff during the short time they worked together, and he said of him:

> I caught a star on his way down that the major companies found difficult or expensive. He could be mischievous, intolerable and selfish, but there were some good times. He was sad, a little lost and hated Iceland. He only did it for the money. There were no monuments and no sculpture, only fish, lava and hot springs, and worst of all – no light. Pamela kept insisting he photograph one more boring saga sight after the other.

Roloff, more and more preoccupied with family problems and determined that his photographic archive and art collection should remain in Canada after his death, set up a Roloff Beny Foundation in 1981,

although it was not fully implemented until after he died. His father's health continued to deteriorate and Mr Beny, now requiring full-time care, was no longer able to look after his personal and business affairs or to give direct financial support to Roloff.

In order to raise additional funding for his Visual Journals and out of a general concern for what would happen to all his possessions after his death, Roloff decided to part with his extensive collection of late nineteenth- and twentieth-century art. Professor John Woods, president of The University of Lethbridge at that time, recalled the complicated negotiations and the way in which the Government of Alberta, who had a few years earlier refused to buy his archive, now came to his support:

> Roloff was in no position financially to gift his collection outright. A gift-purchase arrangement would need to be contrived. But the University had no money for such things. So it proved indispensable to have at hand the Alberta 1980s Endowment Fund, lately proposed by the Alberta University Presidents and brought into being by the able and foresightful Minister of Advanced Education, Mr Horsman; and the brilliant design of the deed of gift by the Gallery's newly arrived Director, Jeffrey Spalding.
>
> The Beny Collection came to the University in 1982. It transformed the collection and served as creative provocation of a flood of subsequent gifts and acquisitions which have made it one of the best in the country.

Roloff concentrated more and more on his Visual Journals. The volume on architecture was a joy to do, and whenever he was in Rome, Roloff and his dedicated assistant, Antonella Carini, would sort through the thousands of architectural photographs in the archive, creating concepts and designing layouts for the book.

He found it more difficult and taxing to come to terms with the 'People' book. He was well aware of the criticism his books had received over the years for their lack of human content. He also knew that there were thousands of people 'living' in the archive only waiting to 'expose themselves'. Roloff was a brilliant portrait photographer. He lacked the technical virtuosity of his fellow Canadian, Yousuf Karsh, but compensated with a moody, impressionistic style and the knack of relaxing his subjects and finding the perfect background to evoke their personalities and achievements. As an exercise, he mounted an exhibition in Rome of 'Americans in Italy: Photographs by Roloff Beny' in March 1983.

Lily Miller, who worked closely with Roloff at McClelland and Stewart on the Persia books and on his Visual Journals, felt that the effort of revealing himself through long-hidden words, feelings and images was wearing him down:

He was clearly floundering, finding the task of evoking his life both difficult and painful. It was his chance to open up and be the person that he had shielded from the world for so long. This represented a challenge to him, but he was also afraid . . .

Roloff was one of the loneliest people I knew. I felt it had much to do with the two people in himself: the private, sensitive, spiritual artist seeking and recognizing the truth, and the truth is always simple; and then Roloff, the exhibitionist, masquerading in his lavish outfits and mingling with the rich and powerful. He knew how empty that world could be and yet he felt he needed it . . .

By the summer of 1983 Roloff was exhausted. The Iceland book was taking its toll. King remembers forcing Roloff, who was in tears, onto the plane to Reykjavik. He was determined to spend more time in Canada and had plans drawn up to build a house on Berryman Street in the Yorkville area of central Toronto, on a property he had bought in the fifties. The night-time notations in his diaries reveal a mood of sadness and reflection:

> My books for me are like a beautiful stable of race horses. Some have won ribbons and medals, but all have been good runners, in fact so good that the publishers have long ago run out of stock and now my cherished horses have been retired to their stables because it is too expensive to reprint these books in their original versions. My books are my lifelines – my ladder from the well of my loneliness.

Christmas 1983 was spent in New York and Hollywood photographing Ginger Rogers, Lillian Gish and other Hollywood legends for the 'People' book. John and Carol Woods and their son and daughters, who had grown close to Roloff during the last few years, invited him to celebrate the New Year with them in Hawaii. John Woods remembered how Roloff seemed unable to shake off his fatigue and worries.

> He was bottomless in his sadness, almost desperate, and looked awful. Puffy and overweight, legs shot. Nothing was going the way he wanted. Maui was a mistake – he needed glamour, needed 'Martha' and the Pahlavi court, not a family holiday in Hawaii.

Roloff returned tired, unrestored to Rome and resumed work on his various projects. He died at Tiber Terrace in his evening bath of a cerebral haemorrhage on 16 March 1984. The body was cremated in Rome and a succession of moving memorial services were held in Rome, Toronto and Lethbridge. At his request, Roloff's ashes, along with copies of his thirteen published books, were buried beside his mother, Roses

221

Beny, in the family plot in Medicine Hat, Alberta. There were many glowing tributes, but the one he would have cherished most was a simple bouquet of spring flowers from the Shahbanou.

The memorial stone was carved with a favourite verse by Rainer Maria Rilke which Roloff had quoted in *an Aegean note-book* and *Odyssey: Mirror of the Mediterranean*, his first and last visual journeys through the Classical world:

Love consists in this,
That two solitudes protect and touch,
And greet each other.

RAJASTHAN and THE ROMANCE OF ARCHITECTURE

Roloff's fourteenth book, *Rajasthan: Land of Kings*, published only a few months after his death, was dedicated to his old friends James and Carol George. Not as luxurious a book as he would have liked, *Rajasthan* nevertheless contains some of Roloff's most moving and powerful photographs of art, architecture and ritual life.

The Romance of Architecture, the first of his three Visual Journals, was published by Thames and Hudson in 1985. Roloff was working on this book when he died. Eva Neurath, who had helped him create his first book, *The Thrones of Earth and Heaven*, together with Antonella Carini in Rome, designed a strong graphic volume which included a number of his early black-and-white masterpieces long out of print.

The photography for *Iceland*, Roloff's sixteenth and final book, also published in 1985, had been completed before his death, and the final layout was done by Laurence King and his staff in London. It is a cold stiff book reminiscent of the country and the effort involved. In her Epilogue to *Iceland*, Pamela Sanders retraced her steps, as did many others (I myself, for instance, returned to the medieval town of Tonk in Rajasthan which Roloff had never managed to reach, but always swore he would one day have 'tea in Tonk', and I toasted him with a cup of sticky sweet Indian 'chai'), and remembered Roloff:

'Remember,' he said, 'I want perfect weather – plenty of new snow, blue skies and sunshine.'

I promised to arrange it . . .

On 16 March, Steve Martindale telephoned to tell me that Roloff had died the night before . . .

Roloff had made one other specific request: he had asked that we revisit the scenes of our very first excursion in May so that he might photograph those same places in winter, especially Gullfoss. So on

24 March his three old travelling companions, Marshall, Leon and I, climbed back into the van and made our pilgrimage . . . We watched Strokkur erupt on a snowy field with no tourists in sight, and then went on to Gullfoss.

The waterfall was frozen along its sides, ice encrusted on the cliffs, rivulets frozen in motion, like a great ice statue. But the centre was still alive and pulsing with power. We stood there looking at it in admiration, listening to the muted roar, feeling the diminished spray, and remembering Roloff.

It was exactly the day he had requested. Last night's snow lay on the ground. The sky was a brilliant blue. The sun was shining.

In death as in life, Roloff's will spelled out in great detail exactly what he wanted done with his own artwork, photographic archive and unfinished books, and how it should be carried out. He left a considerable estate which was greatly increased by the death of his father two years later in the autumn of 1986. Jack McClelland predicted that Roloff would be 'more trouble dead than alive', but gradually his instructions have been carried out.

In 1987 a comprehensive collection of Roloff's paintings, prints and drawings, personal papers and correspondence relating to his career as an artist was presented to The University of Lethbridge Art Gallery. Archiving and research into the collection began almost immediately and resulted in the mounting of a retrospective exhibition, 'Roloff Beny – Painter, Printmaker', which toured Medicine Hat and Lethbridge in 1990 and 1991.

The complete photographic and literary archive was gifted to the National Archives of Canada in Ottawa in early 1993. After many years of uncertainty, the archive came home to Canada, as Roloff had always wanted, where it sits proudly next to the archive of Yousuf Karsh. A team of archivists and scholars, led by Edward Tompkins of the Documentary Art and Photography Division and supported by a generous donation from the Roloff Beny Estate, have begun the monumental task of organizing, analysing and preserving the more than 150,000 photographs and prints, diaries, correspondence, Beny memorabilia and myriad dummies and layouts of his sixteen published books.

The Roloff Beny Foundation – chaired by Jack McClelland, together with fellow directors Arthur Erickson, the distinguished Canadian architect, and, until her death in the autumn of 1992, Signy Eaton, a dear friend and Roloff's first patron – is committed to the support of photography and art across Canada. Its first major act was the donation of one million dollars to endow the Roloff Beny Gallery at the Royal Ontario Museum in Toronto. The Beny Gallery, part of the Museum's Institute of Contemporary Culture, was inaugurated in April 1993 with a

photographic exhibition, 'The Sacred Earth', by the western Canadian photographer Courtney Milne.

The story of Roloff's life as an artist and photographer appears in the pages of this volume, and plans are under way to publish the Visual Journals 'People' and 'Nature'. Roloff, as he had directed, continues to share his visual journeys – the unending odyssey of Marco Polo from Medicine Hat:

> If I were given the privilege of starting life again, I would again choose the fine art of creating books, a total art form which combines all the ingredients of creativity . . . A book of images can be mightier than any weapon – a missile for peace, not destruction. A visual book negates all language barriers – its function is to reveal, if we take the time to see rather than just to look . . .

Roloff's favourite time of day was dusk. It was also a desperate, frantic moment when we 'raced for the sun'. I remember the hundreds of sunsets we shared in Persia, Roloff, 'Chunky' the driver and I scouring the horizon for a ruined caravanserai, a camel train or tribal tents to make it all perfect. When it appeared, he would leap from the car, focus and snap. The return was slow, stately, a knowing smile of contentment on his face, relief on ours. It was time to pack up the cameras. Snuggling down in the back seat for the long dark drive ahead, Roloff would open a slender silver flask and sip his vodka. After all, God had spoken once again and tomorrow was another race.

As they say in Persian when someone is missed, 'His place is very empty'.

PART THREE

Roloff Remembered

by Lesley Blanch

He was a rare bird, a very rare bird, for an undeniable thread of genius lay beneath an appalling mixture of vulgarity, push and snobbery. Yet he was lovable, like some awful child whose single-minded determination to get its own way could still disarm.

Editors told me they dreaded his descent on them, though seizing on his superb photographs, those lyrical visions of the world his cold little grey eyes had discovered. 'Here is your Roly Poly,' he would announce, arriving beaming, podgy, pale and breathless, with a huge portfolio of prints which soon covered every desk and table and paved the floor as he launched into his own brand of panegyric, travelogue and sales-talk – an unstoppable flow.

Could anyone forget the appearance of this holy terror? He had come from some wildly named Canadian town, Moose Rapids, or was it Medicine Hat? Perhaps that explained those pointed yellow shoes, those flamboyant jackets of dreadful cut, those bits of jewelry and a head of hair that changed colour as punctually as the seasons.

Yet he could devise such unforgettable books as *The Thrones of Earth and Heaven* or *A Time of Gods*. All beauty spoke to him, and he responded: a soaring minaret, the curve of a lute, a leaf, a dancer's foot, a pattern of pebbles . . .

I came to know him late, being rarely in England, and less often in Rome, his base. One day he sent me a flowery letter: Couldn't we do a book together? He suggested some romantic, exotic subject . . . a Near Eastern scene perhaps? Would I

discuss it with him in Rome? I was between books at the moment, pottering in my garden, and intrigued by the idea of meeting this singular, much criticized figure; snap, I said yes.

I had come by train and was discovered at the station by some inarticulate figure Roloff had dispatched to meet me, which I thought rather cavalier. However, on reaching his roof-top apartment in Trastevere, I understood. First impressions are all important. He was disclosed – a set piece – stretched languorously on a leopard-skin-covered sofa, draped in a purple velvet Bokhara khalat that Byron might have envied. I advanced through a maze of objects, ancient Indian embroideries, chintzy cushions and disastrous bric-à-brac. A large loving black poodle and a bottle of local wine broke the ice and suddenly it was fun.

'Who do you want to meet while you're here?' he asked negligently, as if able to produce the Pope, no less. I said 'Gore Vidal', Gore being a cherished friend from my life in the States. So Gore came, and there was a lot more fun.

Roloff and I decided to try working together first on some luxurious, light feature for one of the glossies. We both knew and loved the bemusing beauty of Iran, so we telephoned Beatrix Miller of *Vogue* – she being caviar among editors, a pure pleasure to work for, or with. The notion of our collaboration seemed to tickle her. 'Off you go,' she said, so off we went, literally into the blue, that *gamme* of turquoise and lapis lazuli which was once known as the Turquoise Kingdom. And that was the

226

beginning of Roloff's intoxication with the Pahlavi Court.

His was a passionate involvement with both Crown and Kingdom – with the chimera of pomp and the exquisite beauty of the land. It became an obsession. Nothing else would do.

But before that state was reached, at the time of our setting out together, he, as I, was merely an entranced beholder. Dashing about in jeeps, dawdling in musky caravanserais, here, there and everywhere, we were tracing an arabesque of brick- and tile-work beside a crumbling shrine, marvelling at the work of man – of nature, too. In a quiet courtyard in Shiraz, a pomegranate tree spilled out its brilliant crimson seed. 'Oh, look Roloff! A Ruby Tree!' We worked well together, although whenever I needed a shot of something particular for my text, Roloff was invariably absorbed in his own vision and wouldn't play. Did I say he could be tiresome? Tiresome beyond belief.

Through Persian friends I had known on my first visit to Iran and the good offices of the Canadian ambassador, James George, we obtained an audience with the Shahbanou. Together Roloff and I went to the palace at Saadabad. The Shahbanou was known for her love of the arts, and for the leading role she played in the preservation and restoration of the nation's historic treasures, at the time largely forgotten or threatened by the bull-dozers of progress. Our project interested her and she made valuable suggestions. I remember her enthusiastically rushing to her library and staggering back under the weight of two huge volumes of Flandin's engravings of early nineteenth-century Persia. Through her generous help, many doors were opened, many difficulties overcome. Our reportage done, I left Iran, but Roloff lingered. His built-in opportunism took over. The Midas glitter of Court life intoxicated him. He began to see Iran less objectively than subjectively – as it were through a personal lens – a superb subject for superb photographs, but above all, a means of personal aggrandizement. Also, of solid financial support.

Money was always a matter of prime importance to Roloff. Whether he had it or not, he was painfully stingy; perhaps careful would be a kinder word. Nevertheless, beyond all the mish-mash of sycophancy and vistas of wealth, there remained the artist's true and ardent desire to achieve some abiding tribute to the beauty and essence of Iran. And this the Shahbanou recognized. Every page of the book he was finally to achieve, *Persia: Bridge of Turquoise*, is eloquent of her active participation in its making.

A year or so after our trip, I was again in Iran and found Roloff dug-in, a familiar figure about the Palace, and generally addressed as *Dr* Beny, a title bestowed on him some time earlier, by The University of Lethbridge in recognition of his work. He was moving about the country ceaselessly, by jeep, by helicopter, by Royal furtherance, amassing material for his book. He was also acquiring an enormous collection of Royal and near Royal portraits, the Imperial family being revealed in charming settings

– shots which no other photographer had been able to achieve in such an intimate atmosphere, and for which the world's press slavered.

His small, cluttered room in a luxury hotel was choked with cameras and the latest equipment. He was aided by Mitchell Crites, who made order out of the landslides of negatives and prints and became, to myself as well as to Roloff, a much-loved friend. I was often in Iran just then and Mitch and I shared some of Roloff's wilder excursions. But together, he and I generally fled the *contre-danse* of protocol and palaces in which Roloff wallowed. Supping with princes had bolstered his ego alarmingly – his waist-line, too, and he vanished briefly, to undergo some draconian cure, re-appearing almost streamlined, fitted into the sort of suave suiting favoured by the fashion-conscious circles in which he moved.

Gone, Roly-Poly Roloff. Gone those awful yellow pointed shoes, that cosy companion of earlier journeys, and I mourned the change. However, a considerable amount of naughtiness, or downright temper, remained, and he could be what my nanny would have called a 'proper handful'. I remember doing a drawing of him seated in his pram, roaring with rage, chucking his toys out on all sides, Mitch and I ducking to avoid them as we pushed the pram. Where is that scrap of paper now? Whirled far away, into those distances where we adventured.

My last memory of Roloff is an evening in the minuscule island of Kish, a baked brown dot in the Persian Gulf's blueness. There, an inner circle of the Pahlavi Court sometimes retreated briefly. I was then writing something about the Shahbanou, and was invited to continue the audiences there. Roloff and Mitch were also invited, concerned with final additions to *Bridge of Turquoise*.

Some of us were sitting out, under the stars. A newcomer to the gathering leant across the table and addressed Roloff politely.

'I don't think I caught your name, Sir?' Roloff looked thunderous, and, swelling like an angry toad, replied:

'I am Dr Roloff Beny – the greatest photographer in the world!'

It makes a good curtain line – just what he would have wished, I think.

228

127 *A rare formal portrait of Roloff taken in Rome by a close friend, Margaret E. Donnelly, in 1972.*

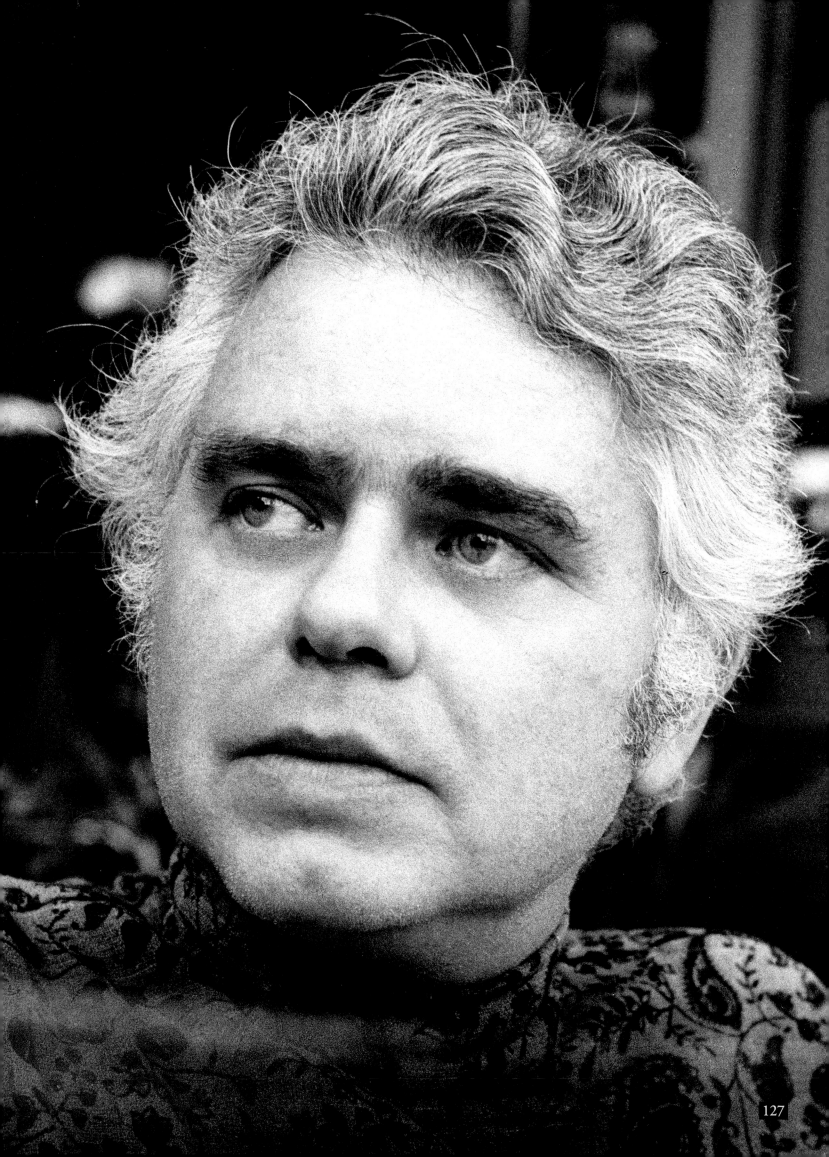

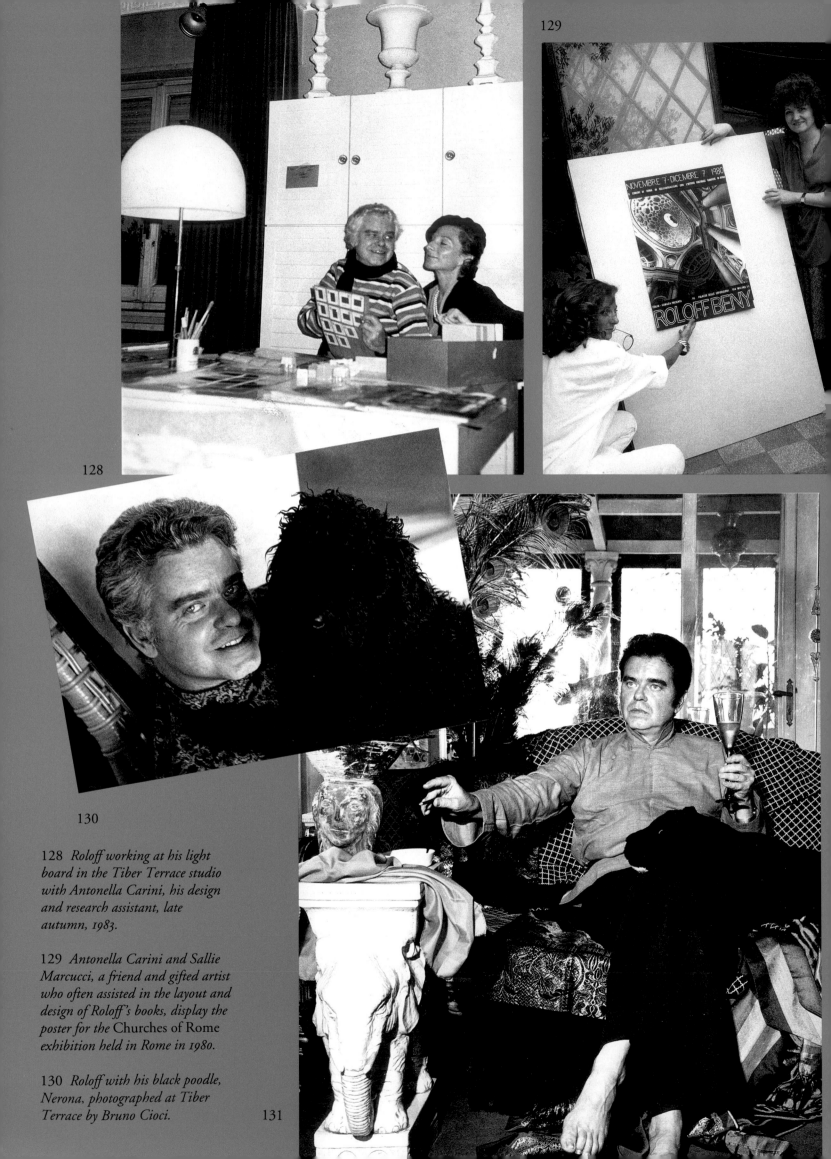

128 Roloff working at his light
board in the Tiber Terrace studio
with Antonella Carini, his design
and research assistant, late
autumn, 1983.

129 Antonella Carini and Sallie
Marcucci, a friend and gifted artist
who often assisted in the layout and
design of Roloff's books, display the
poster for the Churches of Rome
exhibition held in Rome in 1980.

130 Roloff with his black poodle,
Nerona, photographed at Tiber
Terrace by Bruno Cioci.

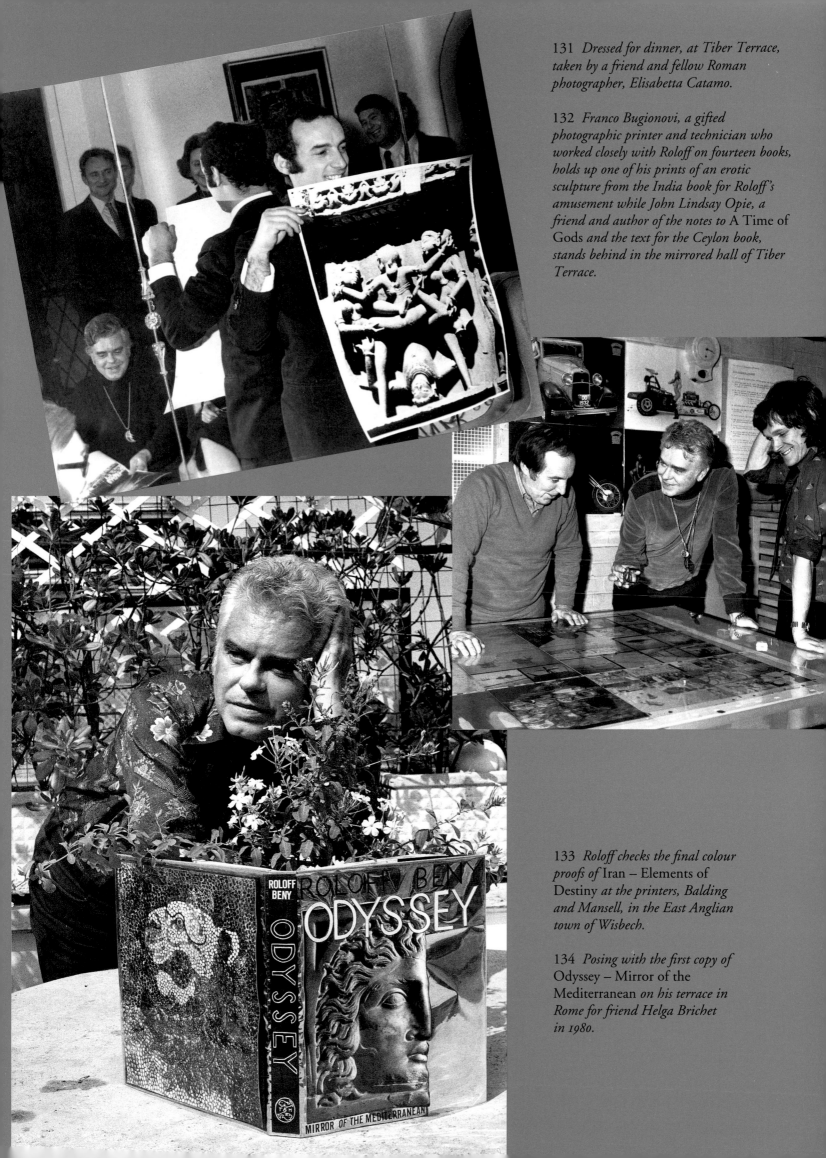

131 *Dressed for dinner, at Tiber Terrace, taken by a friend and fellow Roman photographer, Elisabetta Catamo.*

132 *Franco Bugionovi, a gifted photographic printer and technician who worked closely with Roloff on fourteen books, holds up one of his prints of an erotic sculpture from the India book for Roloff's amusement while John Lindsay Opie, a friend and author of the notes to* A Time of Gods *and the text for the Ceylon book, stands behind in the mirrored hall of Tiber Terrace.*

133 *Roloff checks the final colour proofs of* Iran – Elements of Destiny *at the printers, Balding and Mansell, in the East Anglian town of Wisbech.*

134 *Posing with the first copy of* Odyssey – Mirror of the Mediterranean *on his terrace in Rome for friend Helga Brichet in 1980.*

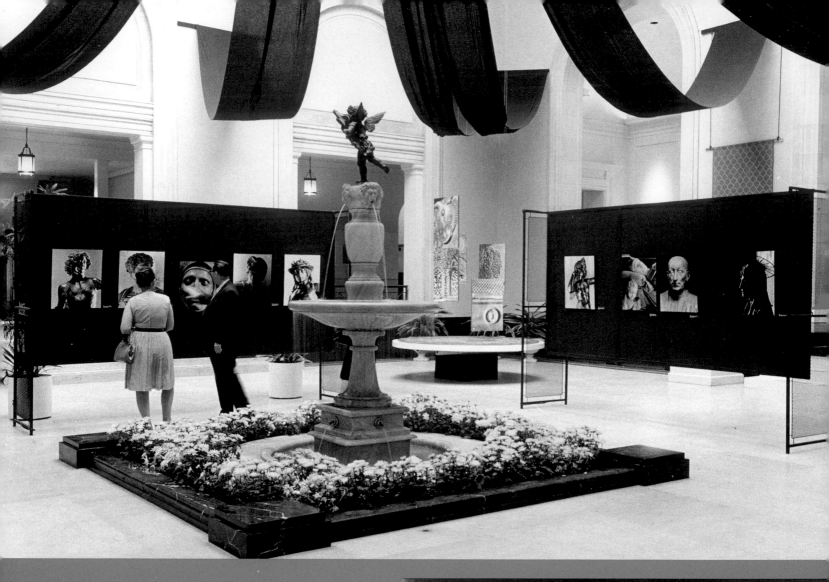

135 *Installation of 'Sculpture of the Renaissance', an exhibition of large black-and-white photographs auctioned in aid of the Save Italian Art Fund, held at the Art Gallery of Ontario, Toronto, in 1967.*

136 *The British actress, Hermione Baddeley, and the American dancer, Geoffrey Holder, join Roloff on the opening night of 'A Visual Odyssey', held at the Gallery of Modern Art, the Huntington Hartford Museum, New York, 1968.*

137 *Yousuf Karsh congratulates Roloff on his 'Pleasure of Photography: The World of Roloff Beny' exhibition in Ottawa in 1966. The exhibition was first shown in London at the Sekers Gallery and later toured a number of cities across Canada.*

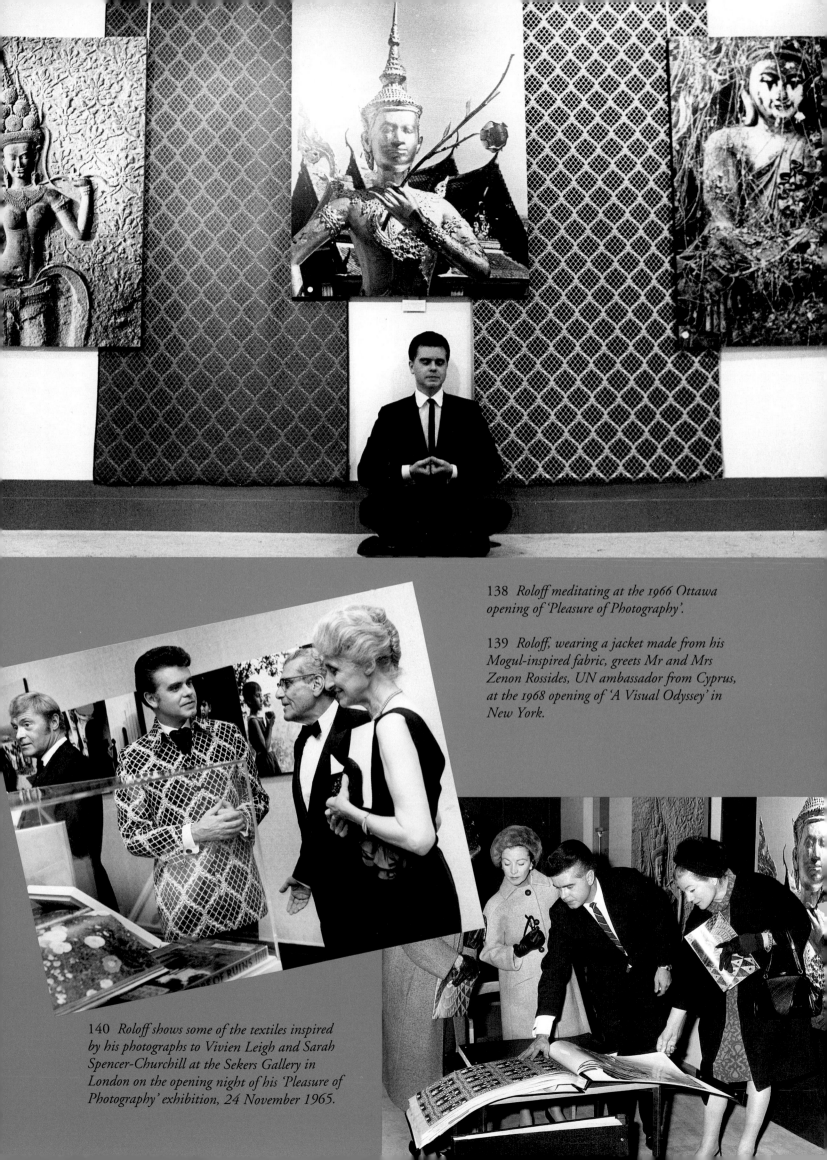

138 Roloff meditating at the 1966 Ottawa opening of 'Pleasure of Photography'.

139 Roloff, wearing a jacket made from his Mogul-inspired fabric, greets Mr and Mrs Zenon Rossides, UN ambassador from Cyprus, at the 1968 opening of 'A Visual Odyssey' in New York.

140 Roloff shows some of the textiles inspired by his photographs to Vivien Leigh and Sarah Spencer-Churchill at the Sekers Gallery in London on the opening night of his 'Pleasure of Photography' exhibition, 24 November 1965.

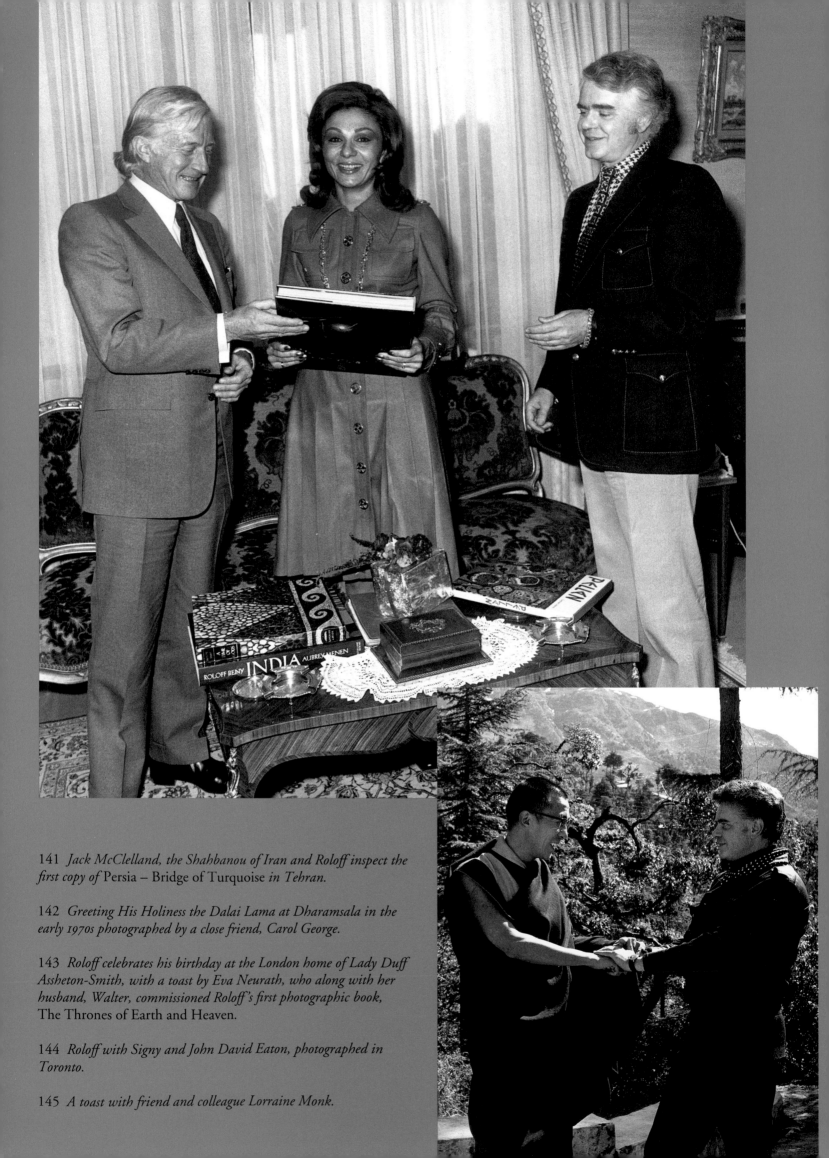

141 *Jack McClelland, the Shahbanou of Iran and Roloff inspect the first copy of* Persia – Bridge of Turquoise *in Tehran.*

142 *Greeting His Holiness the Dalai Lama at Dharamsala in the early 1970s photographed by a close friend, Carol George.*

143 *Roloff celebrates his birthday at the London home of Lady Duff Assheton-Smith, with a toast by Eva Neurath, who along with her husband, Walter, commissioned Roloff's first photographic book,* The Thrones of Earth and Heaven.

144 *Roloff with Signy and John David Eaton, photographed in Toronto.*

145 *A toast with friend and colleague Lorraine Monk.*

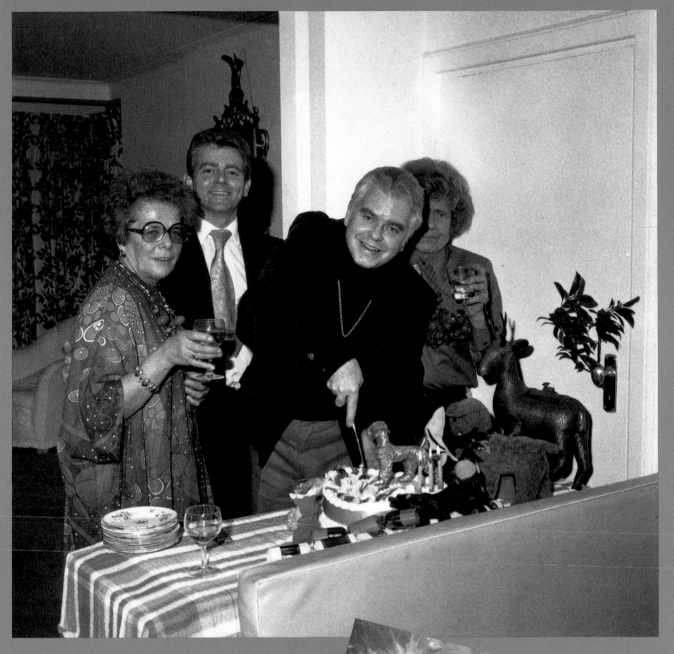

143

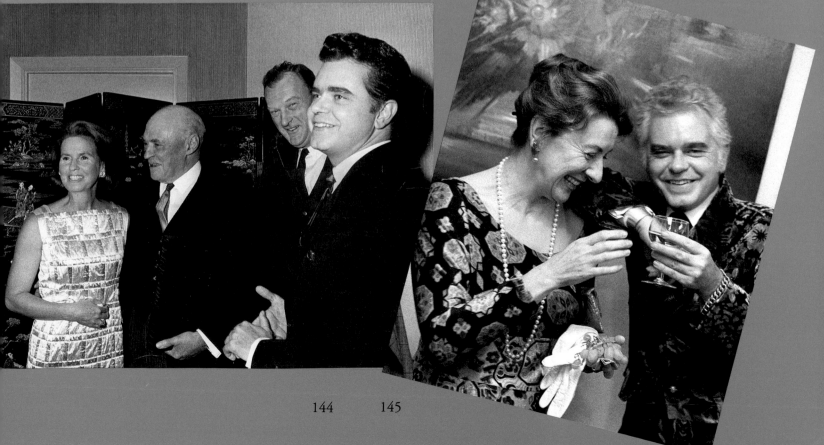

144　　145

146

146 *Roloff and Peggy Guggenheim photographed by Cecil Beaton on the grassy lawns of Villa Lambert, Vicenza, in about 1977.*

147 *Roloff playfully holds his glasses over the penis of the Marino Marini sculpture in the garden of Peggy Guggenheim's palazzo in Venice, photographed by Lorraine Monk.*

148 *One of Roloff's last photographs of Peggy Guggenheim on a solitary ride in her private gondola in Venice.*

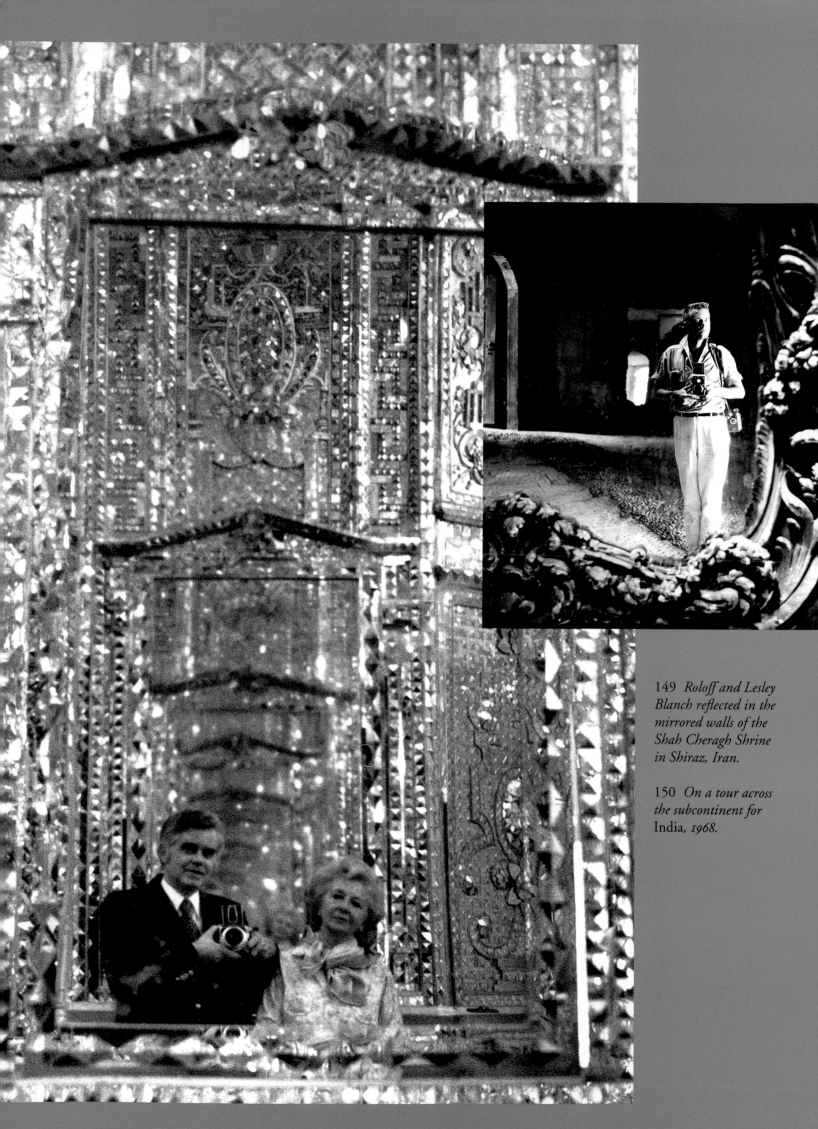

149 *Roloff and Lesley Blanch reflected in the mirrored walls of the Shah Cheragh Shrine in Shiraz, Iran.*

150 *On a tour across the subcontinent for* India, *1968.*

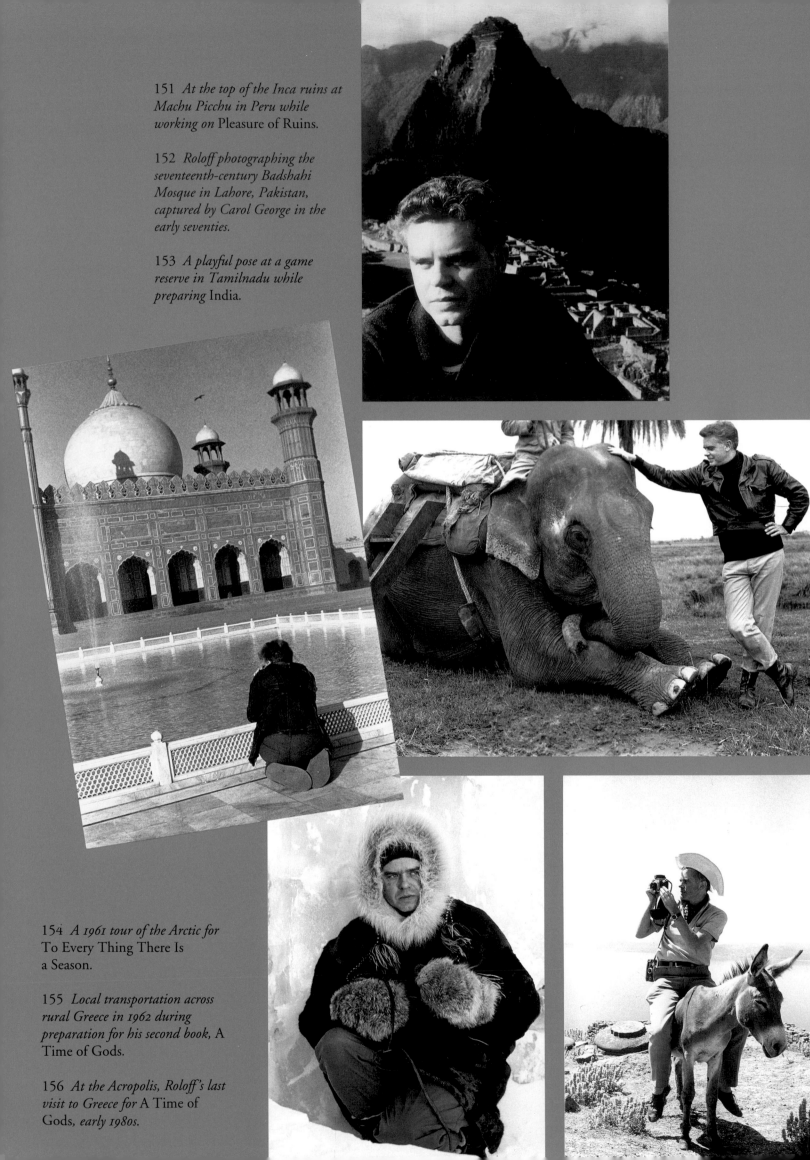

151 *At the top of the Inca ruins at Machu Picchu in Peru while working on* Pleasure of Ruins.

152 *Roloff photographing the seventeenth-century Badshahi Mosque in Lahore, Pakistan, captured by Carol George in the early seventies.*

153 *A playful pose at a game reserve in Tamilnadu while preparing* India.

154 *A 1961 tour of the Arctic for* To Every Thing There Is a Season.

155 *Local transportation across rural Greece in 1962 during preparation for his second book,* A Time of Gods.

156 *At the Acropolis, Roloff's last visit to Greece for* A Time of Gods, *early 1980s.*

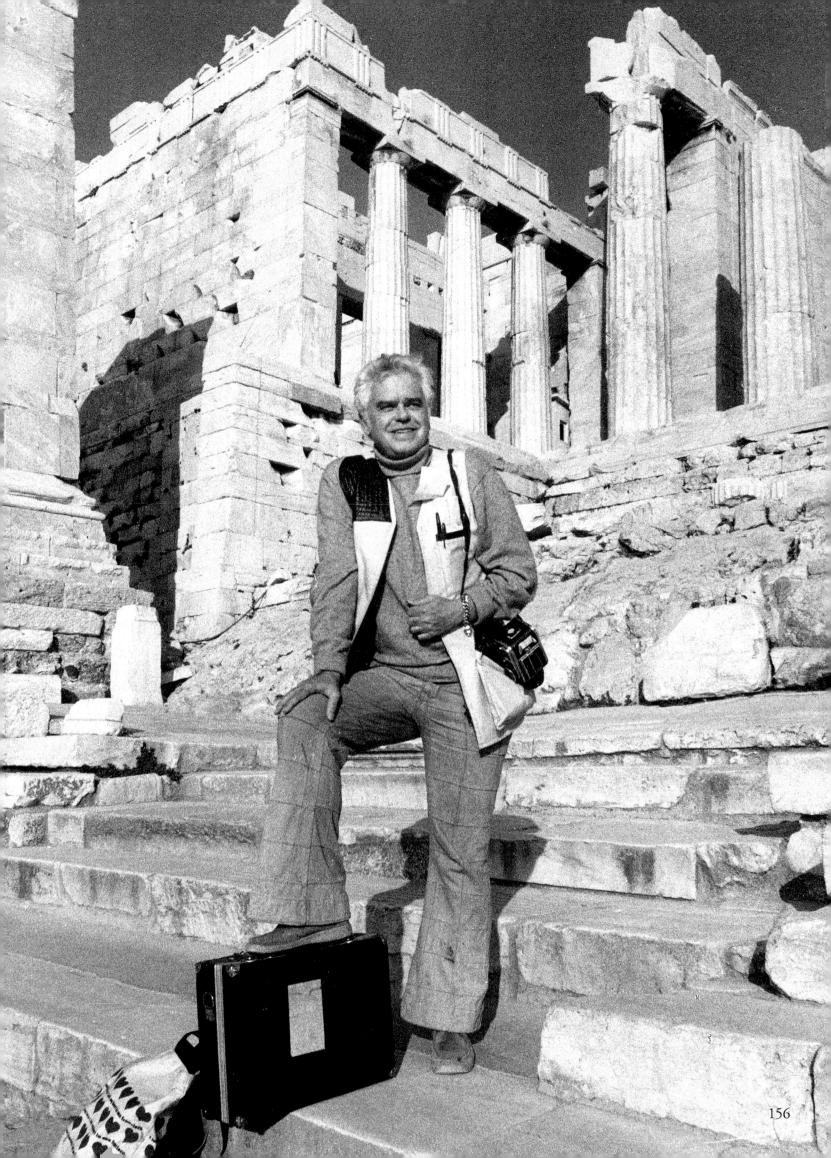

157 *A self-portrait collage
photographed in the mirrored room
at the Belgian Pavilion during the
1968 Venice Biennale.*

ROLOFF BENY THE ARTIST

BY JEFFREY SPALDING

What mischievous sport do the gods play with the fate of us mere mortals? Is it by grand celestial design, involuted bureaucratic happenstance, cruel irony or serendipity that the responsibility to safeguard the legacy of Roloff Beny should come to settle upon his Canadian prairie home town, Lethbridge, Alberta? Was it not, after all, some fifty years ago that Beny, the precocious child prodigy, embarked from southern Alberta upon his world-wide odyssey? Over the course of that journey, Beny, the peripatetic traveller and chronicler, has been lavished with countless international honours. His rise to fame was remarkable and the extent of his international renown seldom equalled by a Canadian-born artist of his day.

Before Beny had reached the age of twenty-one, his art had been included in the annual national exhibiting societies in Canada and praised as noteworthy in its art press. Beny would earn fellowships, awards, academic honours and degrees impressive by any standard. His opinion about printmaking and the artistic spirit would be published numerous times before his formal studies were concluded. By 1950, when Beny was twenty-six, his art had been exhibited and collected by some of the most prestigious, consequential art museums, including the Museum of Modern Art and Brooklyn Museum in New York, the Fogg Art Museum of Harvard University, the National Gallery of Canada, Ottawa, and the Art Gallery of Ontario, Toronto. His group and solo exhibition record was auspicious. The demand for his work in 1953 was such that it

required careful juggling of schedules by him and an associate to accommodate all the opportunities. Beny, in 1955, could count among his acquaintances Herbert Read, Peggy Guggenheim and Jean Cocteau, as well as a staggering array of luminaries and dignitaries as collectors and enthusiasts of his work. Just a few years after graduation, he was intricately connected to the art network, jaunting between New York, London and the Continent.

Roloff Beny was a bona fide art celebrity. His art found an audience internationally and he was in demand upon the social scene. Beny plunged eagerly into the dazzling world of notables, royalty and the wealthy. Remarkably too, his avant-garde abstract art exhibitions were a financial success. Private and public sales were brisk and steady at home and abroad, each purchaser duly recognized by the personal touch of an appreciative letter from the artist. The oft-repeated assessment of reviewers in 1953 granted that Beny was perhaps Canada's most internationally successful artist. Back home in Medicine Hat and Lethbridge, Alberta, news of every global exploit was greeted as a cause for collective pride.

With such an auspicious career marked by attainments and awards, one might expect that an assessment of Beny's historical place as a contributor to modern art must surely be secure. We would expect to see his example incorporated within the historic record and dialogue. Yet Beny's fame and standing have been more mercurial than meteoric; in recent years they have plummeted from view and public awareness. Today, occasions when his paint-

ings, drawings, prints or photos are on view are highly infrequent. Even those works held in public collections seem rarely displayed among general historical installations. Standard art history texts, including Canadian art histories, do not as much as index, list or mention Beny in passing. Neither is it possible to say that his work was once part of this art historical record only to fade away with time through revised texts. Despite attaining some of the most desired indicators of artistic worth – dazzling numbers of exhibitions, representations in museum collections and mentions in the art journals – the demonstrable impact of his work upon subsequent generations of artmakers seems negligible. Even in an era of pluralism and decidedly revisionist art history that has seen many artistic careers rescued from the mists of oblivion, little generosity has been extended to resurrect interest in his work. Acknowledgment and balanced assessment of the contribution and merit of his art remain elusive, filled with paradox and contradiction. Beny's star, if not fallen, is barely if at all discernible upon the cultural horizon. One could factually observe that rather than ignored, neglected or undervalued, his art is, practically speaking, unknown to today's art audience in Canada and abroad.

After decades of wandering, it is home, to Lethbridge, that the legacy of Roloff Beny's efforts as an artist returns. At the artist's bequest, The University of Lethbridge received in 1987 a comprehensive collection of over 750 of Beny's drawings, paintings and prints, chronicling his evolution from his earliest efforts as a child through to artistic maturity. Included in the bequest were Beny's archives, or, more correctly, the raw material from which an archive can be constructed – mountains of boxes and files of correspondence, records, catalogues, photos, diaristic jottings, personal effects and memorabilia. It appears that Beny was reluctant to discard any correspondence, no matter how mundane or slight.

The University of Lethbridge also received works from his impressive collection of the School of Paris and important Canadian art in 1982. The quality of the selection of these works is impeccable. Beny not only identified and collected works by central contributors, he opted for extraordinary individual examples. By this one act of generosity alone, Beny established the basis for a remarkable collection resource which is unparalleled in western Canada. It is now easier to see superlative examples of historical and contemporary international art in Lethbridge than it is in most Canadian metropolitan cities.

So now, as the collected efforts of Roloff Beny's life with art have returned to Lethbridge, we are engaged in the process of sorting, reassessing, investigating and rediscovering. Exhibitions of his work have been organized, a catalogue published, and research is ongoing. What can one usefully and fairly observe about Beny's artistic achievements and standing? What, if any, is the relationship of his early art to his mature work as a photographer and maker of books?

In 1939, Roloff Beny displayed his work publicly for the first time at the Manitoba Society of Artists exhibition. He was fifteen years old. Previously, he had received encouragement to pursue his talent from his high school art instructor. One might remark that his early drawings indicate that he was not an especially gifted draughtsman, and his choice of, and approach to, subject matter differed little from any of a host of emerging, aspiring young amateurs. Yet his good efforts won him a scholarship to attend the 1940 Summer School Programme at the Banff School of Fine Arts prior to his graduation from high school in 1941.

At Banff he studied with significant Canadian artists: H.G. Glyde, André Biéler and Bernard Middleton. In some respects, the work of these artists could be likened to artists more familiar to an international audience, such as the English artist Stanley Spencer or the mid-western American scene painters Grant Wood, Thomas Hart Benton and John Steuart Curry. It was at Banff that Beny's abilities and attitudes were moulded. His Banff notebook records that Biéler advised students to 'burlesque or exaggerate lines to give stronger effect'. Thereafter, Beny's art tends towards the expressive or manneristic rather than naturalistic appearance. Quickly, one discerns in his work awareness of English moderns akin to the Vorticism of David Bomberg and, in western Canada, to the expressionist sweep and simplification of pattern and form in work by Glyde, Bart Pragnell, Margaret Shelton and

Stanley Brunst. In formal terms then, these artists ostensibly sought to incorporate aspects of progressive, modernist invention to liberalize their picture-making. A drawing in his Banff notebook marks Beny's first transition towards this form of modernism. Meanwhile, the social message of North American regionalism established the agenda for subject matter and content. Theirs was a programme of high social purpose, a moral search for lasting human values in a mechanized technocratic world.

Beny's 1942 watercolour, *Unruly Corner*, was included, and favourably remarked upon, in the 1942 Canadian Society of Painters in Watercolour exhibition, circulated by the National Gallery of Canada. Its subject matter offers dignity to, and finds beauty and emotional strength in, the discarded, rebuffed and downtrodden: cars, barns and industrial architecture as contemporary ruins. It is interesting to note that so early in his evolution, Beny pursued 'the pleasure of ruins' which would be the mainstay of his mature photographic career.

Unruly Corner and many other Beny works of 1941–42 employ a compositional device ubiquitous within the Canadian landscape tradition. A central subject as personage is isolated against a qualifying moderating backdrop, staged and contrived to guarantee a specific message. Nostalgia, melancholy and a sense of loss prevail; ruins are remnants and remainders of a longed-for perfection. The natural cycle of birth, death, decay and, hopefully, rebirth acts as a humbling reminder of our mortality, while simultaneously providing spiritual comfort in the continuity of eternal verities. This is a persistent theme of Canadian art of the first half of the twentieth century, especially through the Group of Seven and its offshoot, the Canadian Group of Painters.

In 1943 and 1944, Beny shifted his attention away from the then familiar approach towards the Canadian landscape tradition to pursue darker visions. His works of 1944 leave behind watercolour to embrace the lugubrious effects of grand manner oil paintings. He created a group of powerful figure studies. Many featured intense searching portraits of his friend Tom Rutherford, posed in tragic dramatic roles such as Hamlet. The brooding portrait, *Man*

From Montserrat, 1944, represented Beny in the 73rd Annual Ontario Society of Artists exhibition of 1945. From this point on, we see the rapid transformation and maturation of Beny's art. By and large, his interests would shift irrevocably from nature to human nature and the human condition. Likewise, we see a shift from a regionalist or nationalist attitude towards internationalism.

At Trinity College, University of Toronto, Beny was engaged in Classical studies which might be seen as a natural complement to the prevailing art attitudes fostered between the world wars. As early as 1914, some artists were identifying themselves as 'Post Modern'. These artists were part of a worldwide tendency, the New Century, which simultaneously rejected academicism as reactionary and socially restricting, while they rebuffed pure abstraction as socially mute and irresponsible. Their search for a new order, the new century of progress, favoured a renewed humanism and return to classicism, while incorporating the formal gains of modernist invention.

By 1945, Beny was acquainted with de Chirico's work and the latter's influence can be seen in works such as *Web of the Libido*, 1945 (collection of The University of Lethbridge), and *Tamar*, c. 1946 (collection of McLaughlin Art Gallery, Oshawa, Ontario). The specific formal influence of de Chirico upon Beny's work was short-lived, yet certain basic orientations were now to dominate it for the rest of his artistic life. These works by Beny focus upon Greece as the seat of civilization. The depictions explore ruins, thus establishing Beny's persistent viewpoint which runs throughout his later work, particularly his photowork. All of Beny's art thereafter seems simultaneously to address glories of the past and melancholy concerning its passing.

Much of Beny's work in painting and photography from 1945 to 1984 utilizes fragments of past civilizations, statuary and architecture, set against stark otherworldly stage sets to deliver the artist's message. In many respects, this type of mission to communicate specific thoughts might have catapulted Beny towards a formally conservative, representational direction. However, at the same time as investigating these ideas, he was becoming at ease with the notion of modern abstraction.

Both in Toronto, where Beny served on the University's progressive Hart House Art Committee, and on his travels to New York, Montreal and Alberta in 1945, he would have encountered the work of Canadian abstract artists. He was a member of the Canadian Group of Painters, which, although it was primarily identified with regionalist representation, included among its chief officers prominent experimental artists and other 'Moderns'.

Beny's papers include an exhibition pamphlet for the 1945 show of non-objective paintings by the Canadian Edna Taçon held at the Gallery of Fine Art, Eaton's College Street in Toronto. The work illustrated in the pamphlet shows characteristics that are relatable to Beny's 1947 exploration of abstract form.

In 1945 Beny went on a scholarship to the State University of Iowa, where he studied with the printmaker Mauricio Lasansky. It was the Iowa Summer Exhibition of the following year, where outstanding examples of progressive art were gathered in one place, that provided one of the most formative impetuses for Beny's transformation to the modern mode.

Beny's studies at Iowa confirmed his commitment to aspire to international, as opposed to Canadian, models; his work transformed radically from 1945 to 1947. By 1947, he was exhibiting work which incorporated, side-by-side, semi-abstracted figuration in the humanistic tradition of the School of Paris and experiments in pure form which conjure up associations with a Bauhaus-inspired example. Beny's restless spirit freewheeled among the progressive options presented for his consideration at Iowa, experimenting at will. Nowhere is this clearer than with his acclaimed suite of prints, *Ecclesiastes*, works which imply grandiose, biblical, almost mythic subjects, the human condition 'stripped bare', and all involve exquisite exploration of combined printmaking techniques, lush textural and colouristic effects. As a group, they are split between plates which are purely abstract, such as *A Time to Build*, and those incorporating figurative elements, such as *A Time to Mourn*.

In the 1950s Roloff Beny and many progressive Canadian artists found themselves in an artistic no-man's-land, caught between the positions of the Europeanate School of Paris, the curious combination of intellectual abstraction and humanistic figuration associated with Britain (and, to an extent, with Italy, through Marini and Manzù) and the audacious formal abstraction of the New York School. What room was there left for the Canadian character?

Beny's art in Canada performed the function of participating in the missionary zeal and groundbreaking efforts to popularize these international concepts in legitimate form back home in his native land. What thanks has he received, however? Rarely did reviewers comment about his work without, on the one hand, expressing simultaneous admiration for the general case and reservation about the specifics. Can we not, at the very least, acknowledge that Beny's fine works were excellent examples of the strides towards the international spread of the modern spirit?

By the early fifties, Beny was exhibiting his work at the Knoedler Gallery, New York, with favourable mentions in the press. Year by year, his work evolved and changed. In 1954 he produced works like *Spring Storm*, *Solar Paradox* and others, which one might compare in a diminutive sense with American Abstract Expressionism. Yet Beny's notable achievements of the early fifties in pure abstraction would not hold his attention for long. Despite his own written statements to the contrary, gradually the primacy of meaning began to re-emerge as his central concern. Titles such as *Spring Storm* and *Solar Paradox* point away from 'the thing in itself' to imply other than aesthetic purposes. His temperament and underlying spiritual character and intellectual impulses would not allow him to embrace New York School American-style abstraction. He would be more at home surrounding himself with furnishings, artefacts and decorative accoutrements embracing the trappings of imperial Rome.

Beny's impulses are those of a literary, learned man, seeking connections with the grand accomplishments of Western culture, harking back to Classical antiquity. Elsewhere, progressive modernists at mid-century took pride in denigrating tradition, espousing democratic, socialist ideals. This was the conundrum that faced so many artists of the time who were attempting to create their own

place within the international modernist movement. Canadian politics notwithstanding, was there any place in the modern world for a progressive conservative?

Beny was keenly aware of the conflicting passions and debates concerning the philosophy and purpose of art. In 1944, in his first published article, he rejected both 'the rhetorical extravagance of the non-objective painters of "inner spiritual organization . . . the white ecstasy of mental efforts fulfilled", [and] the other extreme of Tolstoy's social consciousness which insists that the task of Christian art is the establishment of brotherly union among men'. Instead, he suggests that art's vindication is the transformation of barren raw material into the production of beauty and the artist's search is for new forms and meanings 'as a guide to better and fuller living'. From this, we might expect Beny's art to be committed thereafter to formal, secular explorations. We might, therefore, look quizzically at his works illustrated to accompany the article. *The Soil*, *Survival* and *Prairie Symphony* are distinctly symbolic, spiritual, even religious works. However, his closing statement provides the touchstone for understanding the steady unfolding of Beny's lifelong preoccupation and spiritual-philosophic quest, undertaken throughout his paintings, photographs and books: 'In the end, it is the artist who can capture some vision of the truth, who can, in a measure, defy the ancient axiom of life – This too shall pass away'. Whether it be abstracted works, such as *The Height of Time*, 1959, or abstracted figuration reflecting Greek antiquity, such as his *Aegean note-book*, 1950, or *Bottles of Aquilea*, 1952, Beny's works participate in that specifically School of Paris quest for the meaning of human existence and ultimate truths. This is a type of idealism that sends artists reflecting backwards to Classicism, inward to dream realities, and forward to futuristic, otherworldly fantasy.

Lofty ambition and fallen empires are not two concepts happily co-joined in America. Yet these are the messages and warnings sent out by Beny's art (*nota bene*: even in the land of Arcadia, death is ever present). In the long haul, Beny's view of humanity and of our collective vanity may prevail. Meanwhile, the latter part of the twentieth century continues to be intent upon radical political reconstruction and social progress. Wistful backward reflections seem quaint anachronisms. Deferring to a classical European world-view might seem almost treasonous, if not simply mis-timed.

JEFFREY SPALDING, Director
The University of Lethbridge Art Gallery
Lethbridge, Alberta, Canada

PLATES OF ART WORKS BY ROLOFF BENY

18 *Tamar*, 1946. Oil on canvas; 36⅛ × 28 in., 91.9 × 71.1 cm. Collection of the Robert McLaughlin Gallery, Oshawa, Ontario. Gift of Isabel McLaughlin, 1987

19 *Island Pietà*, November 1948. Collage and gouache on brown paper sheet; 26 × 34 in., 66 × 86.4 cm. Exhibited at the Gallery of Fine Art, Eaton's College Street, Toronto; Weyhe Gallery, New York; now in the collection of The University of Lethbridge Art Gallery, Lethbridge, Alberta

20 *Mutilation in the Museum – Agora Excavations, Athens*, from *an Aegean note-book*. 10 × 9½ in., 25.2 × 24 cm.

21 *Mourning Interior*, 1947. Oil and crayon on canvas; 39½ × 29⅝ in., 100.6 × 75.2 cm. Collection of the University of Lethbridge Art Gallery, Lethbridge, Alberta

22 *A Time to Build*, 1947, from the *Ecclesiastes* series of 6 prints, intaglio over relief print 13/15. Sheet: 16⅝ × 13¼ in., 42.2 × 33.7 cm; image: 15 × 12½ in., 38.1 × 31.8 cm.

23 *A Time to Mourn*, 1947, from the *Ecclesiastes* series of 6 prints, intaglio over relief print 2/15. Sheet: 17 × 13 in., 43.2 × 33 cm; image: 15 × 12½ in., 38.1 × 31.8 cm.

24 *A Time of Peace*, 1953. Oil on canvas, 48 × 35 in., 122 × 89 cm. National Gallery of Canada, Ottawa

25 *In the Beginning*, 1958. Charcoal on card sheet; 29¾ × 39⅜ in., 75.6 × 100.1 cm. Collection of The University of Lethbridge Art Gallery, Lethbridge, Alberta

26 *Arctic Vertical*, 1964. Charcoal and gouache on card sheet; 39¾ × 29¾ in., 101 × 75.6 cm. Collection of the University of Lethbridge Art Gallery, Lethbridge, Alberta

CHRONOLOGY

1924 7 January. Born Wilfred Roy Beny in Medicine Hat, Alberta.

1939 First work publicly exhibited – a watercolour shown at the Manitoba Society of Artists, which wins Beny a scholarship to the Banff Summer School of Fine Arts where he studies with H.G. Glyde.
Photographs King George and Queen Elizabeth on their visit to Medicine Hat.

1941 Graduates from high school in Medicine Hat.
Attends Trinity College, University of Toronto.
Meets and becomes friends with Charles Comfort.
Becomes the first undergraduate to have a one-man exhibition at Hart House, Toronto.
Exhibits with the Manitoba Society of Artists.

1942 Watercolour *Unruly Corner* selected by the National Gallery of Canada for inclusion in a nation-wide tour of an exhibition of the Canadian Society of Painters in Watercolour.
Exhibits at Hart House.

1943 *Night Flying No. 34 F. T. S.* shown in the Ontario Society of Artists 71st Annual Exhibition.
Included in the exhibition 'Painters Under Twenty' at the Art Gallery of Toronto (now the Gallery of Ontario).
Watercolour on theme of war selected for the Special Wartime Section of the Canadian Society of Artists at the National Gallery of Canada.
Shows interest in modern scientific theories of space and time as these apply to concepts of the physical universe, ideas which are to have a profound effect on his art.

1944 One-man exhibition at Hart House, his second as an undergraduate.
Represented in two exhibitions in western Canada; the Manitoba Society of Artists in Winnipeg and the Saskatoon Society of Artists in Saskatoon.
Exhibits with the Ontario Society of Artists in Toronto.

1945 Graduates with the degrees Bachelor of Arts, Honours, and Bachelor of Fine Arts from Trinity College, University of Toronto.
Awarded scholarship to the State University of Iowa to study printmaking with Mauricio Lasansky.
Exhibits, for the first time, with the Art Association of Montreal.
Exhibits with the Ontario Society of Artists.
Beny family moves from Medicine Hat to Lethbridge.

1947 Graduates with the degrees Master of Arts and Master of Fine Arts, from the State University of Iowa.
Awarded fellowship to study for the degree of Doctor of Philosophy in art history and aesthetics at Columbia University and at the Institute of Fine Arts, New York University.
First one-man exhibition in the United States at the Weyhe Gallery, New York; exhibits includes *Ecclesiastes* series.

1948– All or part of *Ecclesiastes* series acquired by a num-
1949 ber of public institutions, including the National Gallery of Canada.
Travels in Italy, France and Greece; studies at the American School of Classical Studies, Athens.

First one-man exhibition in Europe at the Vetrina della Strozzina, Palazzo Strozzi, Florence.
Commissioned by author Philip Child to produce eighteen drawings for his book, *The Village of Souls*.
Returns to family home in Lethbridge, Alberta, to convalesce after rheumatic fever.

1950 Produces *an Aegean note-book*, limited edition book containing twenty lithographs, chronicling his sojourn in the Aegean, while recovering from his illness.
Exhibits at Knoedler Gallery, New York.
Retrospective exhibition at the Gallery of Fine Art, Eaton's College Street, Toronto.

1951 One-man exhibition at Knoedler Gallery, New York.
One-man exhibition at Galleria del Corso, Merano, Italy.
One-man exhibition at the Galleria del Calibano, Vicenza, Italy.
Loses sketchbook on trip to Spain and turns to his camera.

1952 One-man exhibition at the Paul Morihien Gallery, Palais Royal, Paris.
'An Exhibition of Easter Eggs', Roloff Beny, Marc Chagall and others, Paris.
One-man exhibition at the Galleria Il Milione, Milan.
Exhibits at the Galerie Kunst der Gegenwart, Salzburg, Austria.
Designs London Festival Ballet poster.
Wins Hallmark Award for Christmas card with painting of Chartres Cathedral, New York.
Awarded John Simon Guggenheim Fellowship for studies in printmaking and painting.
Dabbles in fashion photography, New York.

1953 One-man exhibition at the Gallery of Fine Art, Eaton's College Street, Toronto.
Group exhibition of contemporary printmakers, Brooklyn Museum.
Group exhibition, Dallas Museum of Fine Arts.
Young American Printmakers' Exhibition, Museum of Modern Art, New York.
Group exhibition, Bezalel Museum, Jerusalem.

1954 Maintains residences in Lethbridge, New York and Rome.
Collects works by European and North American artists.
Exhibits at the Cincinnati Art Museum.

One-man exhibition at Knoedler Gallery, New York.
One-man exhibition at Robertson Gallery, Ottawa.
One-man exhibition at Waldorf Galleries, Montreal.
Exhibition 'Roloff Beny and Jack Shadbolt' at the Art Gallery of Toronto, includes series of paintings, *Ecclesiastes*.
'The World of Roloff Beny' exhibition at Art Gallery of Ontario, Toronto.

1955 Travels with Nellie van Doesburg to Yucatán.
Works tour Western Canadian Art Circuit.

1956 One-man exhibition at The Contemporaries gallery, New York.
Exhibits at the Weyhe Gallery, New York.
One-man exhibition at Galleria Sagittarius, Rome.
Photographs of Spain and Yucatán exhibited at Institute of Contemporary Art, London, and meeting with Walter and Eva Neurath from Thames and Hudson, London.
Photographic tour of the Mediterranean for *The Thrones of Earth and Heaven*.

1957 Moves into 'Tiber Terrace', Rome.

1958 *The Thrones of Earth and Heaven*, first photographic book, published.

1960 'Metaphysical Monuments', photographic happening at Galleria Appunto, Rome.

1962 *A Time of Gods* published.

1963 Nine-month around-the-world tour photographing for *Pleasure of Ruins*.

1964 *Pleasure of Ruins* published.

1965 Exhibition: 'Pleasure of Photography: The World of Roloff Beny' at Sekers Gallery, London.

1966 'Pleasure of Photography' exhibition tours Ottawa, Vancouver, Toronto, Montreal and Prince Edward Island.
Helps to arrange purchase of Henry Moore sculpture, *The Archer*, for Toronto.

1967 Photographs exhibited at VIP Pavilion for Expo '67, Montreal.
Exhibition of photographs and paintings at Galleria Paolo Barozzi, Venice.
To Every Thing There is a Season published.

Japan in Colour published.
Created a Knight of Mark Twain.
'Sculpture of the Renaissance' photographs auctioned in aid of Save Italian Art Fund, Art Gallery of Ontario, Toronto.
Donates some of his early art works to The University of Lethbridge.
Receives Canadian Centennial Medal.

1968 'A Visual Odyssey: 1958–1968', photographic exhibition at the Gallery of Modern Art, The Huntington Hartford Museum, New York.
'The Renaissance', photographic exhibition at the University of Toronto.
Visual Arts Award, Canada Council.
Creates permanent photographic exhibition for firm of Nesbit Thomson, Toronto.

1969 *India* book published.

1971 *Island: Ceylon* published.
'The Art of Roloff Beny' exhibition at Canada House, New Delhi.
'A Visual Odyssey', Toronto Dominion Centre.

1972 Receives honorary Doctorate of Laws degree from The University of Lethbridge.
'Beautiful Canada' calendar published by McClelland and Stewart Ltd, Toronto.

1973 'A Visual Odyssey' exhibition purchased by the Siebens family for the University of Calgary.
Made life member of Royal Canadian Academy of Arts.
Made an Officer of the Order of Canada.

1974 *In Italy* published.
Photographic exhibition in the Cloister of the Church of San Francesco, Sorrento, sponsored by the Canadian Cultural Institute, Rome.
Roloff Beny lecture tour to fourteen cities across Canada to promote *In Italy*.

1975 *Persia: Bridge of Turquoise* published.
'Roloff Beny: Iran', photographic exhibition at Ontario Science Centre, Toronto, and at Bowman Arts Centre, Lethbridge, in 1976.
Exhibition of photographs of Iran and Canada, Negarestan Museum, Tehran.

1978 *Iran: Elements of Destiny* published.
'Patterns of Persia' and 'Metamorphosis of the Book', two photographic exhibitions at Museum of Contemporary Art, Tehran.

Roloff's painting, prints and literary archive given to The University of Lethbridge Art Gallery.

1979– Furore over purchase of Beny Photographic
1980 Archive by Alberta government.

1980 'Roloff Beny in Italy and Canada', photographic exhibition at Palazzo delle Esposizioni, Rome.
Beny photographs of Peggy Guggenheim given for permanent exhibition, Venice.
Canadian Cultural Institute sponsors two photographic exhibitions, 'To Every Thing There is a Season' and 'Churches of Rome', to tour Europe.

1981 *Odyssey: Mirror of the Mediterranean* published.
The Churches of Rome published.
Photographic exhibition, 'The Churches of Rome', at Royal Institute of British Architects, London.
'Odyssey' exhibition, Rome, Ankara, Rabat and across Canada.
'Odyssey' exhibition sponsored by Smithsonian Institution Travelling Exhibitions to tour United States.

1982 Roloff's photographs of Peggy Guggenheim exhibited at the opening of '60 Works: The Peggy Guggenheim Collection', Venice.
Roloff's collection of North American and European art received by The University of Lethbridge Art Gallery in two stages: 1982 and 1984 through a gift-purchase agreement assisted by the Alberta 1980s Endowment Fund.

1983 'Americans in Italy', photographic exhibition at the Galleria San Marco, Rome.
The Gods of Greece published.
'Four Photographers in Rome and Regione Lazio', photographic exhibition, Palazzo Braschi, Rome.

1984 16 March, Roloff dies at Tiber Terrace, Rome.
Rajasthan: Land of Kings published.

1985 *The Romance of Architecture* published.
Iceland published.

1987 The jury appointed in Roloff's will decides that The University of Lethbridge should be the recipient of more than six hundred of his own paintings, drawings and prints, the archives relating to his career as an artist and the remainder of works from his collection of European art.

1989 'Odyssey. A Journey of Discovery Through Modern Art. Roloff Beny 1924–1984' organized by The

University of Lethbridge Art Gallery.

1990 'Roloff Beny: Painter, Printmaker', retrospective exhibition of Roloff's art work, shown at the Medicine Hat Museum and Art Gallery and again during the summer of 1991 at The University of Lethbridge Art Gallery which also researched and organized the exhibition.

1991 Roloff prominently featured in 'Nomads', an exhibition of famous Canadian travellers, National Library of Canada, Ottawa.

1993 Roloff Beny Photographic Archives officially received by National Archives of Canada, Ottawa; archiving and preservation of more than 150,000 photographs, personal diaries, correspondence and publishing records initiated.
The Shahbanou of Iran publishes a book on her travels in Iran drawing extensively from the Beny Photographic Archive, Ottawa.
Roloff Beny Gallery in the Institute of Contemporary Culture, Royal Ontario Museum, Toronto, endowed through a grant from the Roloff Beny Foundation, holds its inaugural exhibition 'The Sacred Earth: Photographs by Courtney Milne'.

PHOTOGRAPHIC BOOKS
BY ROLOFF BENY

The Thrones of Earth and Heaven
Thames and Hudson Ltd, London (1958)
Harry N. Abrams Inc, New York
Droemersche Verlagsanstalt, Munich
Editions B. Arthaud, Paris
TEXT: Freya Stark, Bernard Berenson, Jean Cocteau,
Rose Macaulay, Stephen Spender; Foreword by
Sir Herbert Read; notes by Roloff Beny
International Prize for Design, Leipzig Book Fair

A Time of Gods
Thames and Hudson Ltd, London (1962)
The Viking Press Inc, New York
Longman (Canada) Ltd, Don Mills
Droemersche Verlagsanstalt, Munich
Editions B. Arthaud, Paris
Liberia Editorial Argos S.A., Barcelona
Uitgeverij W. Gaade, The Hague
Bokförlaget Natur och Kultur, Stockholm
Werner Söderström Osakeyhtiö, Helsinki
Electa, Milan
TEXT: Quotations from Chapman's translation of the
Odyssey edited by Roloff Beny with notes by John
Lindsay Opie
Silver Medal, Leipzig Book Fair
French edition selected as one of the fifty great books of
1965 by the Comité des Arts Graphiques Français

Pleasure of Ruins
Thames and Hudson Ltd, London (1964)
International Book Society, Time-Life Books, New
York
Droemersche Verlagsanstalt, Munich
Librairie A. Hatier, Paris
Edito-Service S.A., Geneva
Ediciones Grijalbo S.A., Barcelona
Uitgeverij Contact, N.V., Amsterdam

Bijutsu Shuppan-Sha, Tokyo
Jugoslavija Izdavacki Zavod, Belgrade
TEXT: Rose Macaulay, selected and edited by Constance
Babington Smith
Original and revised editions (1977), Time-Life Book-
of-the-Month Club selections in the United States

To Everything There is a Season:
Roloff Beny in Canada
Thames and Hudson Ltd, London (1967)
The Viking Press Ltd, New York
Longman (Canada) Ltd, Don Mills
TEXT: Anthology of prose and poetry edited by Milton
Wilson
Centennial Medal from the government of Canada
Silver Eagle, Nice International Book Fair, 1969
Best-seller list in Canada for six months

Japan in Colour
Thames and Hudson Ltd, London (1967)
McGraw-Hill Book Company, New York
Longman (Canada) Ltd, Don Mills
Bucher, Lucerne
Editions Leipzig GmbH, Leipzig
Editions B. Arthaud, Paris
Lademann, Copenhagen
TEXT: Anthony Thwaite; Introduction by Sir Herbert
Read
Gold Medal, Leipzig International Book Fair, 1968, for
the most beautiful book of the year

India
Thames and Hudson Ltd, London (1969)
McGraw-Hill Book Company, New York
McClelland and Stewart Ltd, Toronto
Editions B. Arthaud, Paris
Ediciones Destino S.A., Barcelona

Meulenhoff-International N.V., Amsterdam
TEXT: Essay by Aubrey Menen
Book-of-the-Month Club selection in the United States

Island: Ceylon
Thames and Hudson Ltd, London (1971)
The Viking Press Ltd, New York
McClelland and Stewart Ltd, Toronto
TEXT: John Lindsay Opie; Epilogue by Arthur C. Clarke

In Italy
Thames and Hudson Ltd, London (1974)
Harper and Row Publishers, Inc, New York
McClelland and Stewart Ltd, Toronto
Bucher, Lucerne
Forum, Sweden
Arnoldo Mondadori, Milan
TEXT: Anthony Thwaite, anthology by Peter Porter and
Epilogue by Gore Vidal
Book-of-the-Month Club selection

Persia: Bridge of Turquoise
McClelland and Stewart Ltd, Toronto (1975)
Thames and Hudson Ltd, London
New York Graphic Society Ltd, Greenwich, Ct.
Arnoldo Mondadori, Milan
Bucher, Lucerne
Mercatorfonds, Antwerp
Librairie A. Hatier, Paris
Persian language edition, McClelland and Stewart,
Toronto
TEXT: Essay and anthology by Seyyed Hossein Nasr;
Foreword by the Shahbanou of Iran and historical notes
on the plates by Mitchell Crites
French edition awarded the Charles Blanc Medallion by
the Académie Française, 1977
Special award of excellence, Stuttgart Book-Week, 1976

Iran: Elements of Destiny
McClelland and Stewart Ltd, Toronto (1978)
Everest House, New York
Collins, London
Mercatorfonds, Antwerp
TEXT: University of Tehran team of professors; Message
from the Shah of Iran and notes by Mitchell Crites.
Editorial direction Shahrokh Amirarjomand

Received award as the most beautifully printed book of
the year in the United Kingdom

Odyssey: Mirror of the Mediterranean
Thames and Hudson Ltd, London (1981)
Harper and Row Publishers, Inc, New York
McClelland and Stewart Ltd, Toronto
Editions Bordas, Paris
Arnoldo Mondadori, Milan
Bucher, Lucerne
TEXT: Text and anthology by Anthony Thwaite
Bronze Medal from International Book Design
Exhibition, Leipzig Book Fair, 1982

The Churches of Rome
Weidenfeld and Nicolson, London (1981)
Simon and Schuster, New York
TEXT: Peter Gunn

The Gods of Greece
Weidenfeld and Nicolson, London (1983)
McClelland and Stewart Ltd, Toronto
Harry N. Abrams Inc, New York
TEXT: Arianna Stassinopoulos

Rajasthan: Land of Kings
McClelland and Stewart Ltd, Toronto (1984)
The Vendome Press, New York
Frederick Muller, London
TEXT: Sylvia A. Matheson

The Romance of Architecture
Thames and Hudson Ltd, London (1985)
Harry N. Abrams Inc, New York
McClelland and Stewart Ltd, Toronto
Editions Du Chene, France
TEXT: Anthology and introduction by John Julius
Norwich

Iceland
Muller, Blond and White, London (1985)
Salem House, Salem, New Hampshire
McClelland and Stewart Ltd, Toronto
Örn og Örlyguru, Reykjavik
TEXT: Pamela Sanders and Foreword by John Julius
Norwich

COUNTRIES PHOTOGRAPHED
BY ROLOFF BENY

ALGERIA	HONDURAS	MOROCCO
BULGARIA	HONG KONG	NEPAL
BURMA	ICELAND	NORWAY
CAMBODIA	INDIA	PAKISTAN
CANADA	IRAN	PERU
CYPRUS	IRAQ	SPAIN
DENMARK	IRELAND	SRI LANKA (CEYLON)
EGYPT	ISRAEL	SYRIA
ETHIOPIA	ITALY	THAILAND
FRANCE	JAPAN	TUNISIA
GERMANY	JORDAN	TURKEY
GREECE	LEBANON	UNITED KINGDOM
GUATEMALA	LIBYA	UNITED STATES
HAITI	MACAO	YUGOSLAVIA (FORMER)
	MEXICO	

PHOTO CREDITS

Gainsboro Studio, Medicine Hat, Alberta, 5; *Lethbridge Herald*, Lethbridge, Alberta, 8; Tom Hustler, 11; Islay Lyons (photo no. RB/A/6) 13; Bruno Cioci, 16; Collection of the Robert McLaughlin Gallery, Oshawa, Ontario, 18; Collection of The University of Lethbridge Art Gallery, Lethbridge, Alberta, 19, 21; National Gallery of Canada, Ottawa, 24; Collection of The University of Lethbridge Art Gallery, Lethbridge, Alberta, 25, 26; Peggy Guggenheim Collection, Venice (Solomon R. Guggenheim Foundation), 38 and, gift of Roloff Beny, 39; George Mott, 123, 124; Margaret E. Donnelly, 127; Bruno Cioci, 130; Elisabetta Catamo, 131; Helge Brichet, 134; Chris K. Economakis Photography, 136; Doug Bartlett, 137; Chris K. Economakis Photography, 139; Hulton Deutsch Collection, 140; Carol George, 142; Toronto Star Syndicate, Toronto, Ontario (photo no. B832-17) 144; R. Tarnovetsky, 145; gift of Cecil Beaton, 146; Lorraine Monk, 147; Peggy Guggenheim Collection, Venice (Solomon R. Guggenheim Foundation), 148; Carol George, 152; photographer unknown, 7, 9, 10, 12, 14, 15, 17, 125, 128, 129, 132, 133, 135, 138, 141, 143, 151, 153-56. Every effort has been made to contact the photographers and copyright holders of documentary material from the Roloff Beny archives which has been included in the book, but the publisher regrets that in a few instances it has not been possible to trace a source.

All other photographs were taken by Roloff Beny and are now in the collection of the National Archives of Canada, Accession No. 1986-009, Documentary Art and Photography Division, with those listed above.

Acknowledgments

As would be expected with a book about Roloff Beny, my gratitude and acknowledgments span the world. In his native Canada, I am particularly indebted to Jack McClelland, Dr John Woods and Bernard Fahy who, through the patronage and support of the Roloff Beny Estate and the Roloff Beny Foundation, have encouraged and supported me throughout this project. Many of Roloff's friends and colleagues contributed insightful reminiscences and interviews including Dr Margaret P. Hess, Stewart McKeown, Dorothy Cameron Bloore, Lorraine Monk, Signy Eaton, Hamilton Southam, David Shaw, Peter Scaggs, Gordon Frith and James and Carol George.

Lily Miller, a dear friend from the 'Persia' days, guided me as she often did Roloff when he came to sort out his editorial problems at McClelland and Stewart. In Ottawa, Lily Koltun and her staff at the National Archives of Canada, especially Edward Tompkins, revealed remarkable patience as I delved deeper and deeper in my search for images, letters and diaries. Jeffrey Spalding at The University of Lethbridge Art Gallery generously assisted me in my research and wrote a scholarly essay on Roloff's career as an artist.

In London, where *Visual Journeys* finally came together, all at Thames and Hudson were marvellous in their support and tolerance with my constant travels abroad, especially Sue Ebrahim who produced such a sensitive layout . Michael Shaw, Roloff's literary agent, remained a diplomatic and reassuring voice throughout.

In my own office, Anthony Kan and my fellow colleagues were long-suffering and supportive through the months of research and travel that took me away from our work in India.

From Rome, John Lindsay Opie contributed a Sri Lankan adventure and many hours on the telephone remembering Roloff. Antonella Carini, a loyal and gifted researcher and photographic editor who worked with Roloff in the Tiber Terrace studio until his death, shared many insights into his last troubled years.

A special word of gratitude to the Shahbanou of Iran, Farah Pahlavi, a treasured friend of Roloff and his greatest patron, and to Lesley Blanch, who shared many of our Persian adventures, and from her home in Menton, France, wrote the moving and witty epilogue for the book.

Roloff's autobiographical writings which eloquently grace many of the pages of this book went through many agonizing versions over the years guided and edited by three friends who deserve special recognition for their painstaking and sensitive efforts: Peter Wilson, an American poet and author we first met in Iran, Lily Miller, Roloff's editor at McClelland and Stewart in Toronto, and Gilbert Read, a friend and colleague based in Rome.

I conclude with a special thank you and acknowledgment for my wife, Niloufar Afshar Crites, who too loved Roloff and saw so wisely that it was a book I needed to do not only for Roloff but even more for myself. Without her, I could never have finished.

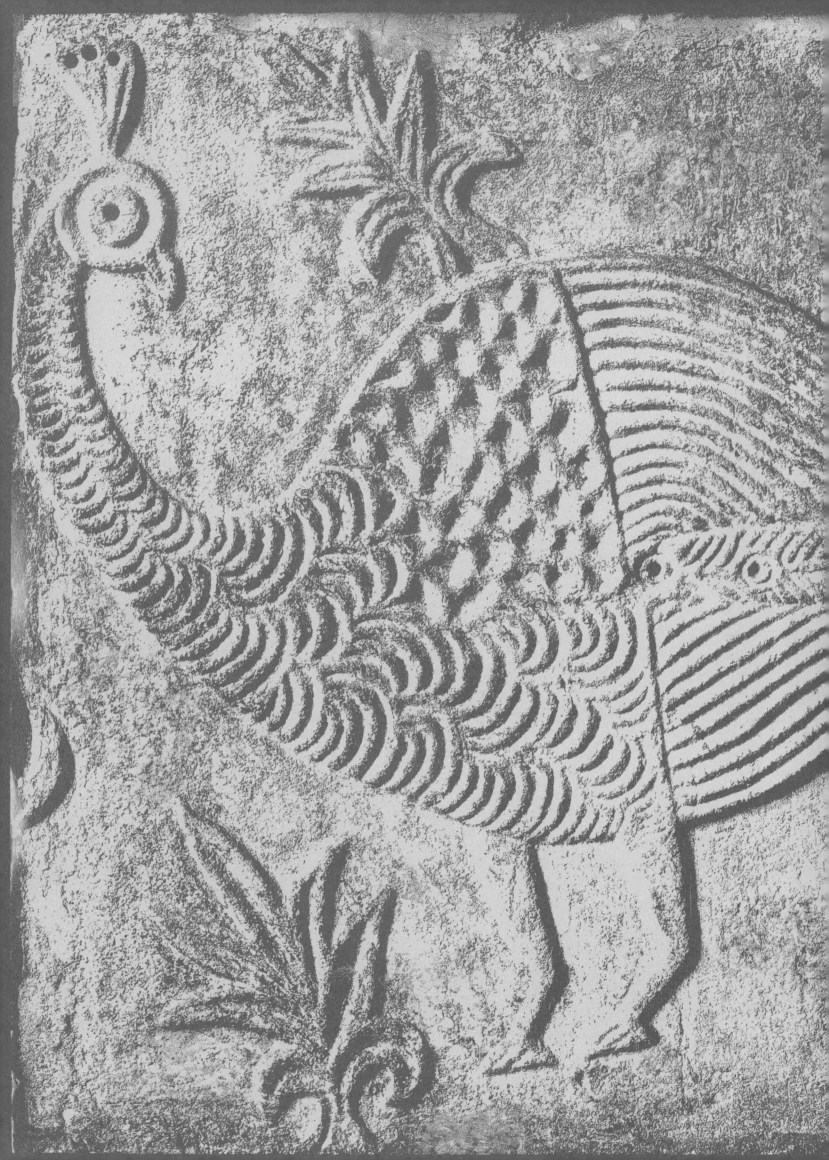